VOICES OF OCTOBER

PORTRAITS OF MODERN HALLOWEEN

BY PAUL COUNELIS
WITH PICTURES BY FREDA COUNELIS, CRYSTAL COUNELIS AND MAGEN RANDOL

OTHER BOOKS BY PAUL COUNELIS

YOUNG ADULT:

KENDALL KINGSLEY AND THE SECRET OF THE SCARECROW

SPOOK SLEUTHS: THE LEGEND OF OLD MAN GOOCH

KENDALL KINGSLEY AND THE MIDNIGHT CALL OF THE WILD WOLF

FILM COMMENTARY AND ESSAYS:

ANYTHING AND EVERYTHING UNDER THE SUN

25 UNDERRATED HORROR FILMS (AND THE EXORCIST)

POETRY:

SWEET CITY SYMPHONY

SEVEN LETTER POEMS

Cover photo: Magen Randol

ISBN – 978-1-105-60799-8

Copyright 2011 by Paul Counelis

CONTENTS

PROLOGUE 5

WE DO THE MASH 9

SCARRIAGE TOWN 34

COMMERCE 80

PICTURES OF AUTUMN 93

AFTERWORD 117

PROLOGUE

"The air resounds with tuneful notes

From myriads of straining throats,

All hailing Folly Queen;

So join the swelling choral throng,

Forget your sorrow and your wrong,

In one glad hour of joyous song

To honor Hallowe'en!"

-John Kendrick Bangs

The earliest memories I have of Halloween are of an exotic night air; children giggling as they sang their Trick 'r Treat song, an electricity seeping out of the evening and filling us all with a sense of excitement and promise. What a strange night, too, born of a myriad of different eras; mixed up traditions, modern interpretations and vintage, charmed, stark imagery.

I remember taking it all in. The smell of the treat bag, the different costumes marched around in the most unorganized masked parade up and down the entire street, the squeals and startled laughter emanating from the decorated porches and ghoulishly attired yards.

The ever present wind, just chilly enough to remind that a new season would soon begin, but for now, the orange/yellow moon staking it's mysterious claim on the current harvest season.

I remember talk of the Halloween parade at Civic Park Elementary, in the morning. Kids were scrambling to prepare for the walk around the school, which suddenly seemed like the most important thing in the world as I ran home, costume free, at lunchtime. In twenty minutes or so, as I ate a peanut butter sandwich, my mother whipped me up a pretty snazzy pirate costume and I ran proudly back to that school.

For many years after that, we didn't celebrate Halloween. We still did fun things around the same time; a treasure chest of candy hidden and clues given to navigate. But I remember the exact night when I realized that sometimes Halloween night felt different, that it wasn't just a manufactured date. I was probably 15 years old.

I was standing in the middle of the road, poised between my house and my grandparents' house. I stopped and listened to the wind as it whistled ancient tales through the gnarled, old trees. I smelled the summoned leaves, newly fallen and randomly assembled all around. I heard the joyful laughter from the children. And I felt as if that night were somehow different than any other night of the

year, and not just because you could walk to someone's house, say the magic words, and get free candy. Something more.

That electricity. That feeling of anything just waiting to happen.

I love the Halloween season. I love the images, and the sights, and the smells, and the sounds. The little boy aspect of me rejoices at all the monsters popping up in unusual places, like an animatronic creature in the middle of what used to be just a plain, old grocery store. Or orange and purple lights highlighting the ghouls and goblins on what was once just a random, vanilla suburb lawn. Or even the simple cartoon art on a candy display. It's not just commerce, it's a sign of the season. The season where creativity is outwardly apparent, and openly encouraged.

It ushers in the thoughts of the hayrides through the woods to the sprawling pumpkin patch, where children choose their favorite pumpkins off of the vine to take home and decorate. The pleasant, satisfied smiles as they hold their chosen gourds on the ride back through the woods, no doubt deciding what face to embody their would be jack o'lanterns with.

The cool, clear nights, sitting snuggly sheltered inside with apple cider and donuts and Halloween specials on television (even TV takes a break from the mundane to present more colorful, spooky programming).

And the best thing happens on Halloween night. Something special; something unique. Every year without fail, just like before in those stirring memories. You can walk outside, stand amidst the mirthful conviviality of the gathered and amid the howling winds of autumn, look around at the sights of the festive evenfall, and listen to the wayward sounds of the season.

And you can hear the children. Playing, yelling, laughing.

PART ONE: WE DO THE MASH

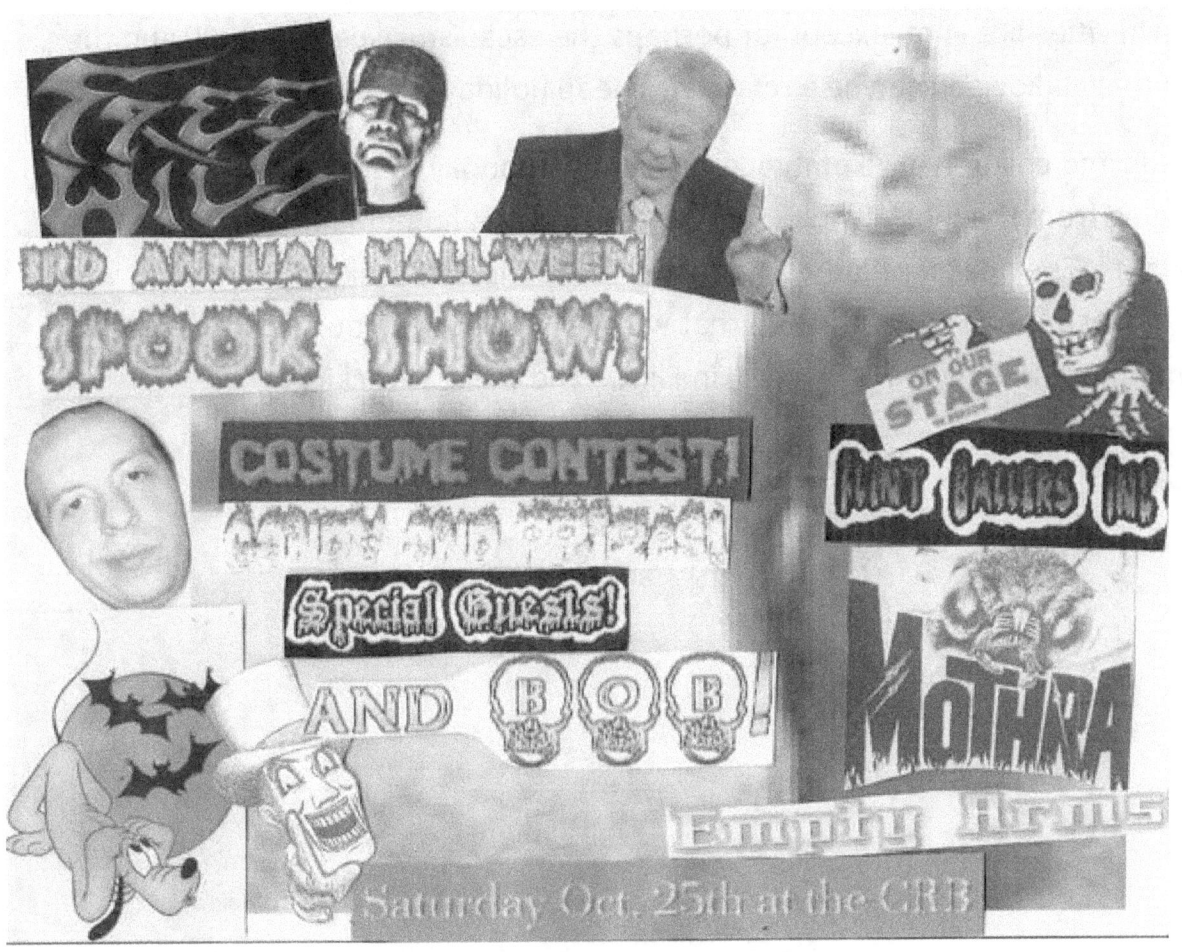

FLYER FROM FREE WILL'S "3RD ANNUAL HALL'WEEN SPOOKSHOW", AT THE CORUNNA ROAD BAR IN FLINT, MICHIGAN.

IN LATE AUGUST or so in Flint, Michigan, many different Halloween tinged businesses, ideas and displays start popping up around town. There are the different Halloween stores that invade previously empty buildings for a few months between late summer and the indoctrination of fall. There are also a number of inspired haunts that seem to rise from nowhere to add an exciting flavor to the season, and many yard displays from Halloweenies all around the city.

For Flint, it's an active time. The recent history of Flint has been chronicled quite often and by a number of different sources. Suffice to say that the city has seen it's share of infamous ups and downs. I'm not sure why Halloween is such a big deal in cities like Flint, except for perhaps the escapism aspect of it all, and the fact that Halloween can be a relatively cheap holiday to take part in.

Adults and children alike embrace the colorful spooky season, with costumes ranging from the most simple to the most sublime; homemade and "store bought". The appeal of pretending to be someone else is likely present, as well as the basest notion of dressing up that we are instilled with during childhood. In other more Halloween-ish words, in Flint, "The scene is rocking."

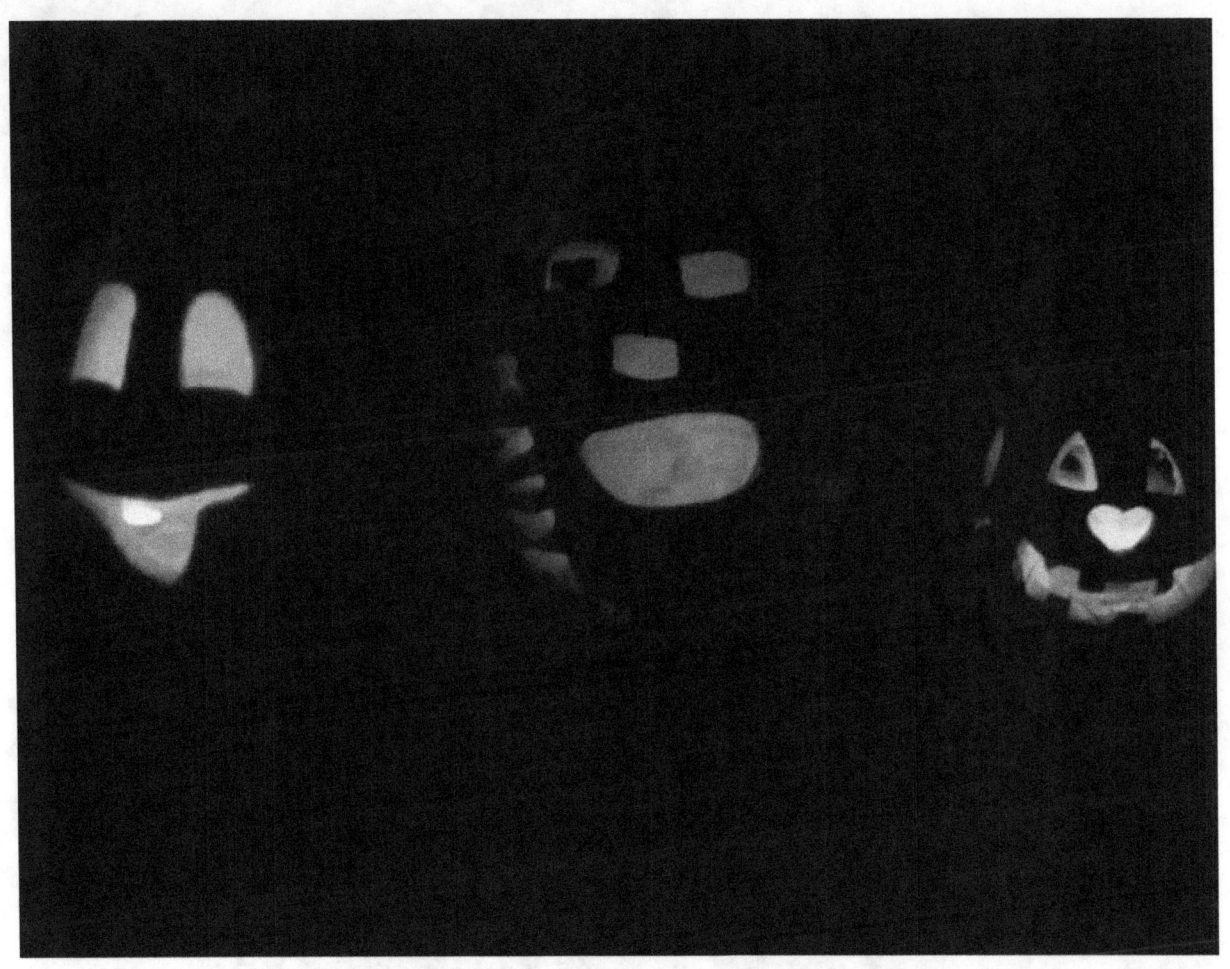
PUMPKIN CARVING, EXAMPLES OF SOME OF THE SEEMINGLY ENDLESS JACK O' LANTERN POSSIBILITIES.

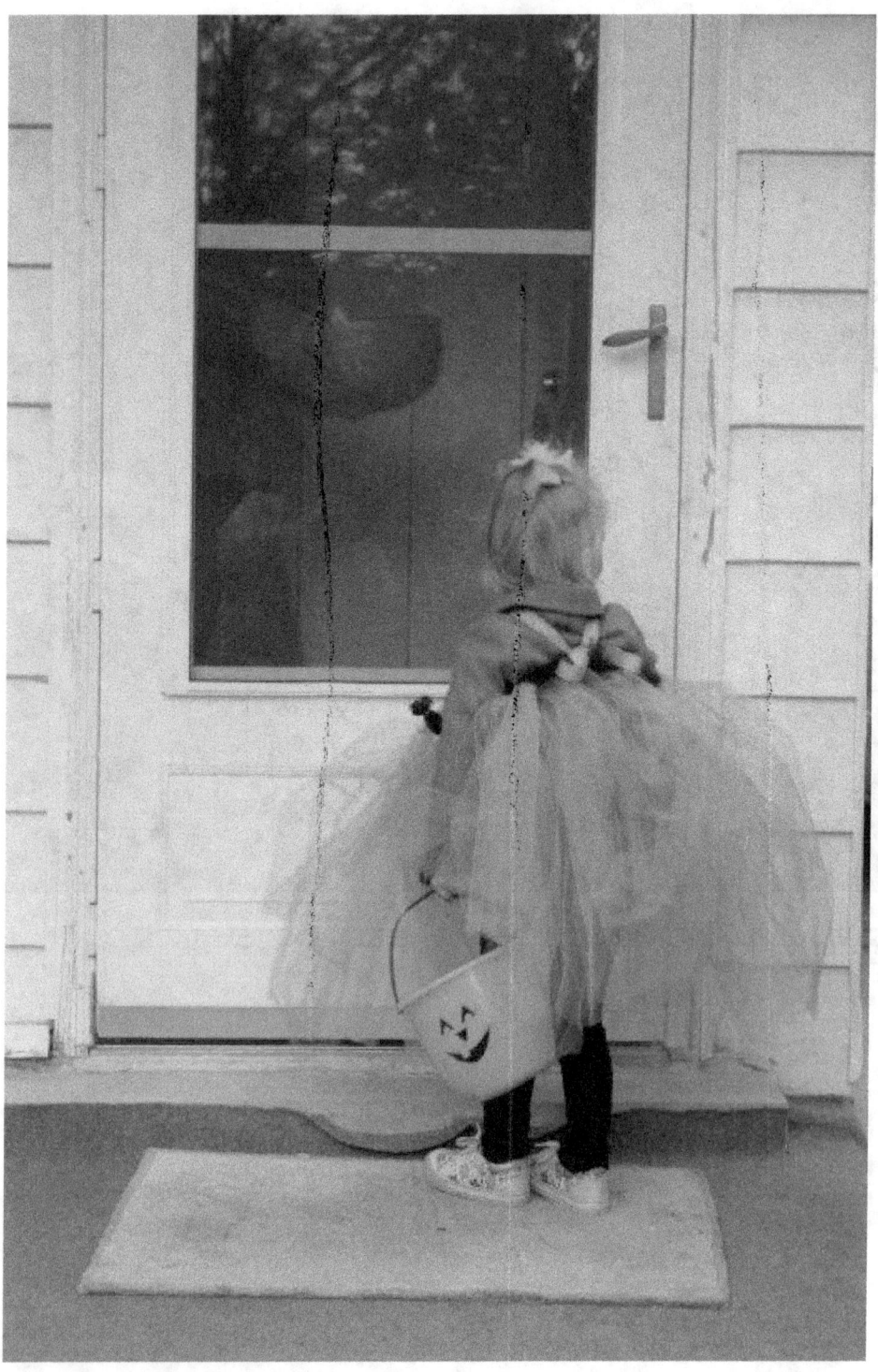

TRICK OR TREAT.

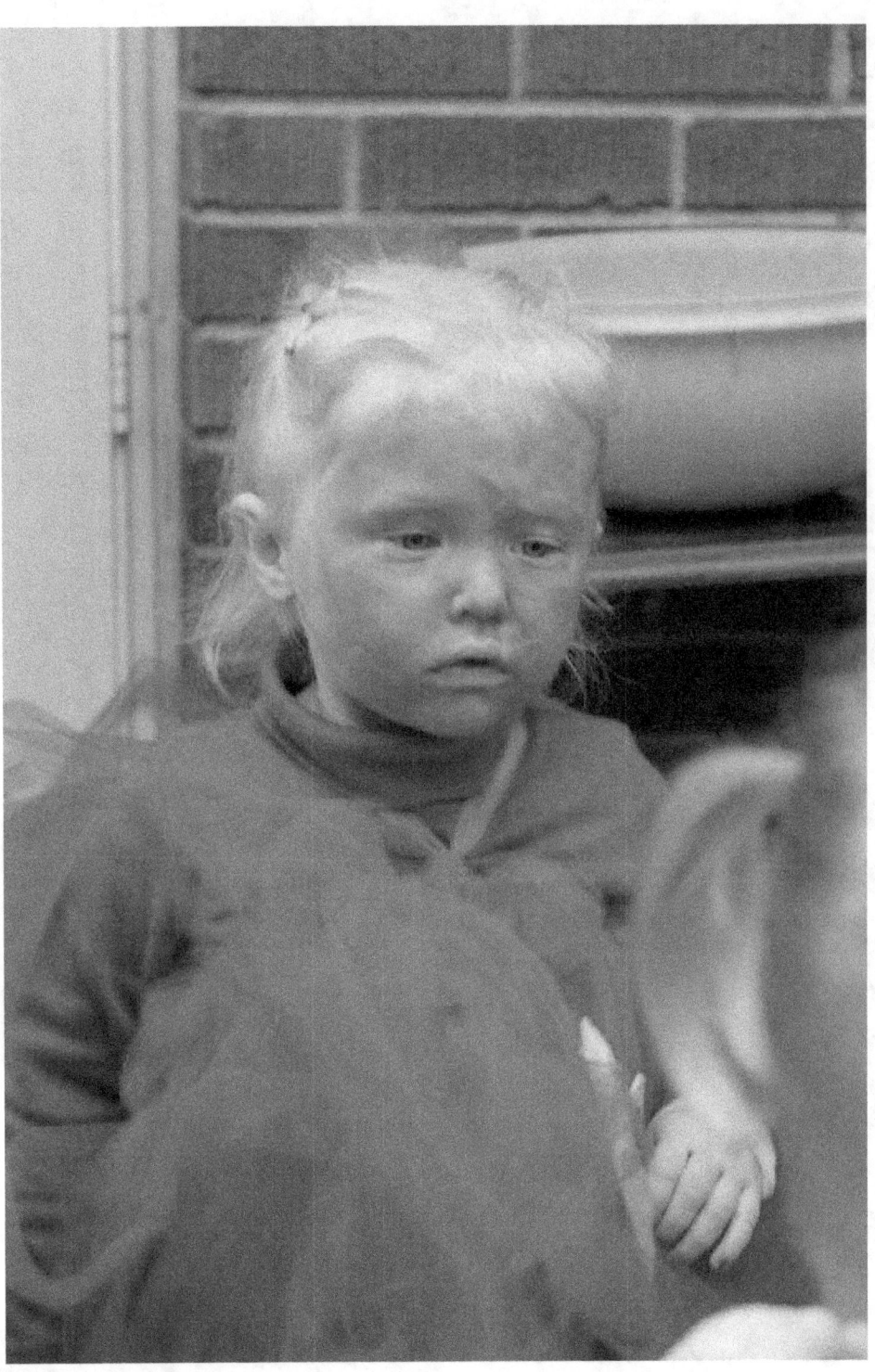

ELMO UNMASKED.

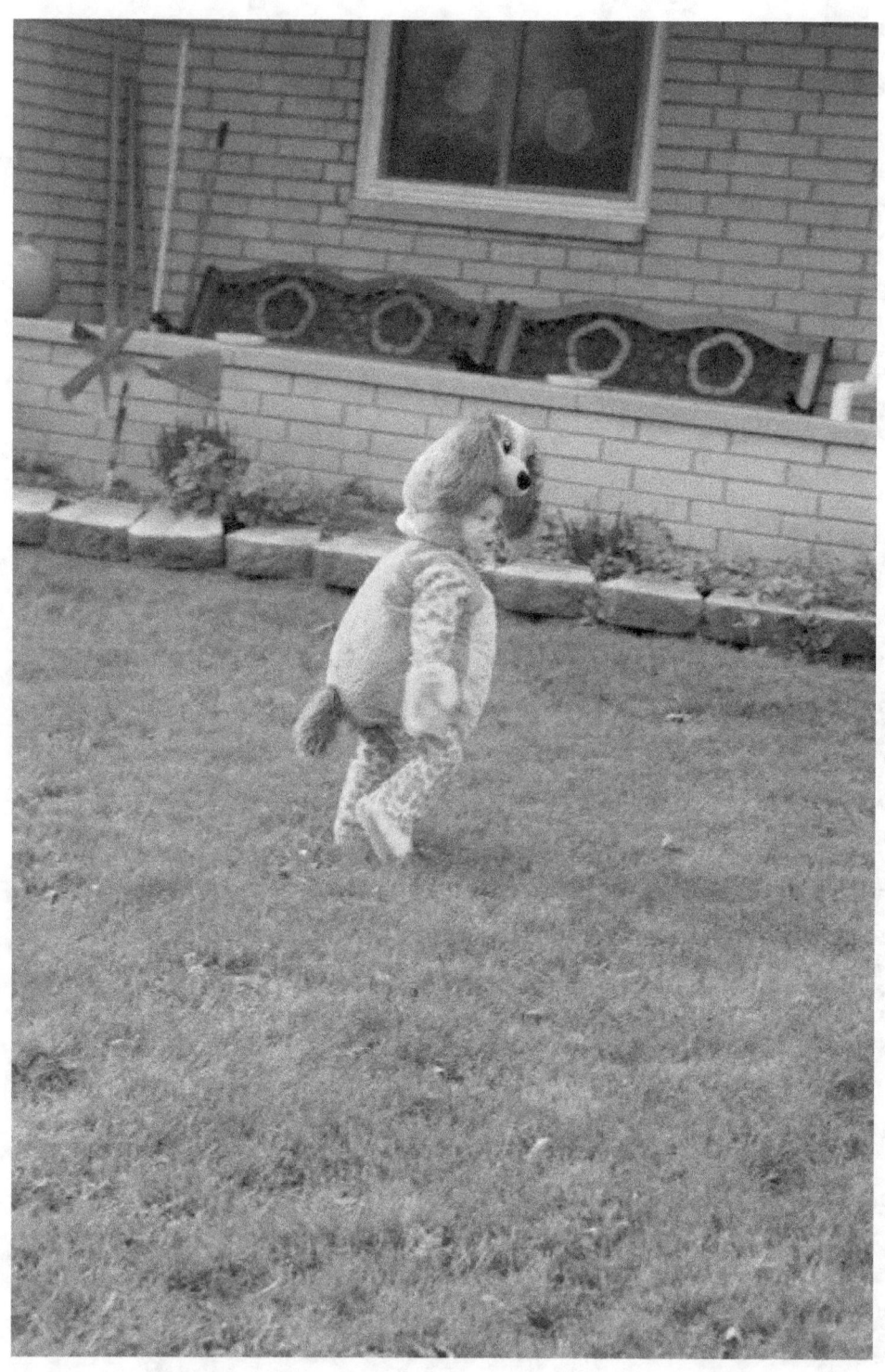

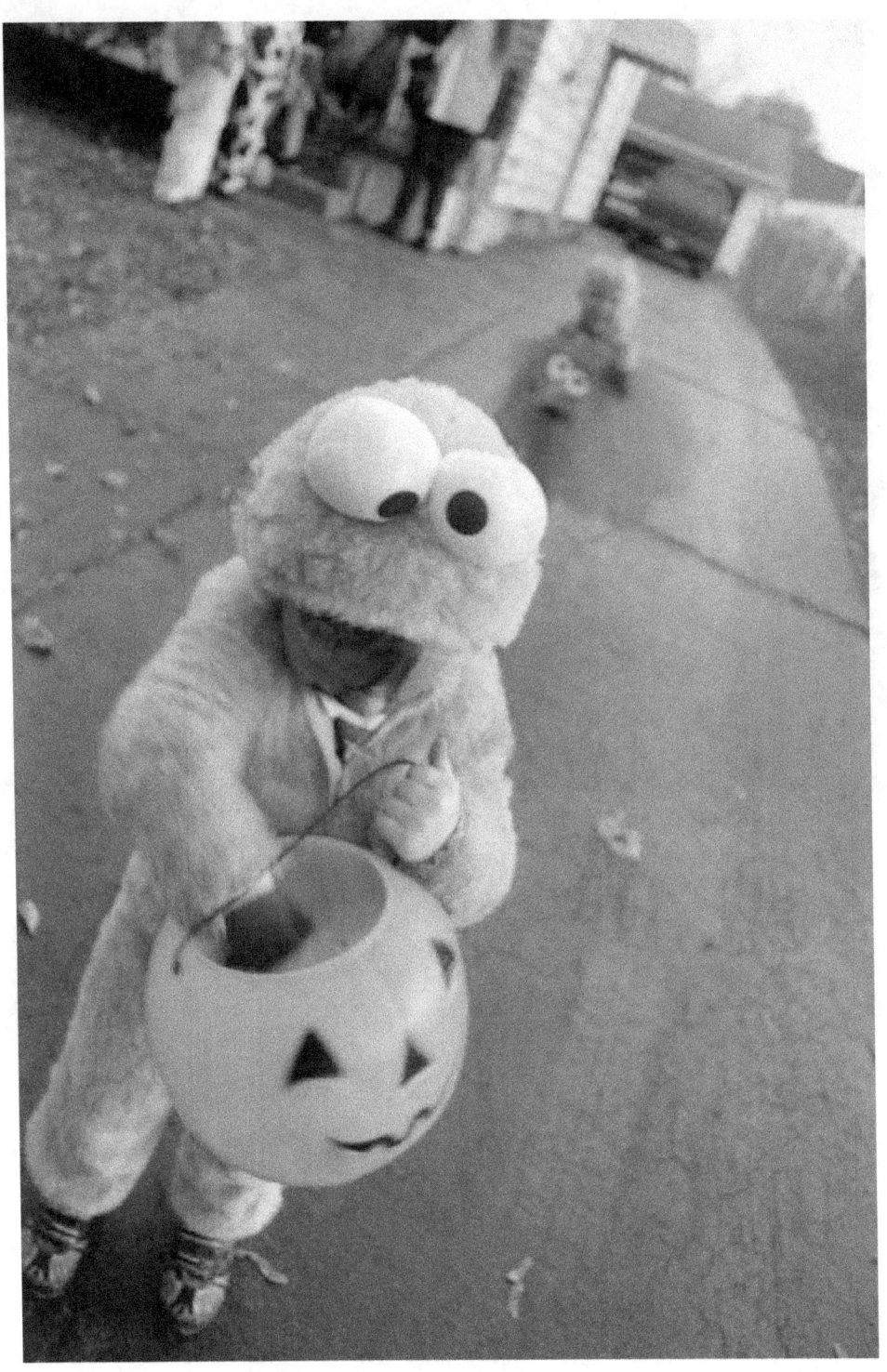

15 | VOICES OF OCTOBER

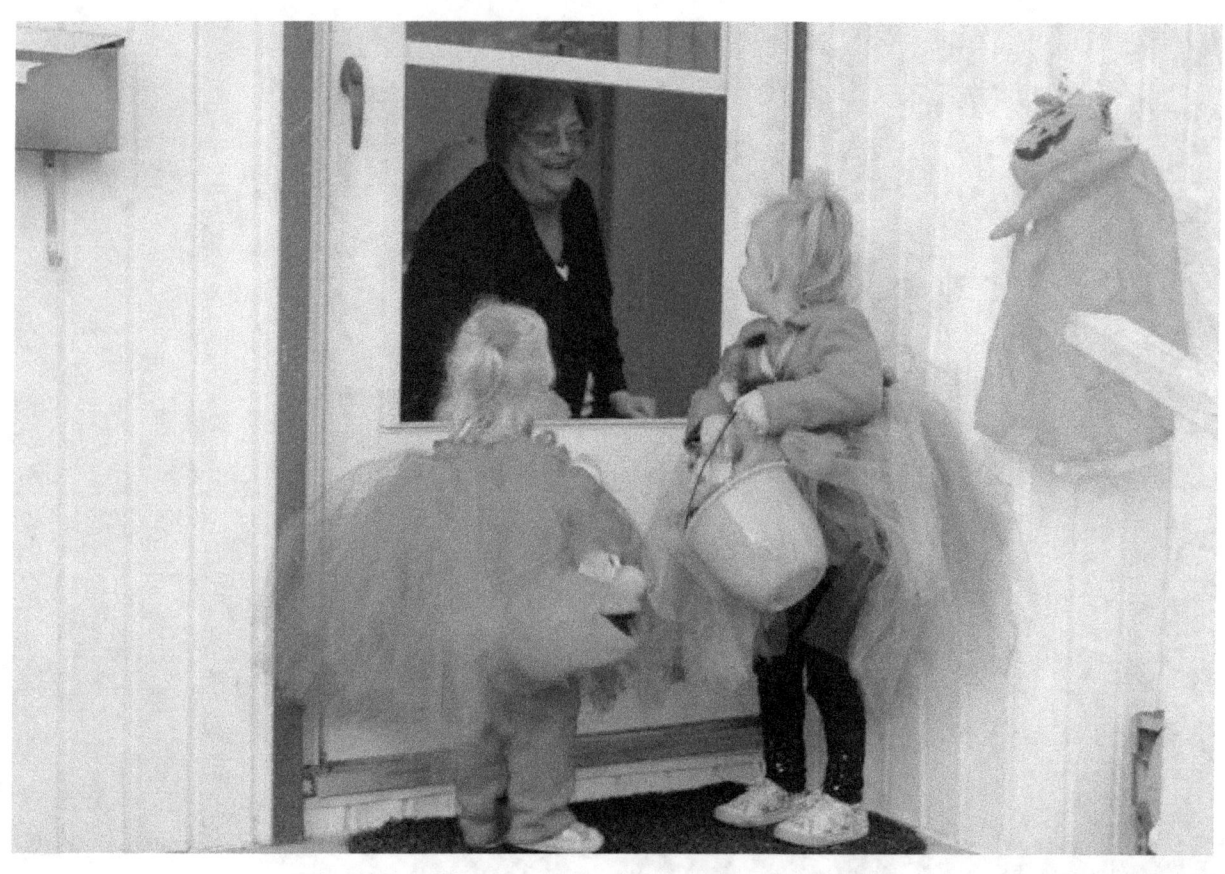

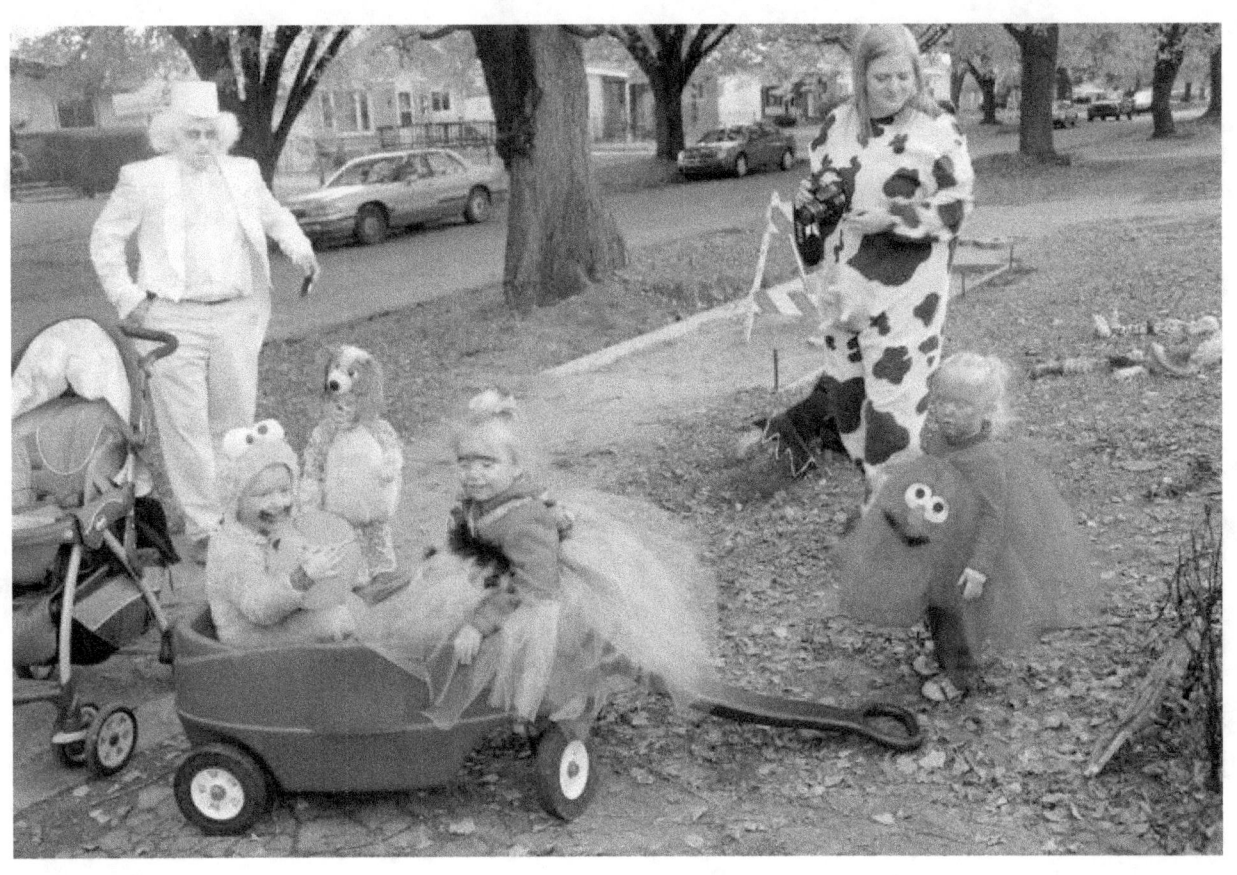

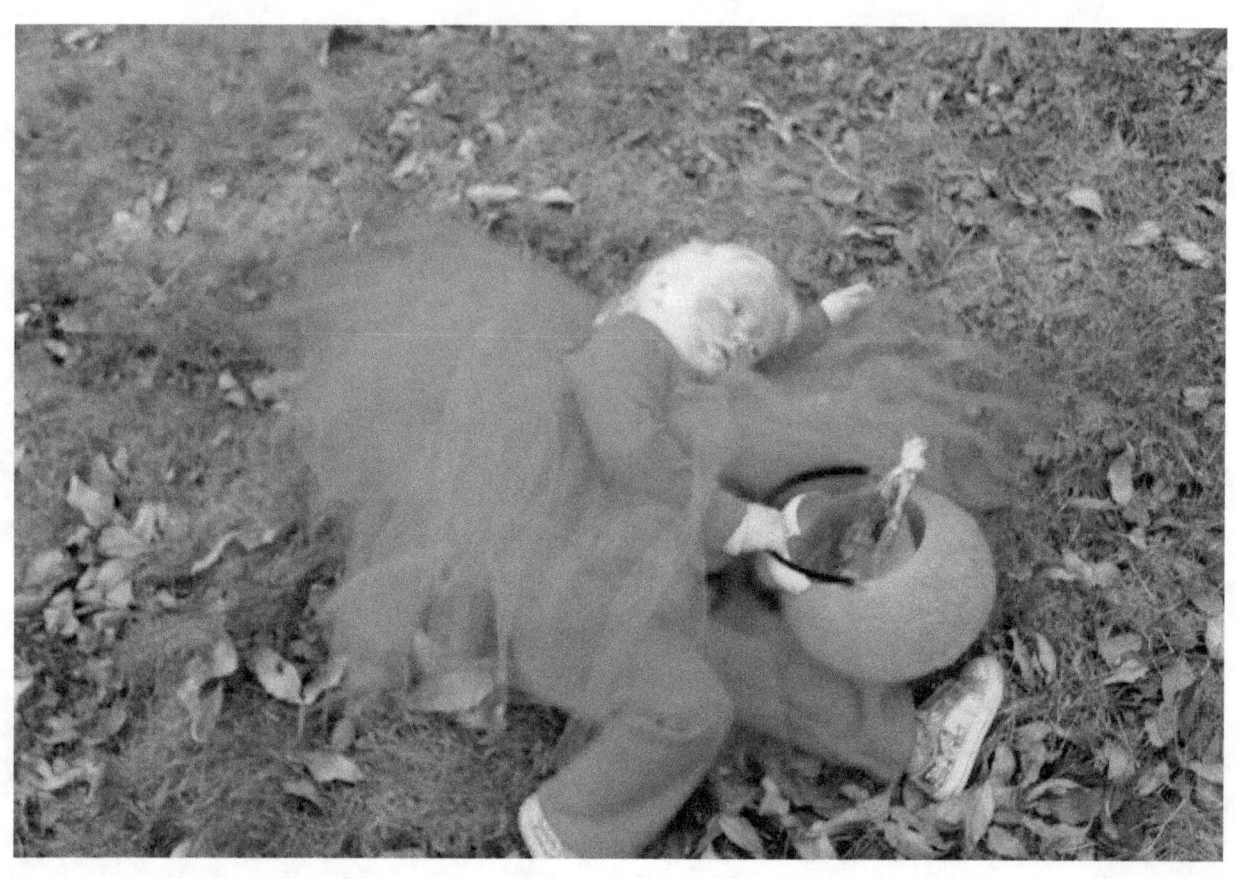

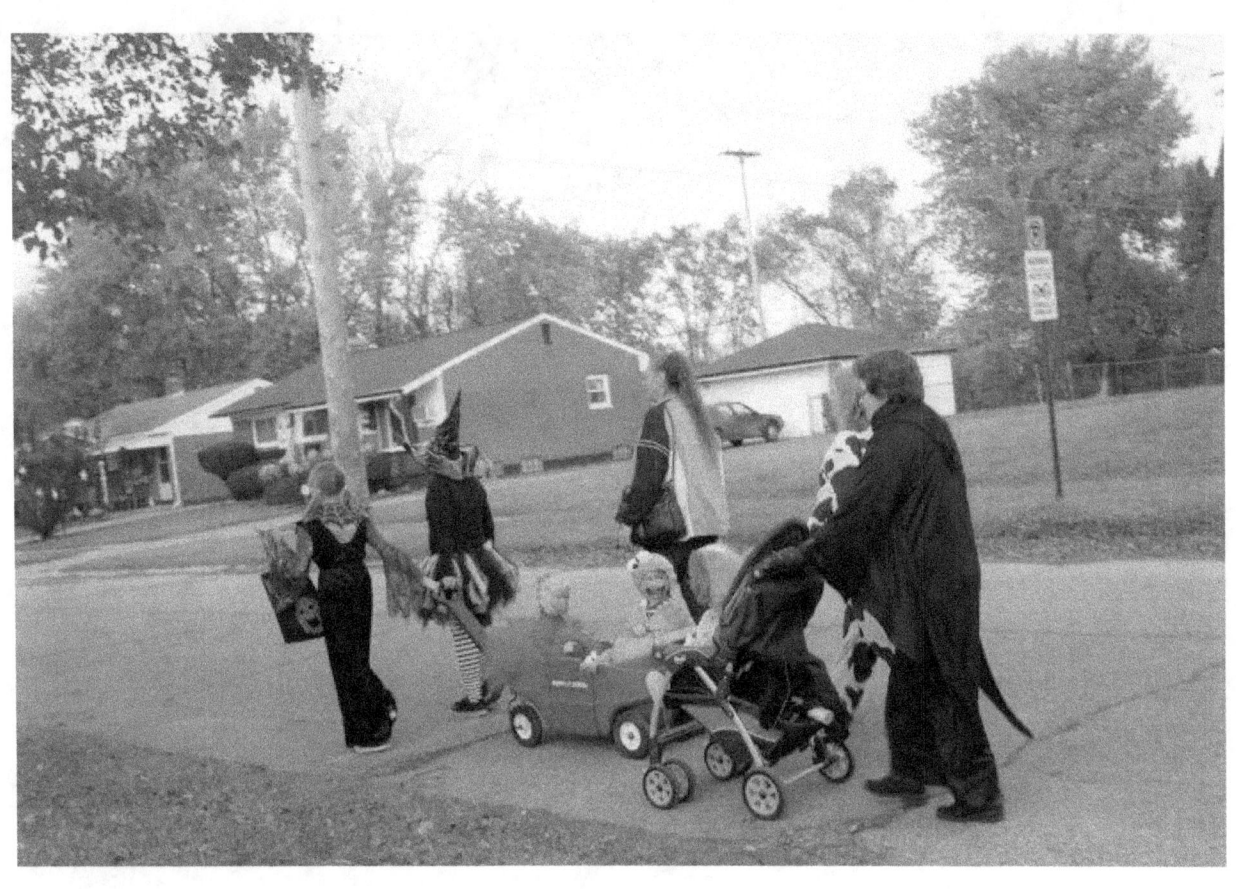

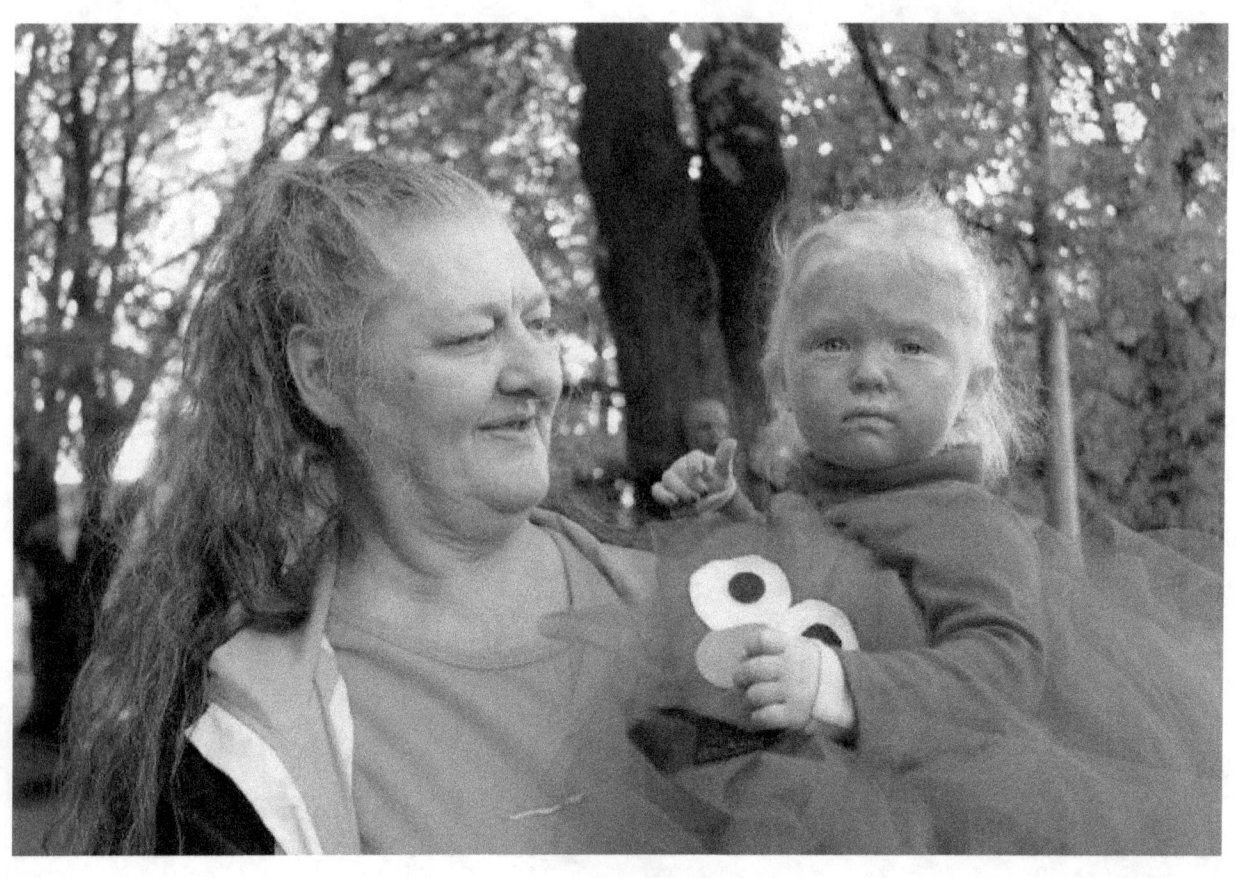

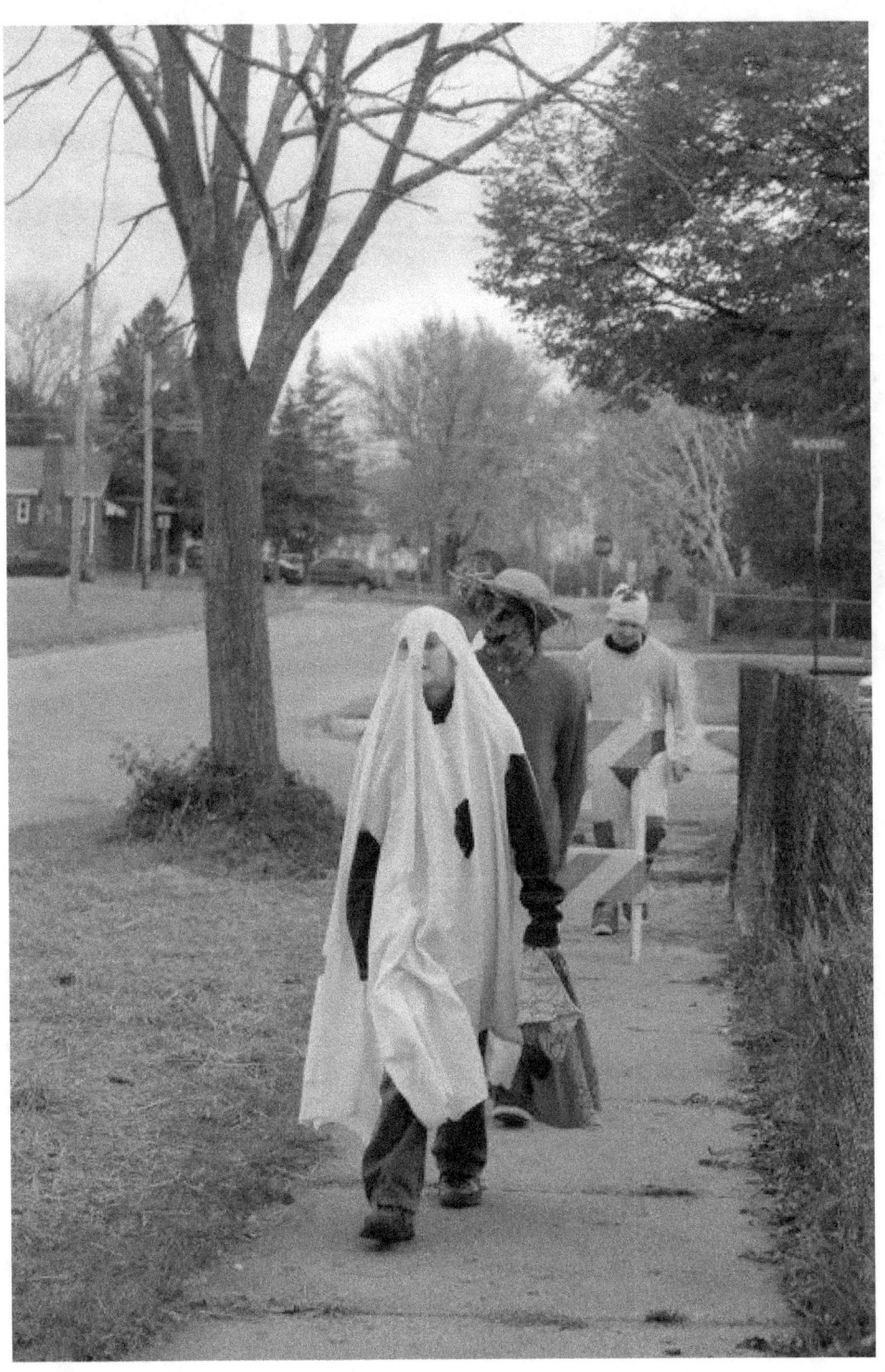

I GOT A ROCK.

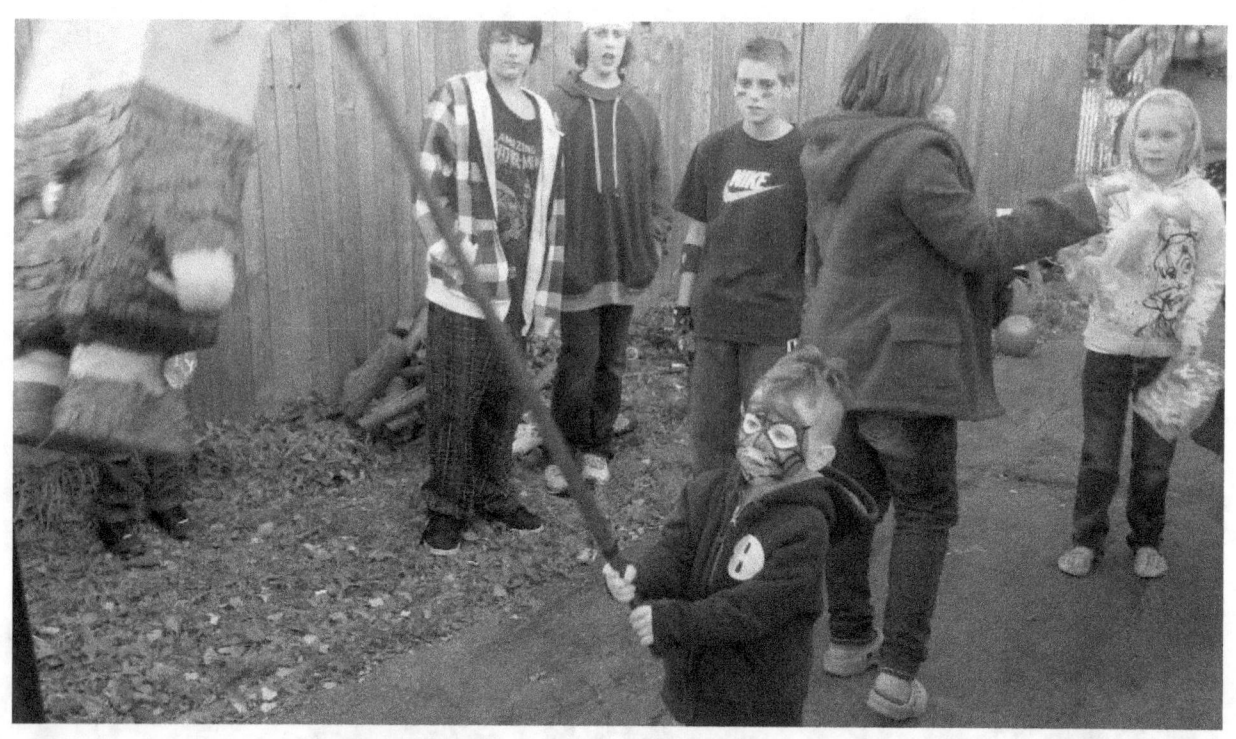

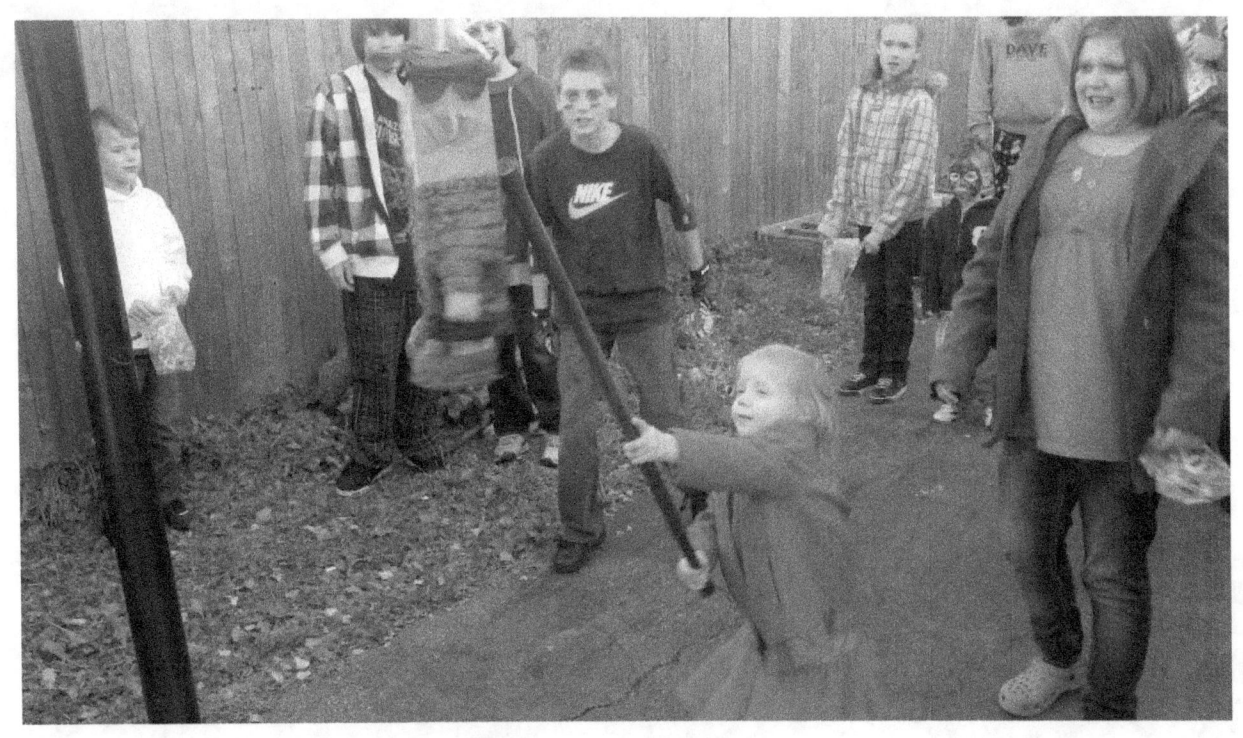

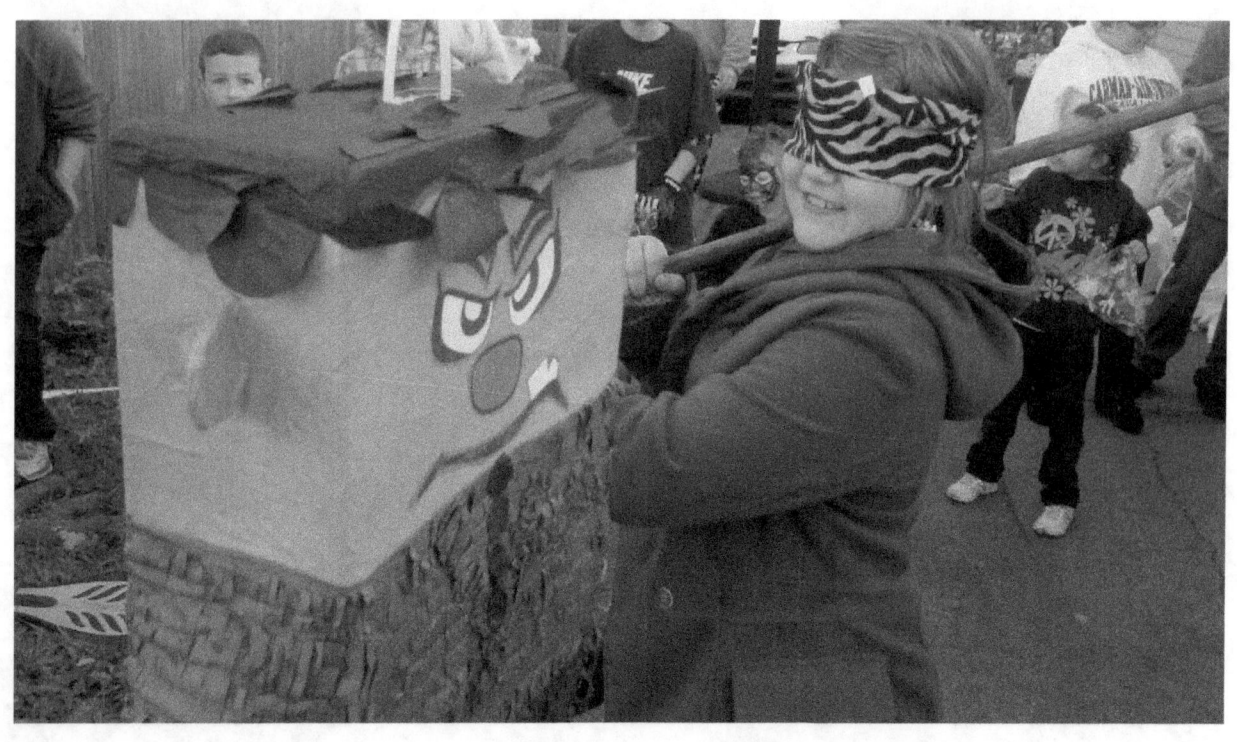

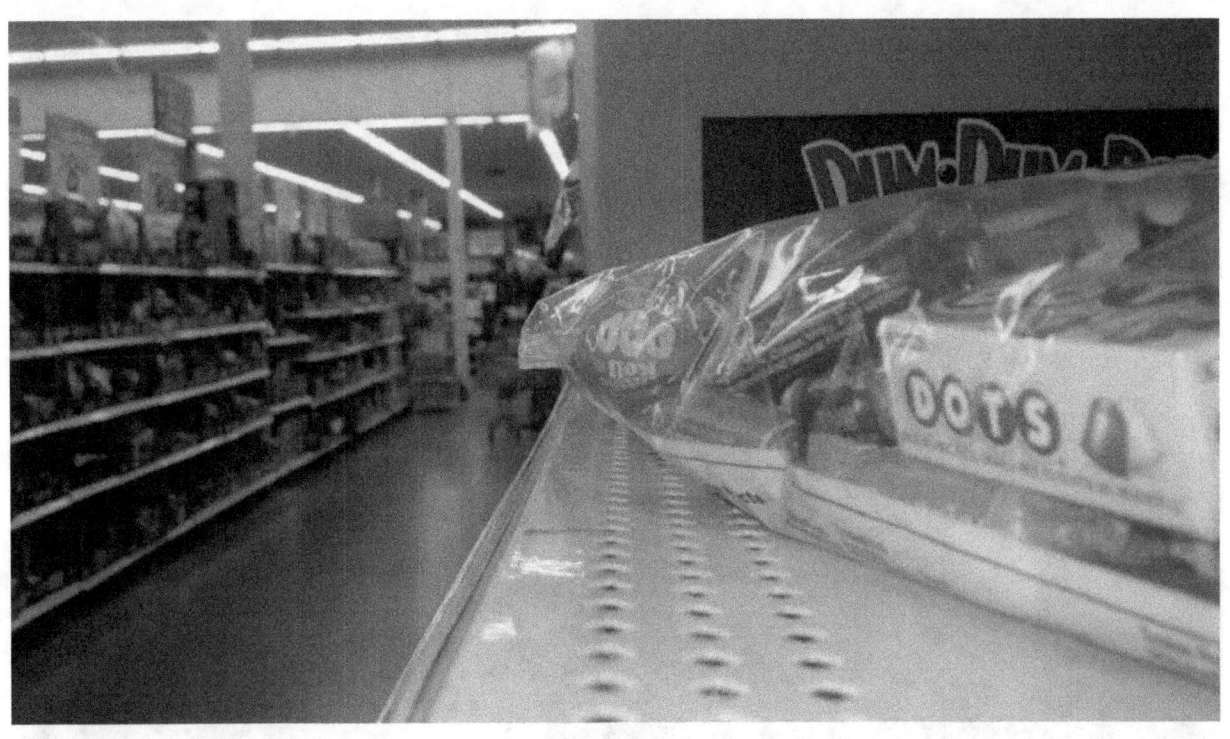

OKTOBERFEST – FRANKENMUTH, MICHIGAN

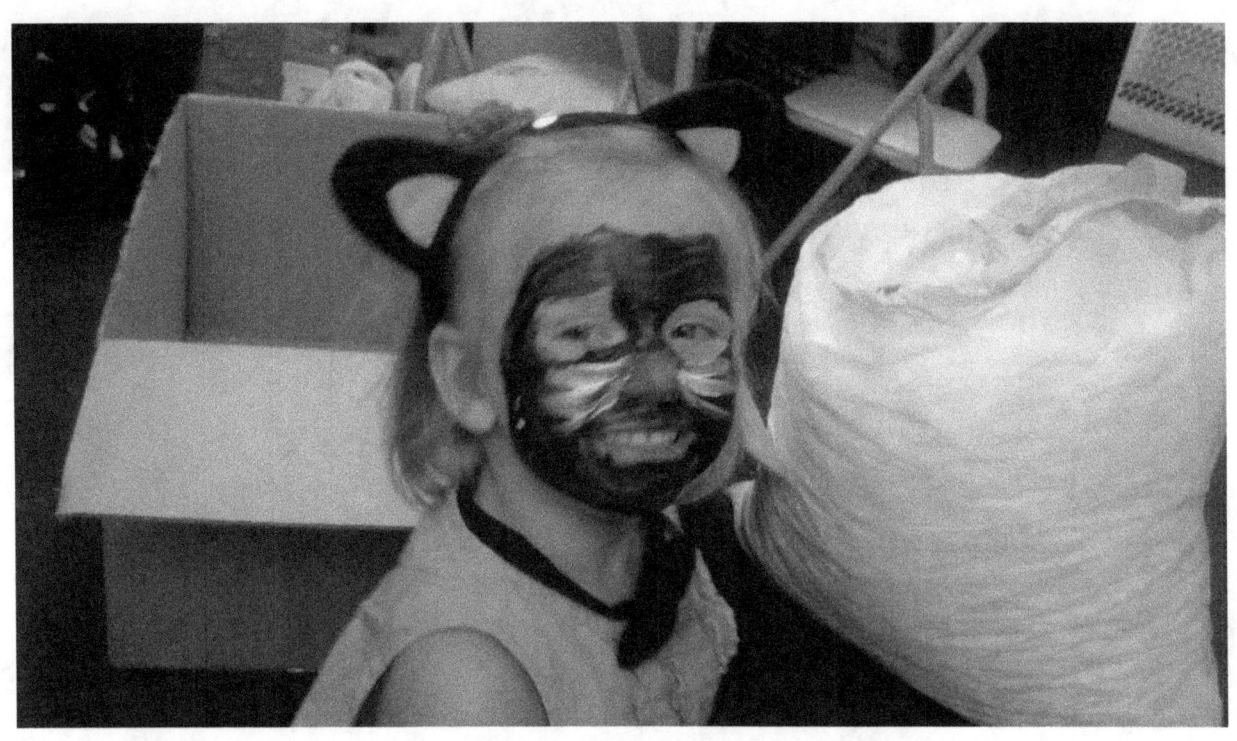

AUTUMN ART. MAKAYLA RANDOL.

HORRORDAY SHOPPING.

STALKING A HALLOWEEN PARTY.

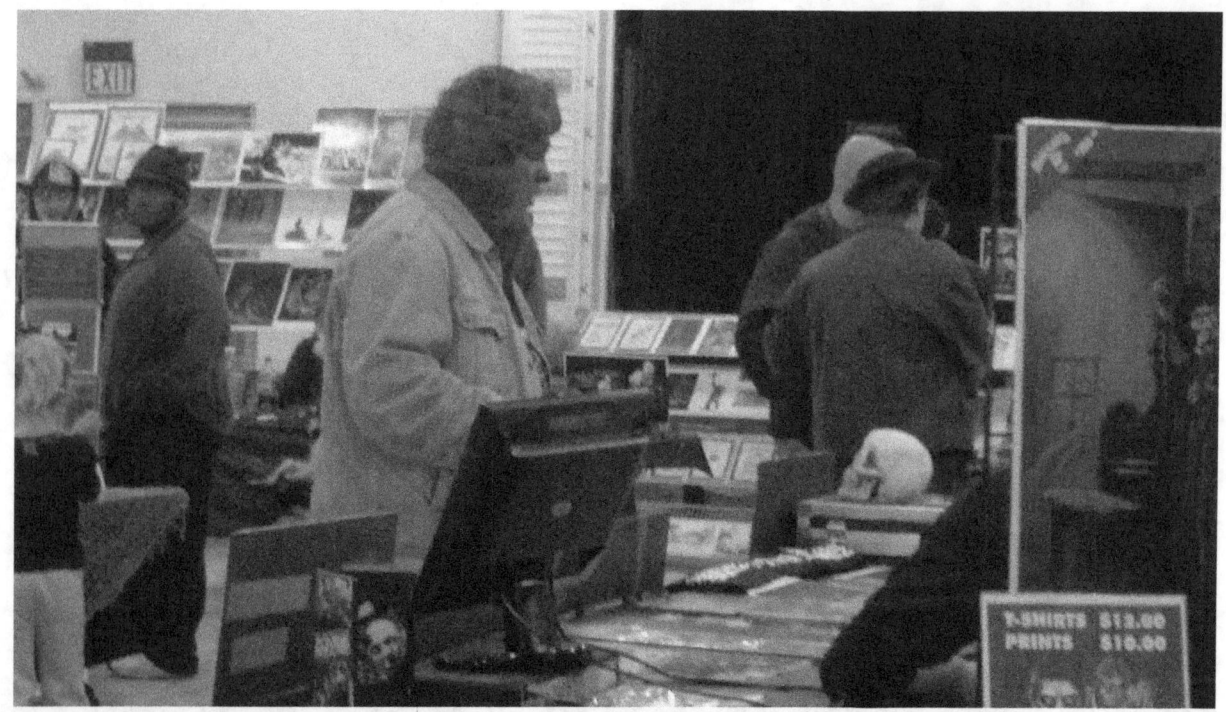
WOLFMAN MAC HOWLS AT THE FIRST FLINT HORROR CONVENTION, MASONIC TEMPLE IN DOWNTOWN FLINT.

PART 2: SCARRIAGE TOWN

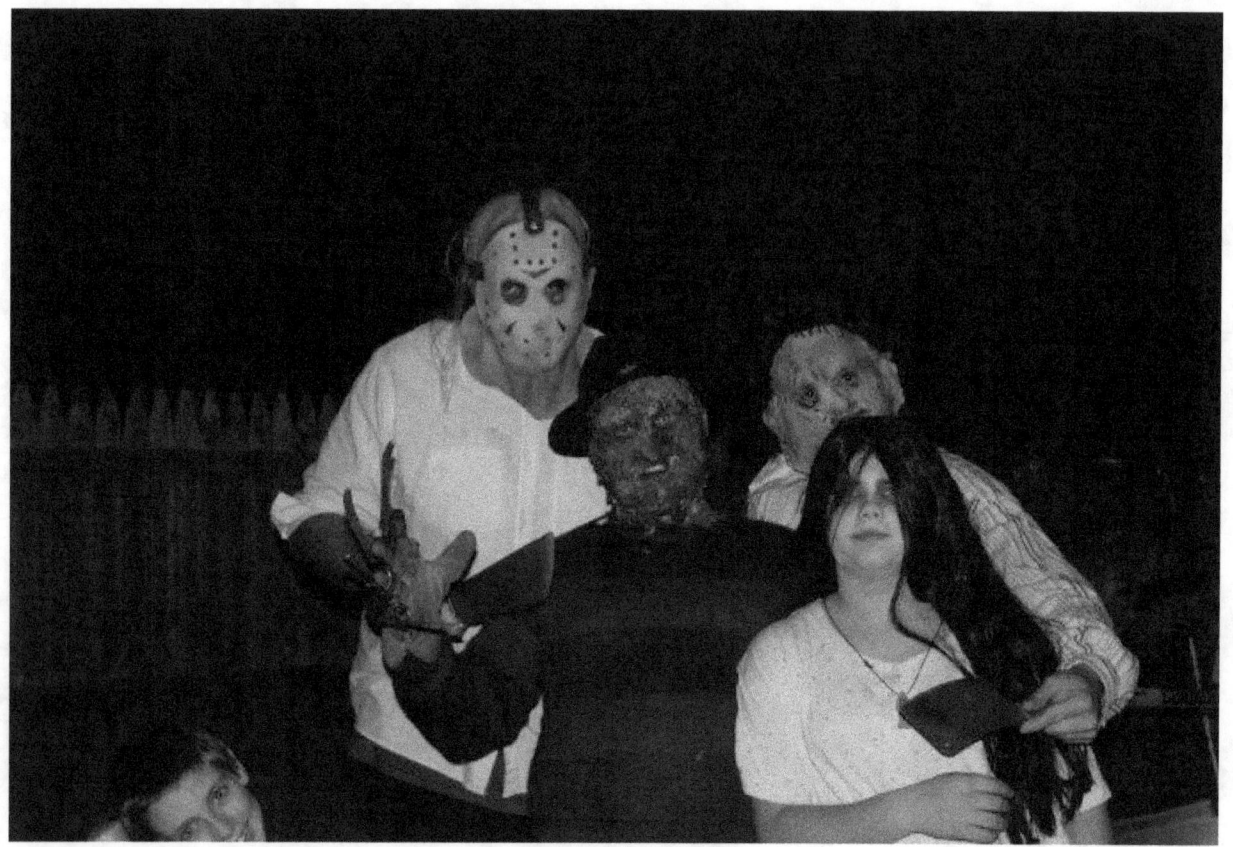

FIENDS OF THE NIGHT: HOME HAUNTERS STALK "SCARRIAGE TOWN"

THERE'S A SERIES OF MOMENTS, when walking through a good haunt, where nothing else matters for that time period. You are in a fantastic element, wherein things that don't happen in everyday life go on around you. It's enticing because you don't know what's waiting for you around the corner and when you see it, as your mind adjusts to what it is that you're seeing, adrenaline pumps into your body. It's intensified when you're in a group of other people, laughing and screaming together. It's funny, but in this context, there's a communal feeling between the haunters and the crowd, and the members of the crowd with each other.

I recall my uncle challenging me to walk through the haunted house by myself at the local county fair. I was probably 10 years old. He said he would pay my way in and give me a dollar if I made it through. The spooky art on the outside of the

haunt display scared me, but also intrigued me...so I went in. There were two other kids, one directly in front of me and one directly behind me in line. We didn't know each other at all. The man running the ride ushered us into the haunt opening, the lights went out...and, in an amusing yet truthful illustration of the community aspect of a good scare, we all immediately held hands and ran through the entire thing together.

My wife and I have seven kids, six of whom play a part in our haunt (my youngest is two, so she generally just goes trick or treating). Literally everyone helps out in some way; my parents have brought us props (my dad has joined us in scaring folks on several occasions), our kids and some of our other friends and family are a part of the haunt, my sister helps with creations and set-up, my brothers-in-law and my cousin help build the walk-through and don costumes for the scares. An old friend of mine who lives across the street and plays in local bands comes over dresses in costume for the haunt. We even have a young neighbor who we've brought in from our previous neighborhood to play "Samara" from "The Ring", and she climbs through the giant TV (never fails to create a few jumps and screams).

Even our neighbors are extremely supportive---I once caught one of them putting fresh batteries in some of our animatronics.

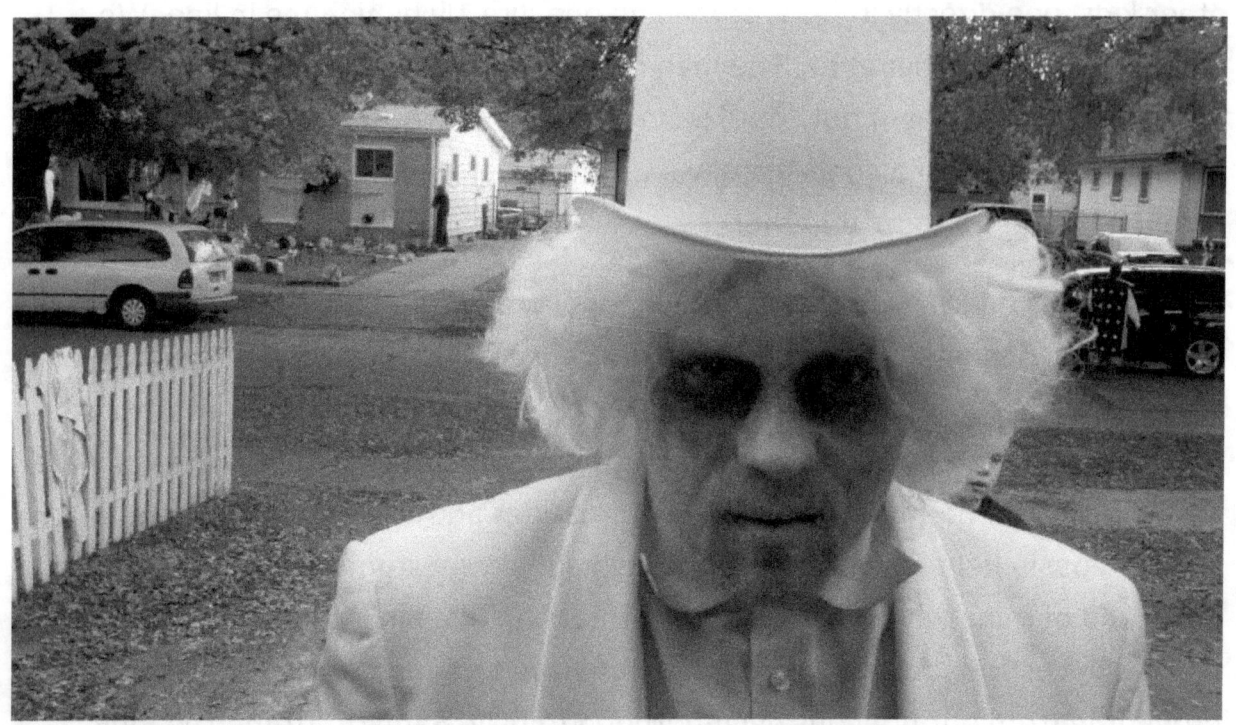
"WELCOME TO SCARRIAGE TOWN!" THE GHOSTLY CARETAKER (LEN RANDOL) LEADS PEOPLE THROUGH THE HAUNT, EVER READY WITH THE QUIPS.

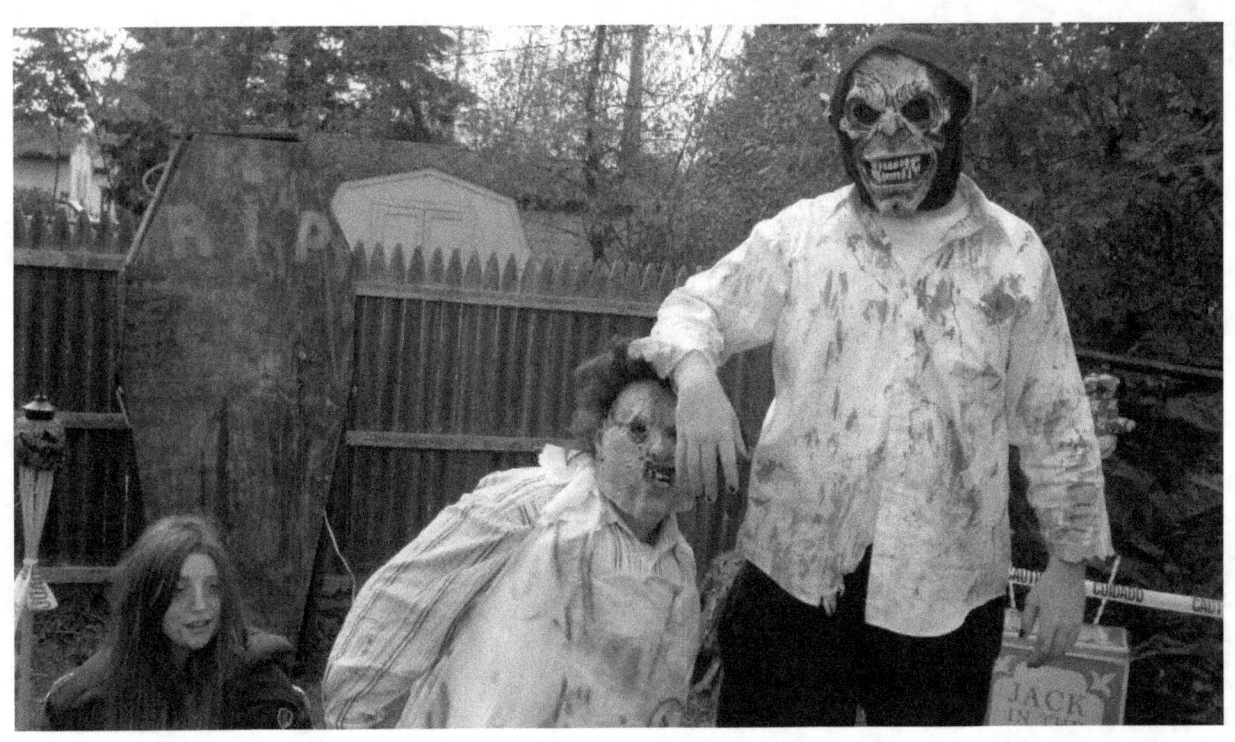

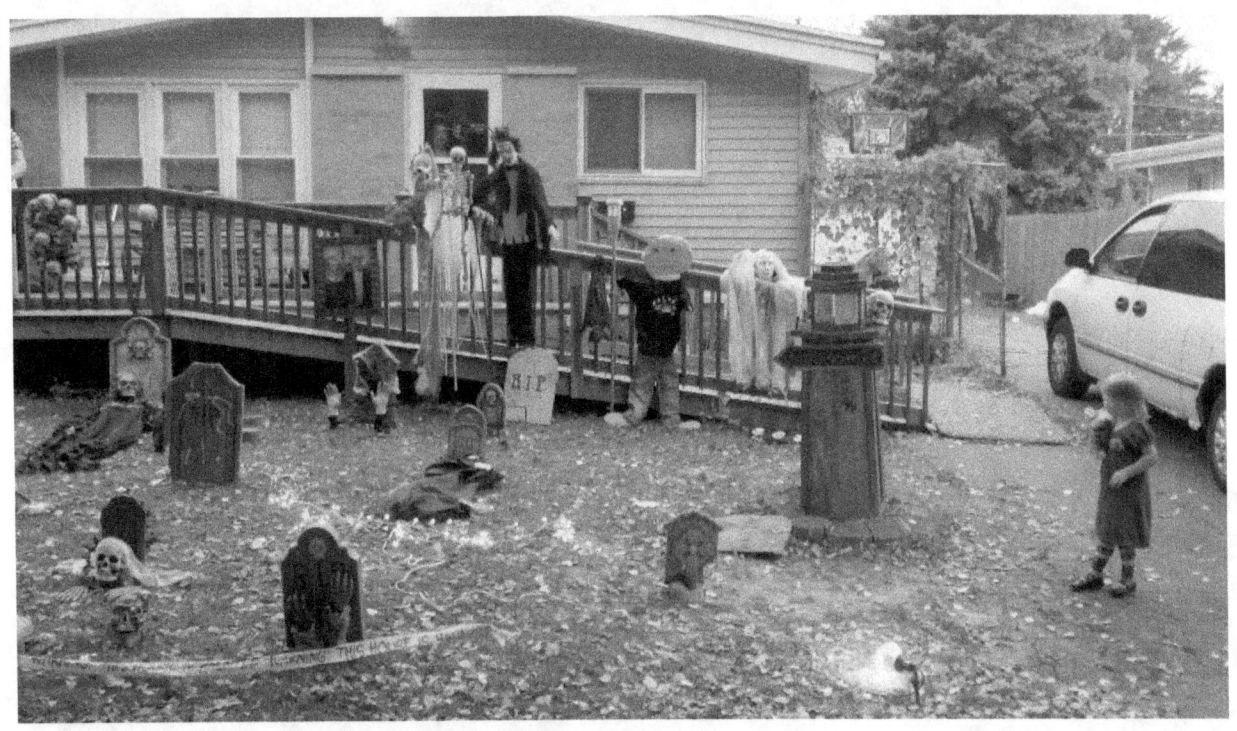
TWO YEAR OLD MILEY SURVEYS THE YARD A FEW WEEKS BEFORE THE HAUNT.

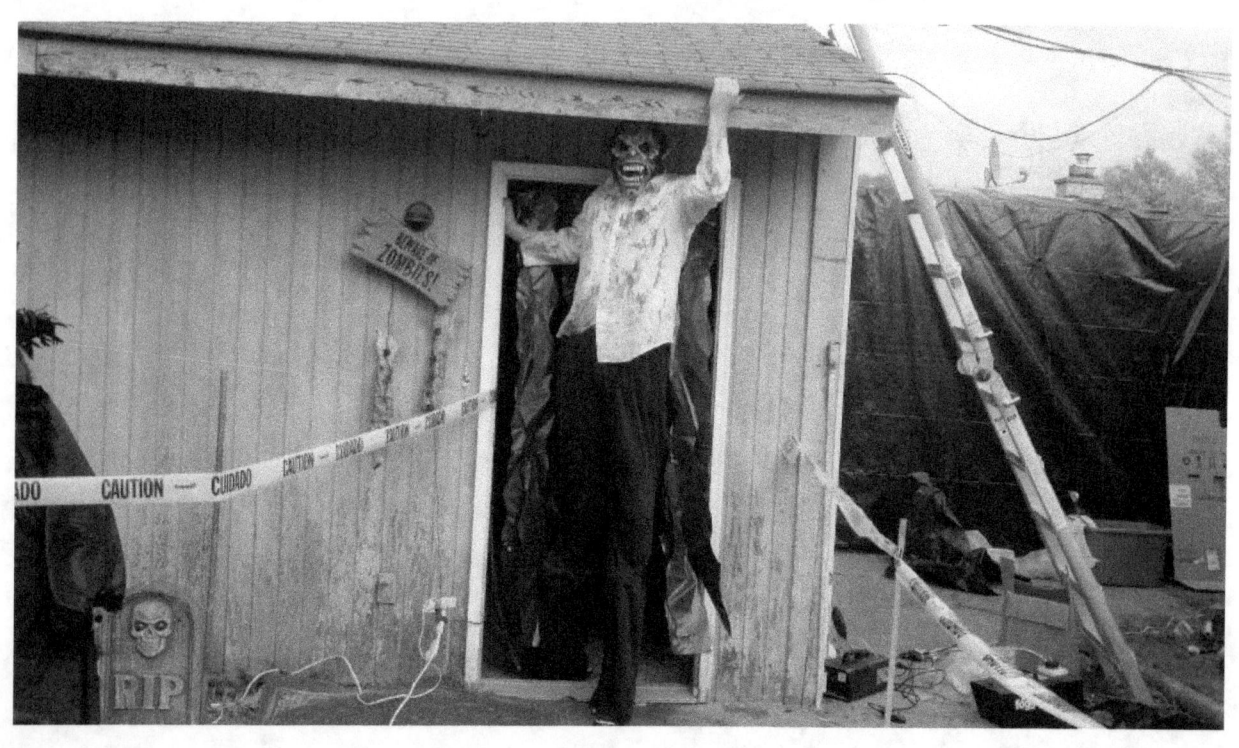

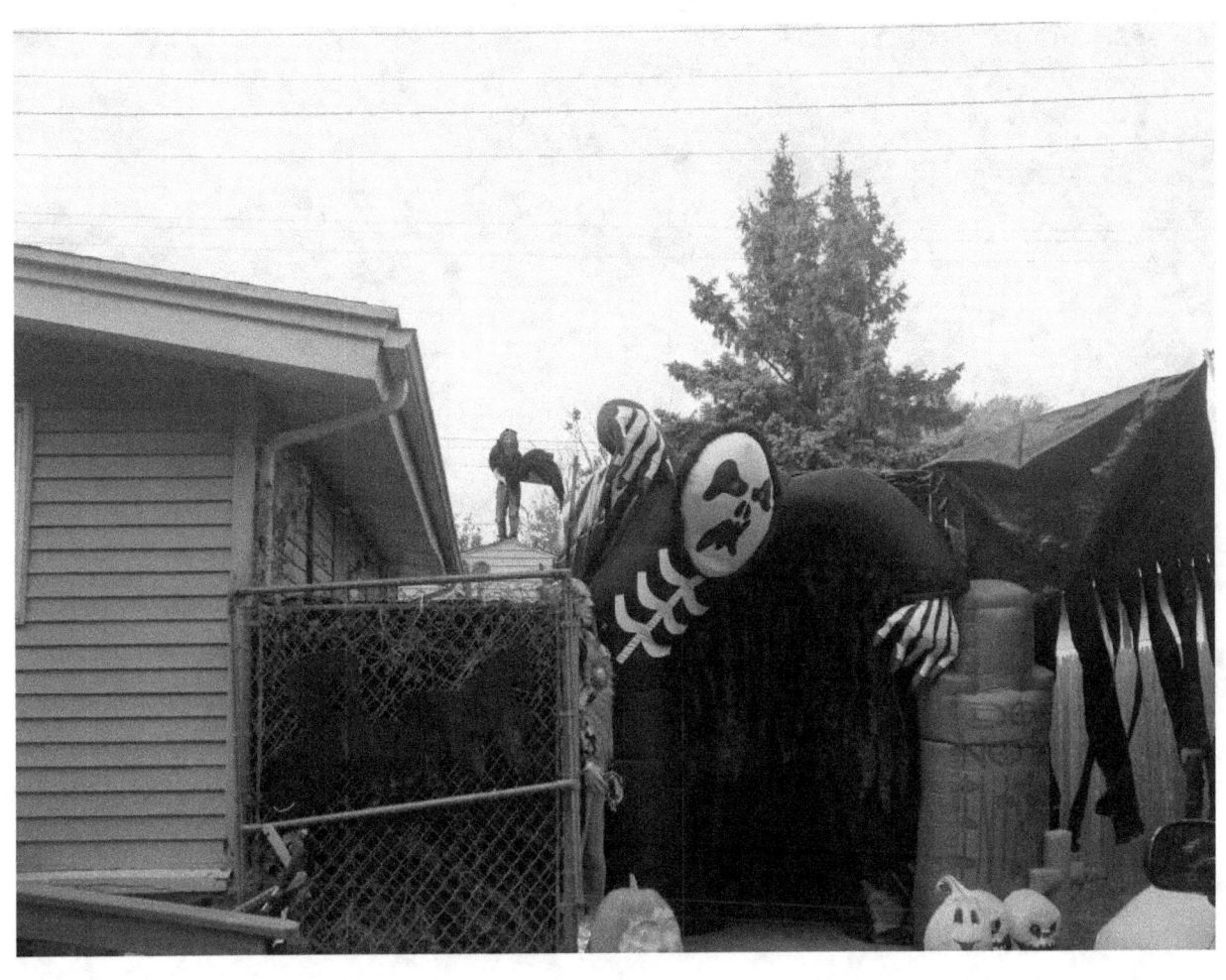

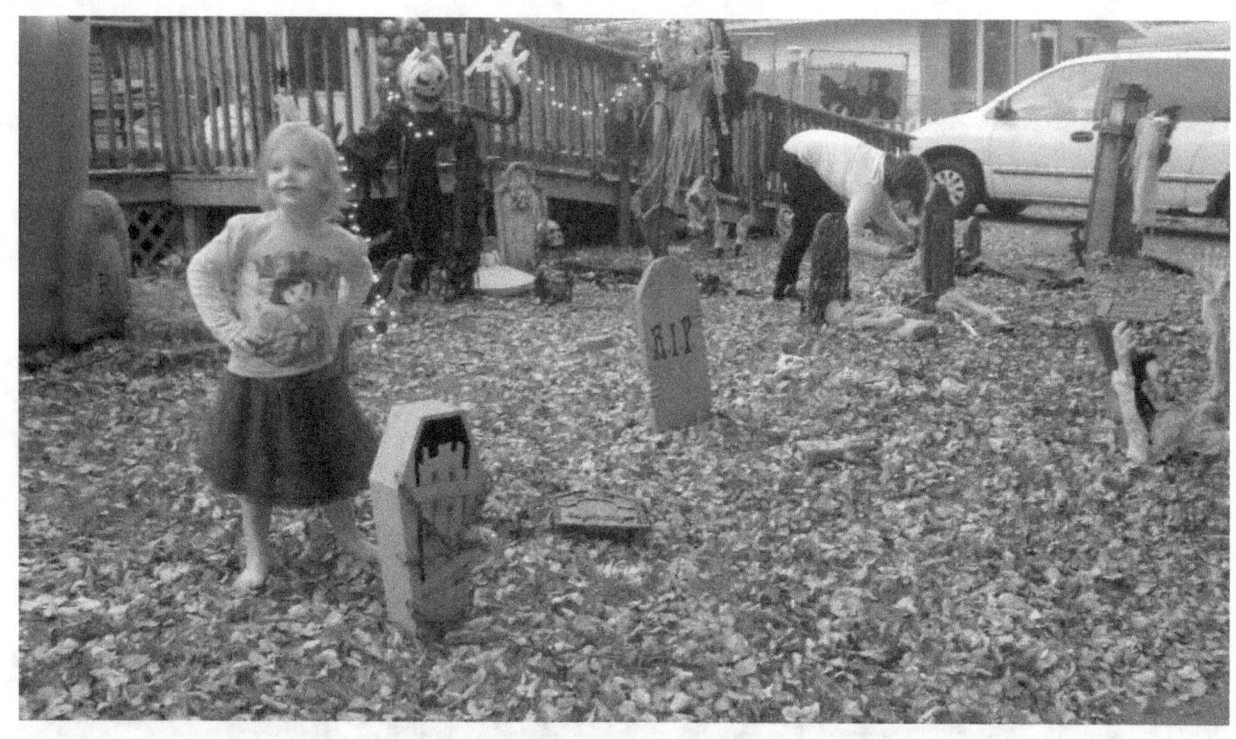

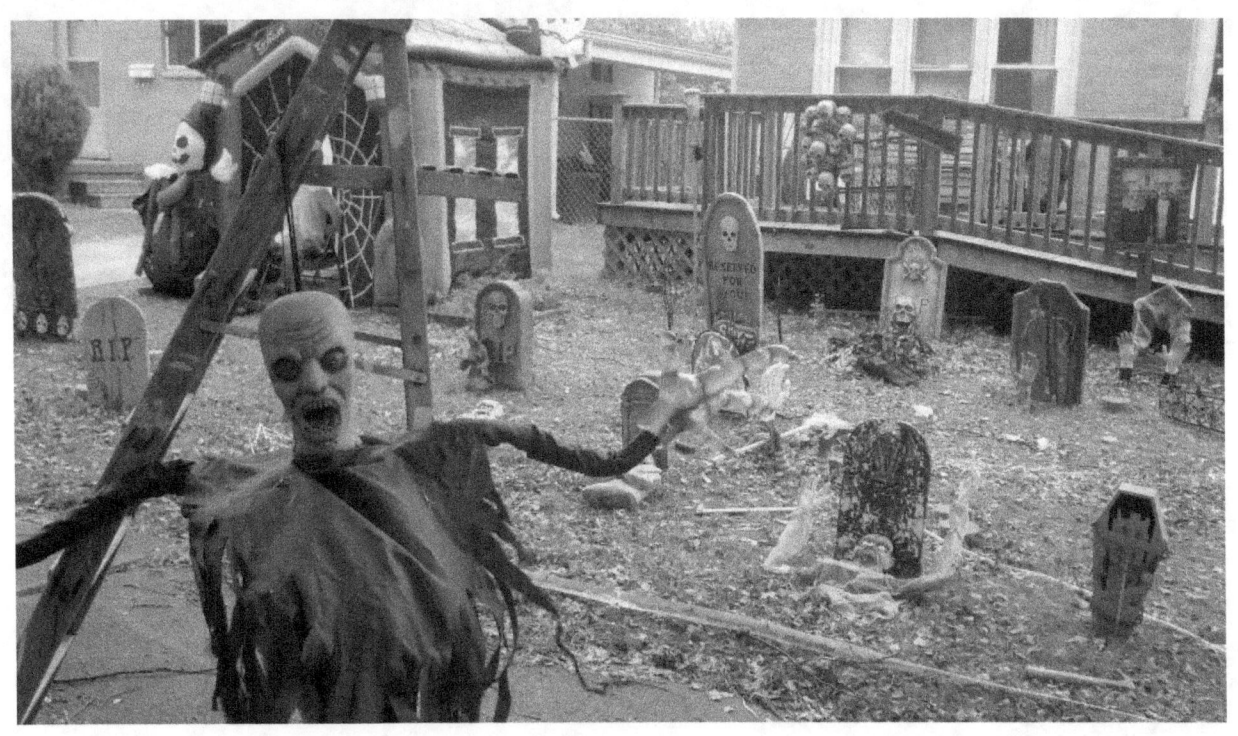

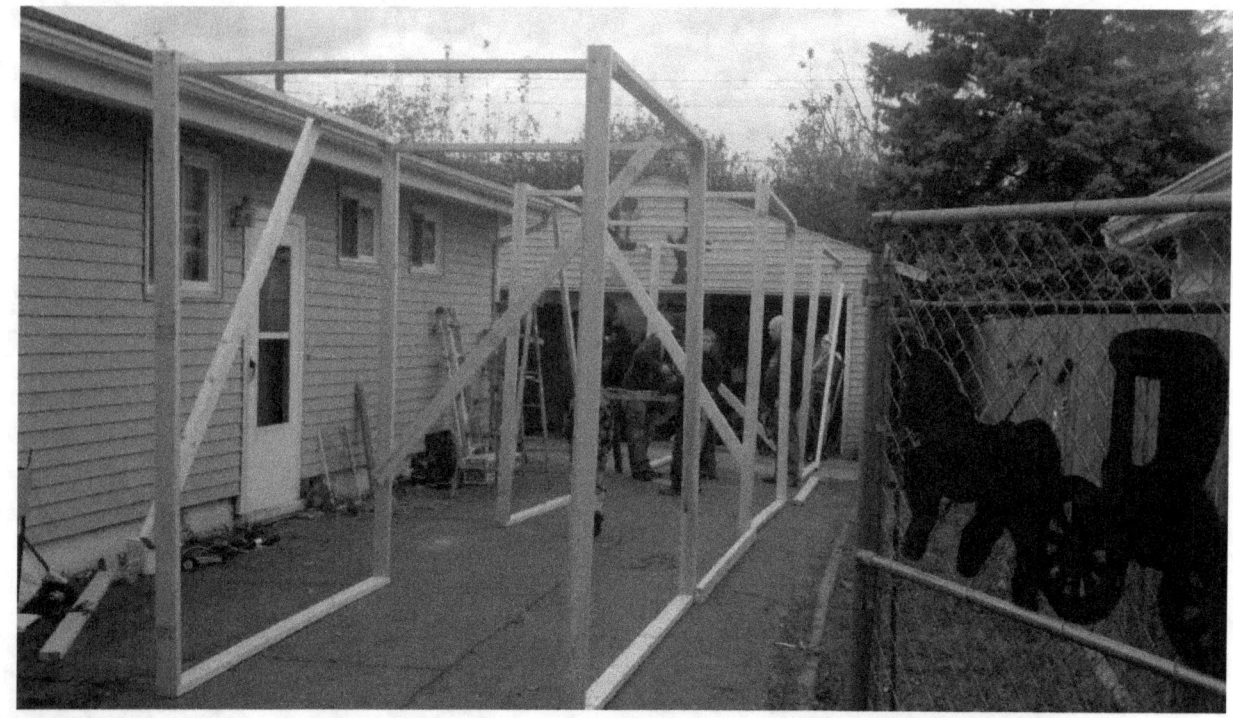

THE "SKELETON" OF THE TUNNEL WALKTHROUGH. THE SIGNIFICANCE OF "SCARRIAGE TOWN" IS EMBEDDED IN THE HISTORY OF FLINT, MICHIGAN, ALSO KNOWN AS CARRIAGE TOWN.

FROM CITYOFFLINT.COM: "THE CARRIAGE TOWN NAME BEST DESCRIBES THE MAJORITY OF EXTANT HOUSING BUILT WHEN FLINT WAS THE CARRIAGE CAPITOL OF THE UNITED STATES."

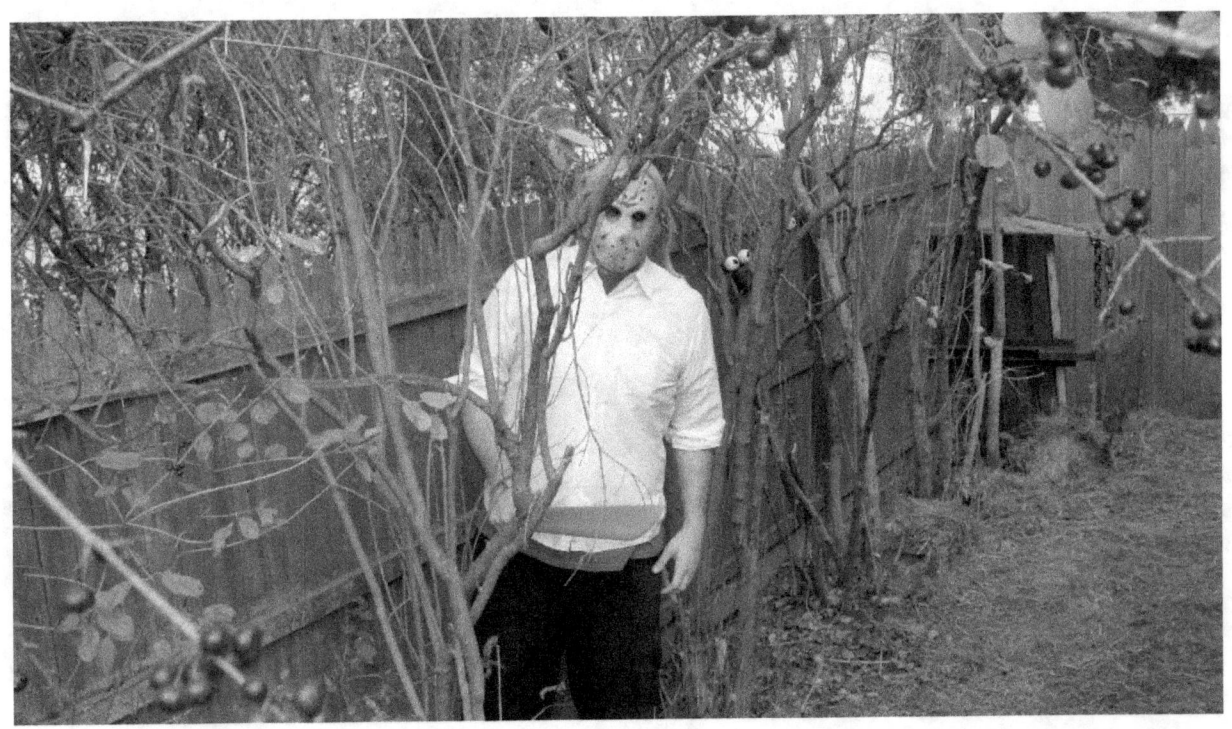

THE AUTHOR STALKS THE BACKYARD.

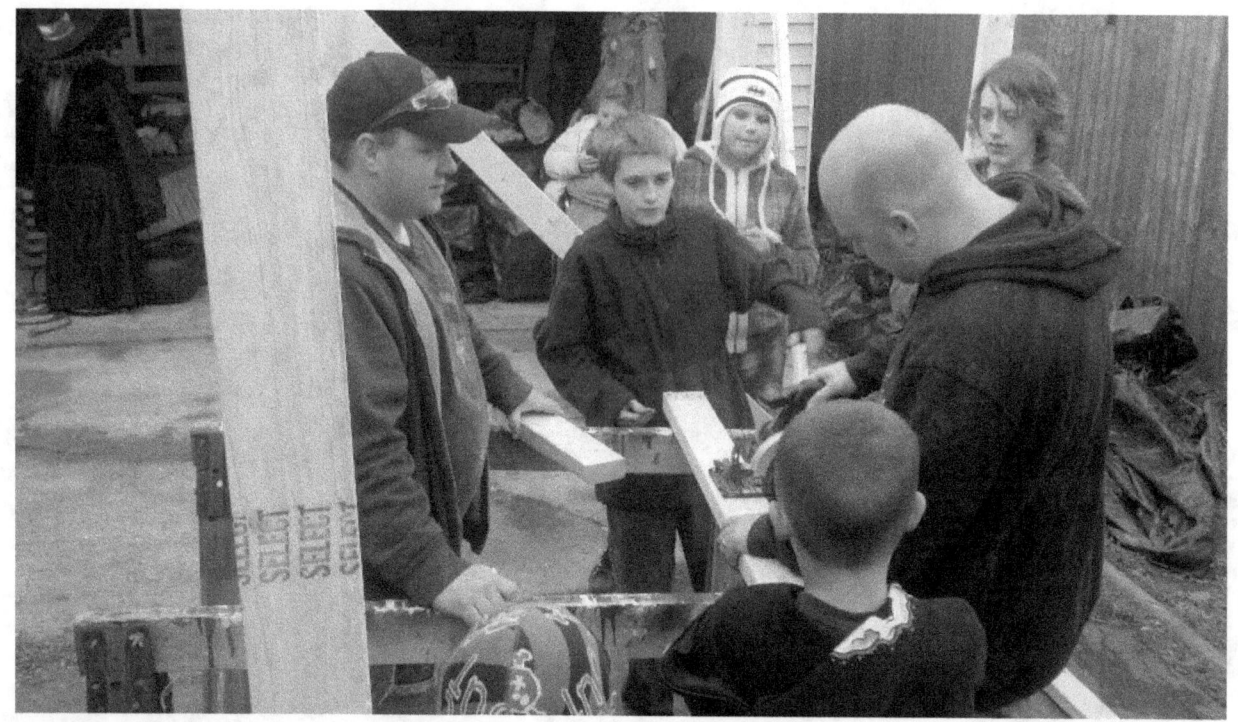

BROTHERS JOHN AND LEN RANDOL MEASURE AND CUT FOR THE STRUCTURE. FLEDGLING 'HALLOWEENIES' LOOK ON.

MULLING IT OVER.

LEN AWAITS THE TRICK OR TREATERS, WITH JOE WOLF.

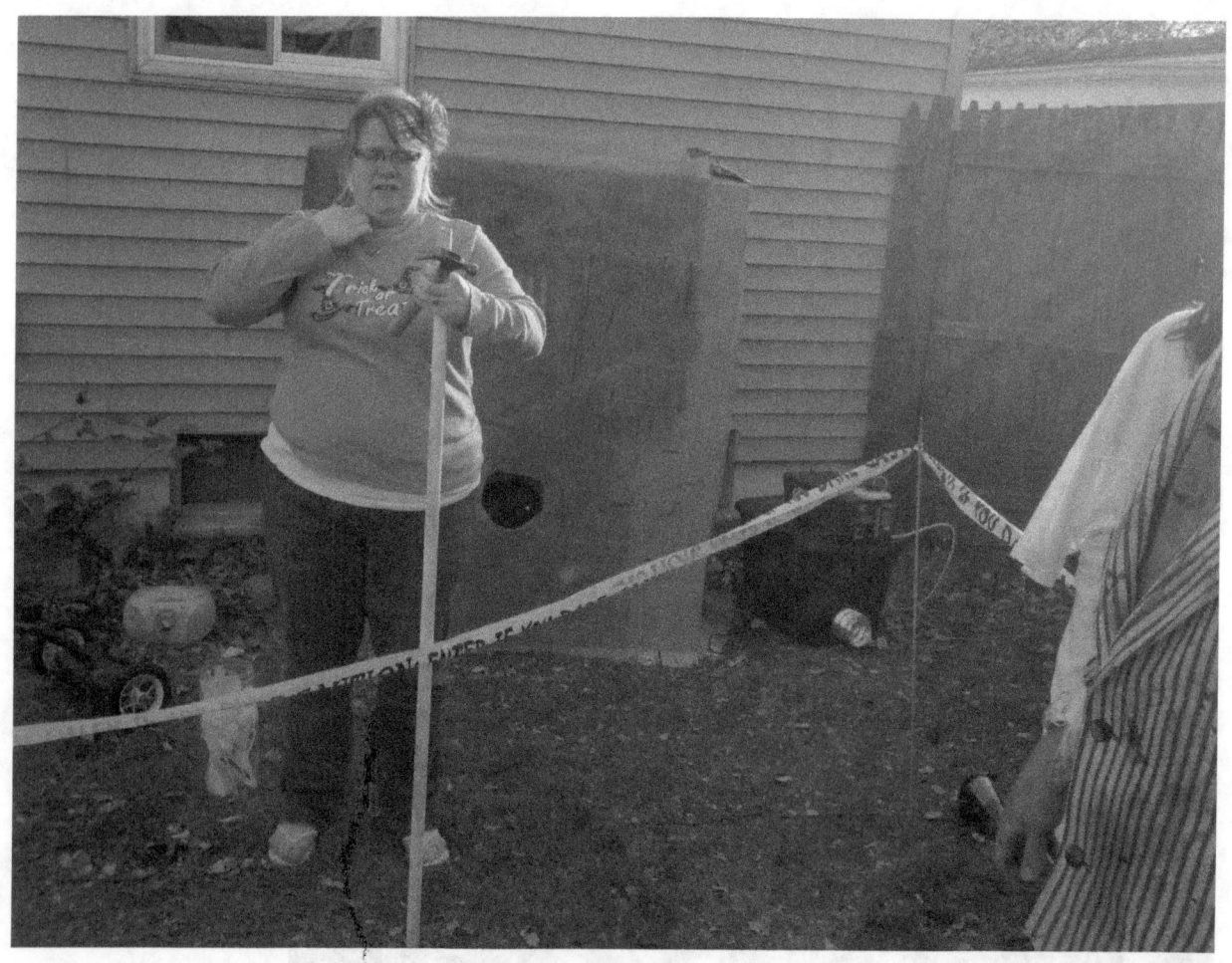
CRYSTAL COUNELIS HELPS WITH LAST SECOND SETUP.

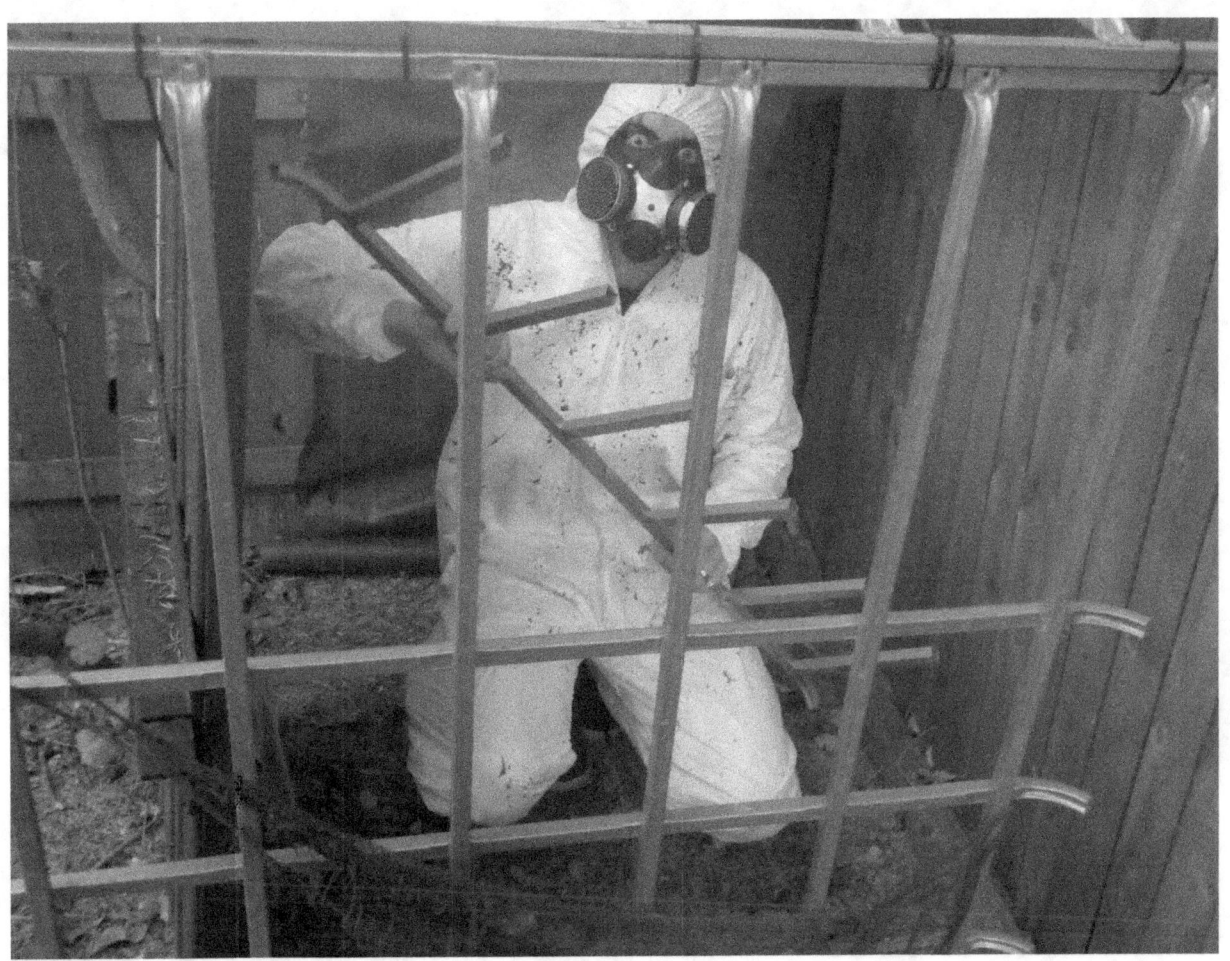

JASON COUNELIS: "I'M FLYING!"

GRANDPA CHAZ HENRY, HAUNT PROBLEM SOLVER EXTRAORDINAIRE.

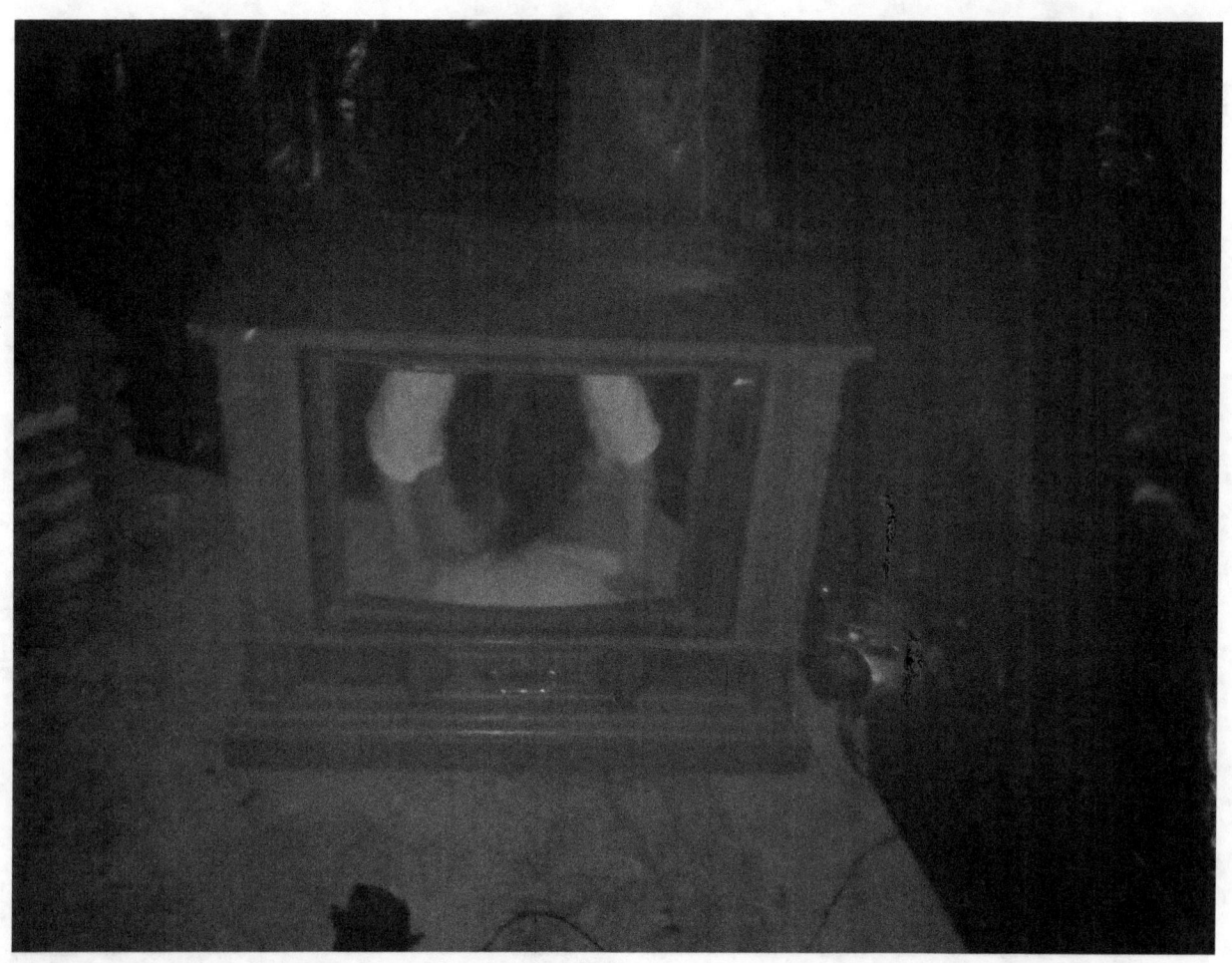
"THE RING" ROOM (EMILY RODA).

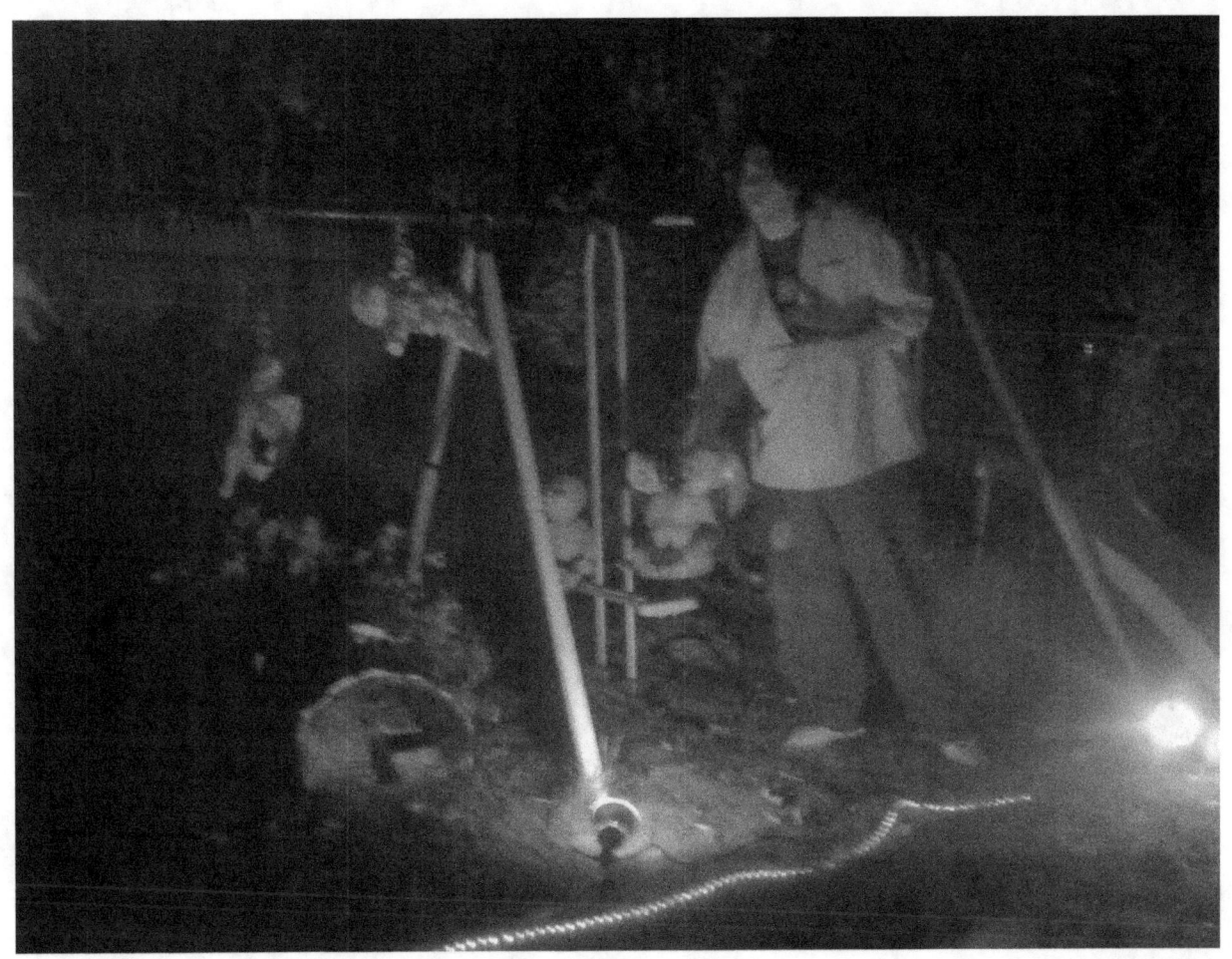

SETTING UP THE HAUNTED PLAYGROUND.

NO ONE EXPECTS THE TREE TO MOVE. BUT IT DOES, BECAUSE IT'S MANNED BY J.R. COUNELIS.

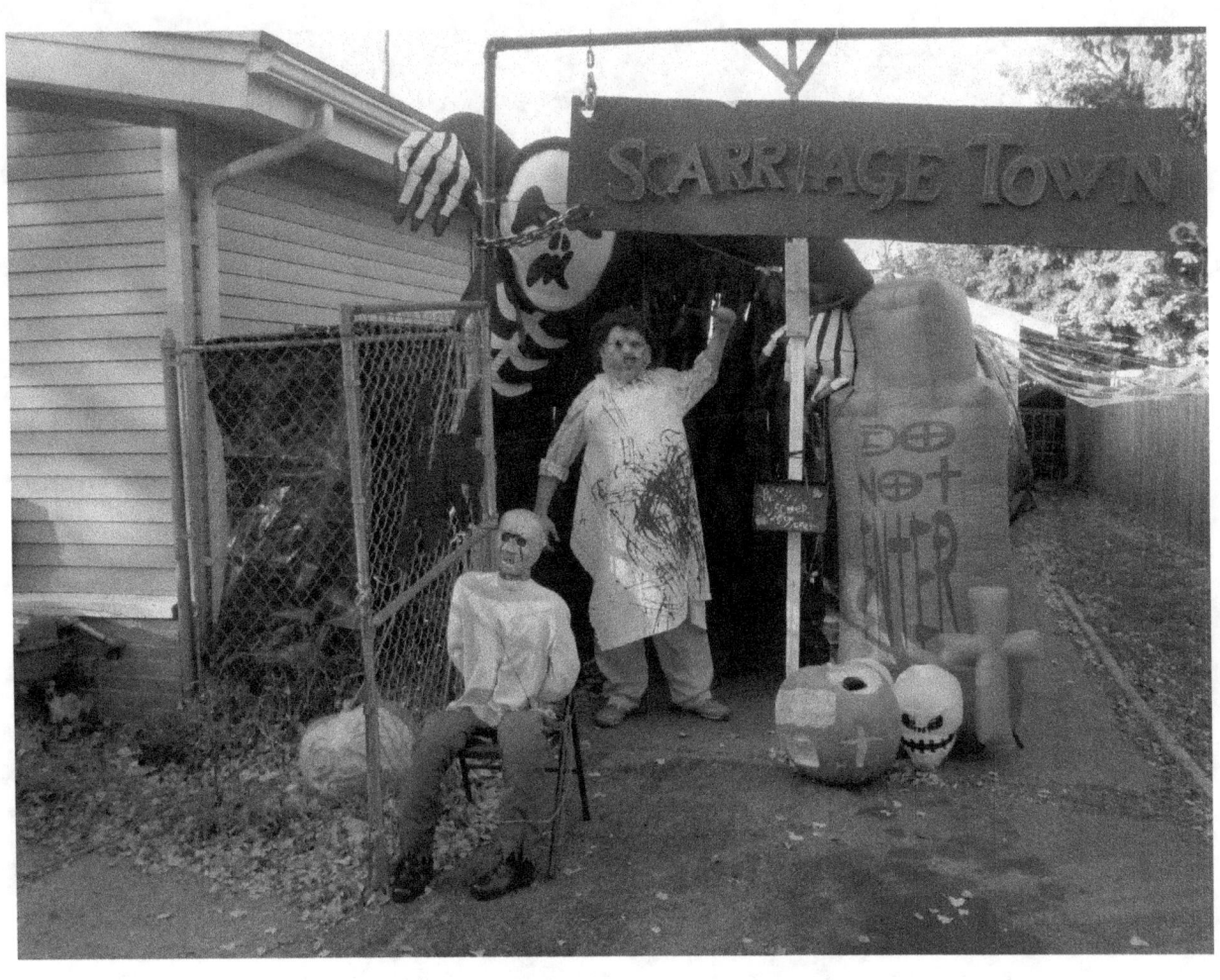

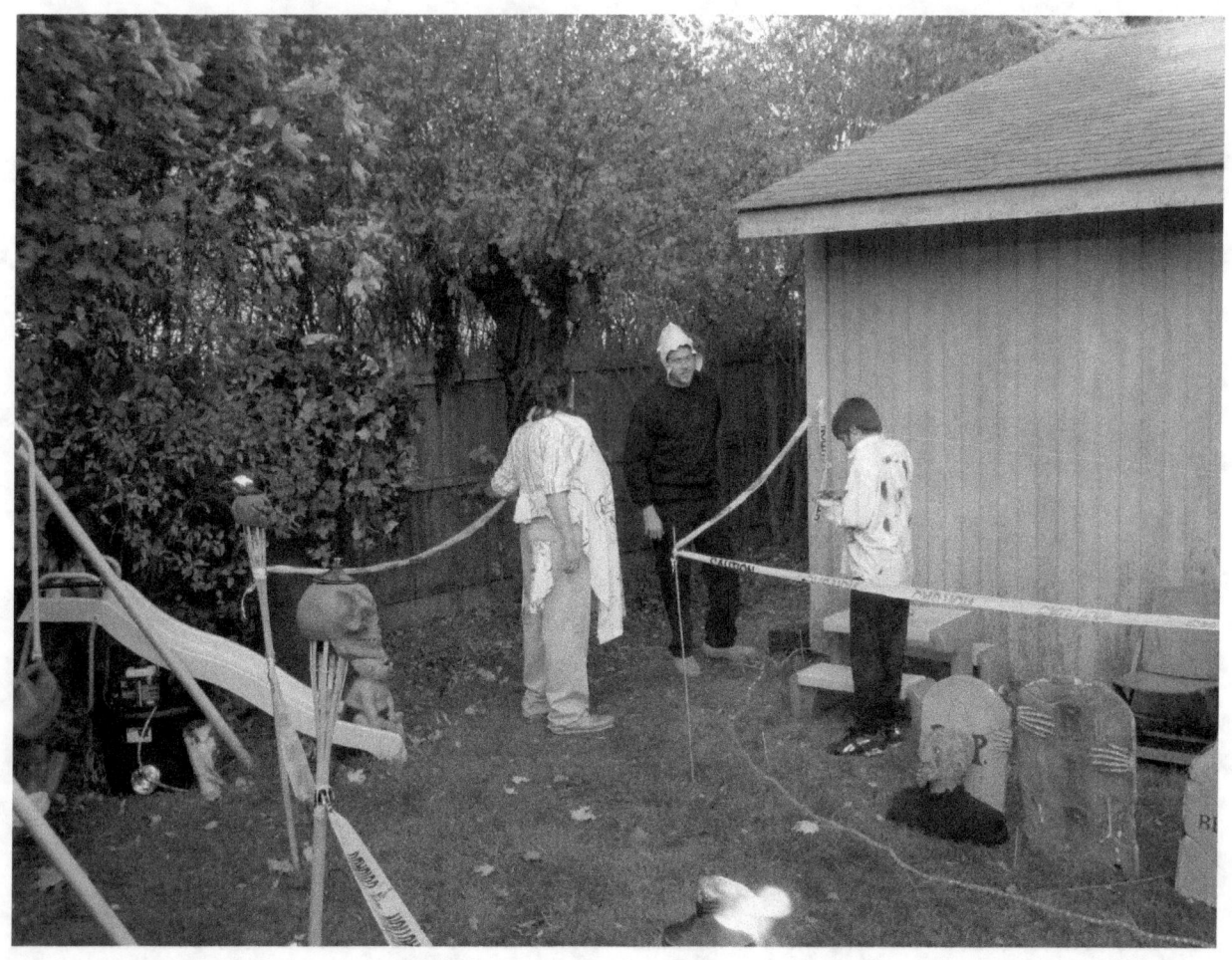
PREPARING FOR SCARING. (JAMIE LANE, BOB HINOJOSA, JESSE RAYMOND COUNELIS).

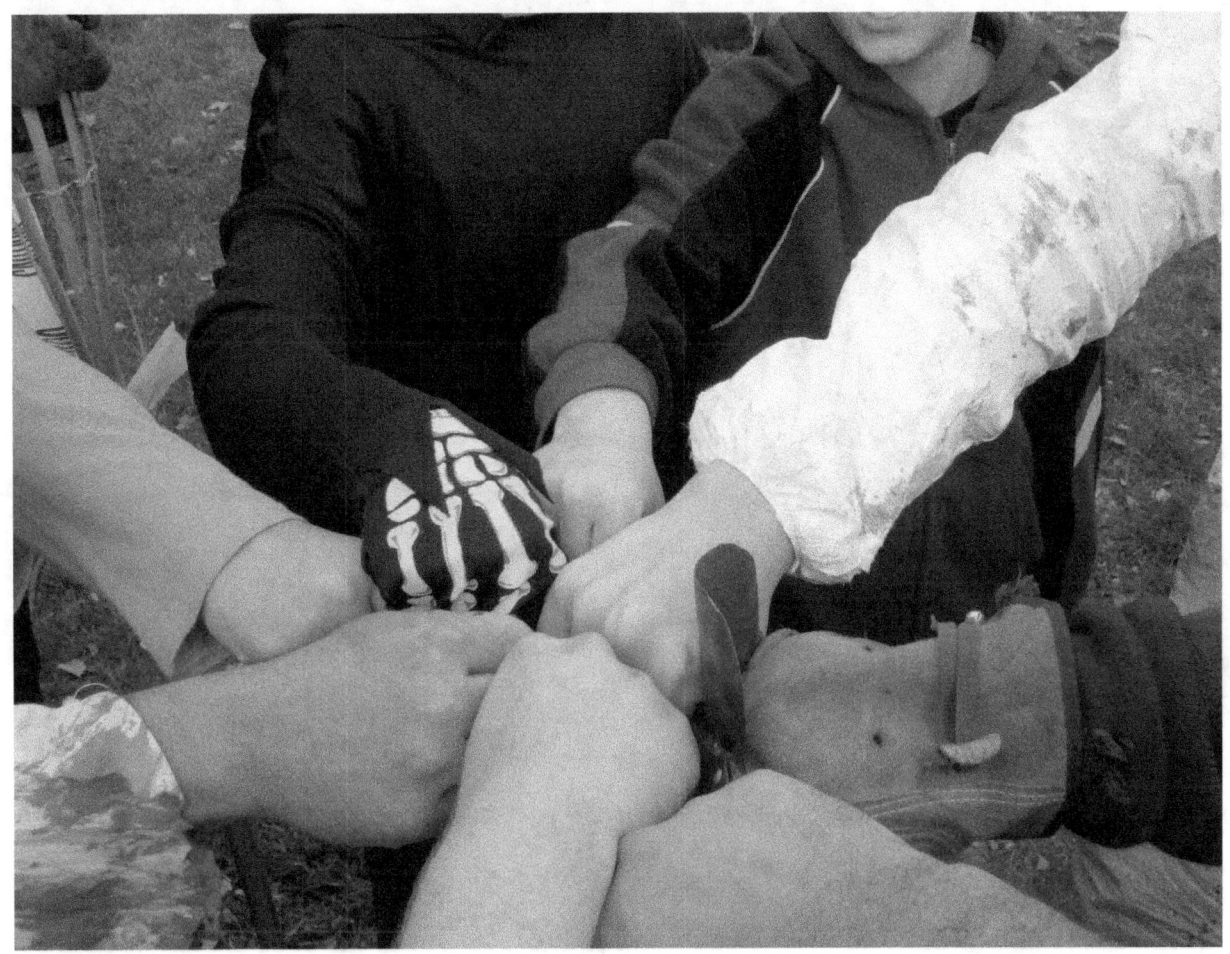

ALL FOR ONE.

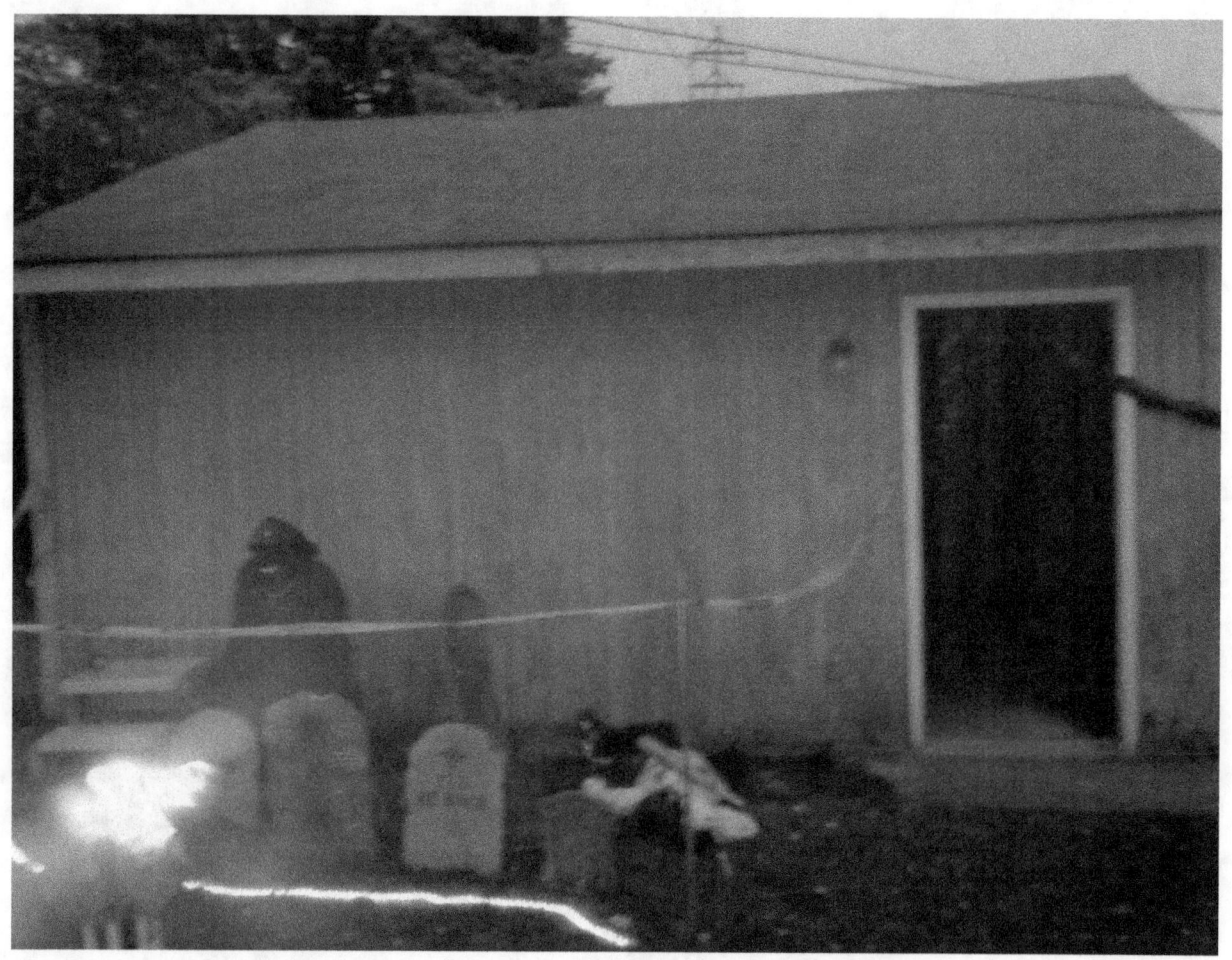
GUS COUNELIS AND JESSE COUNELIS AWAIT.

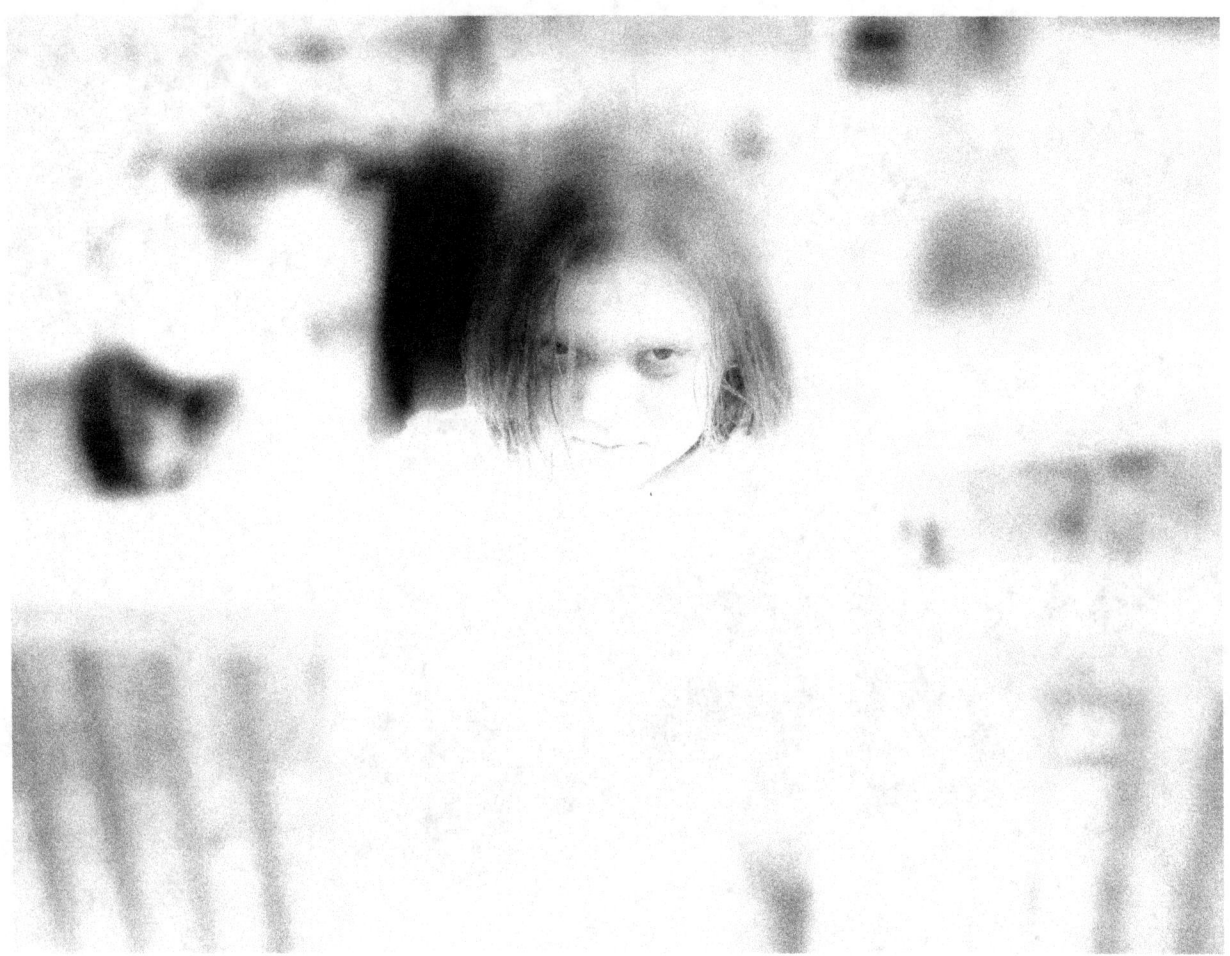

AUDRIANA COUNELIS.

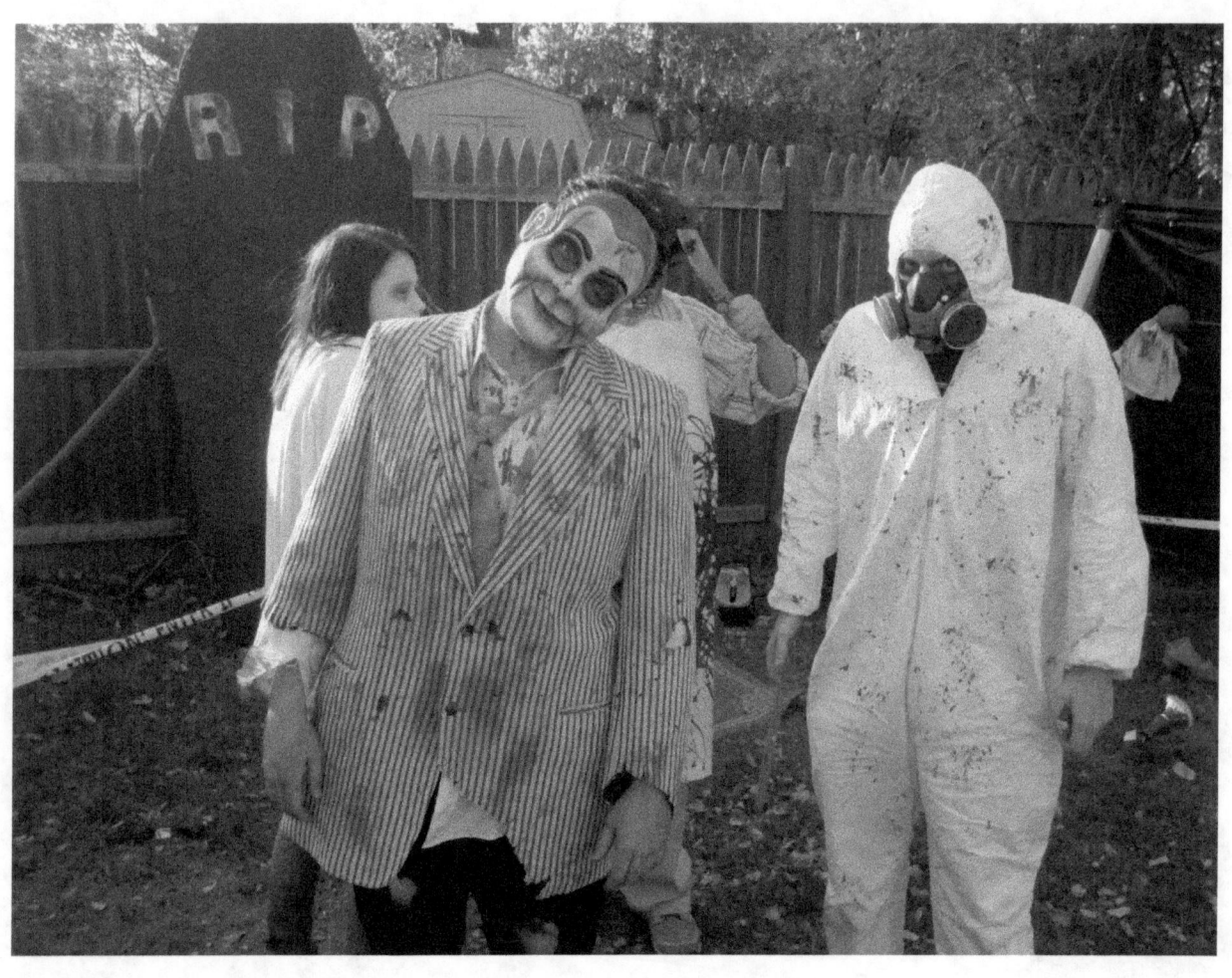

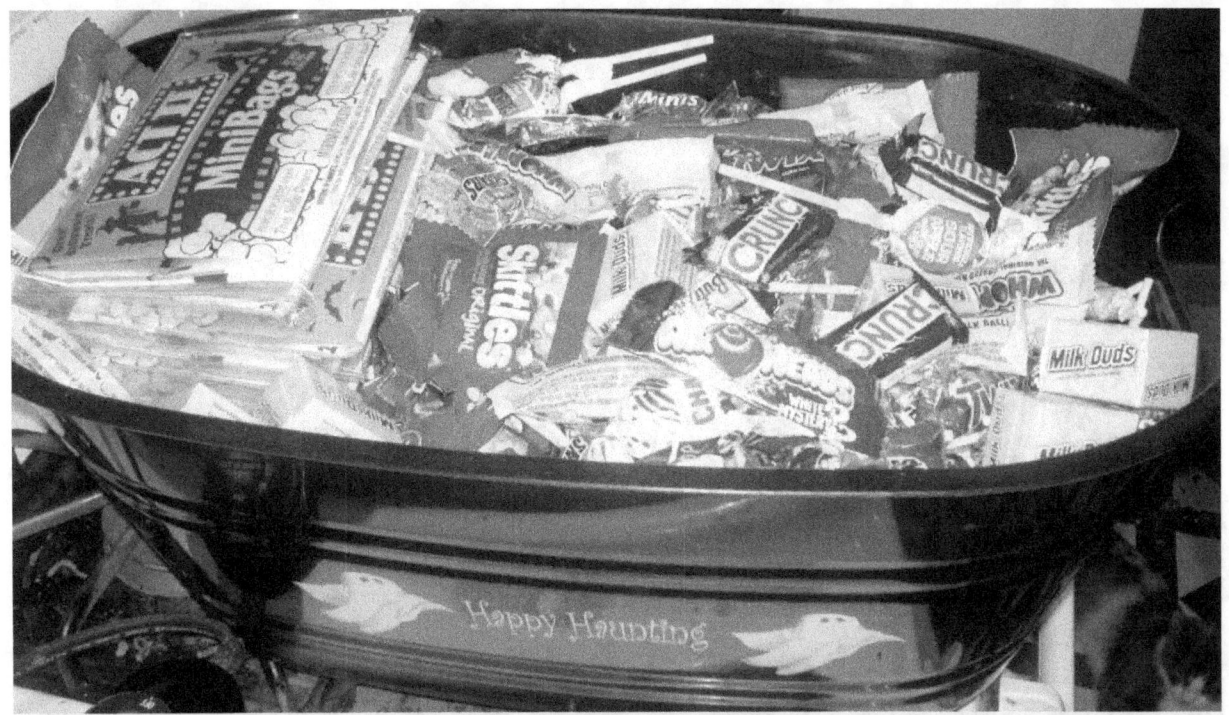

'SCARRIAGE TOWN REVUE' PODCAST.

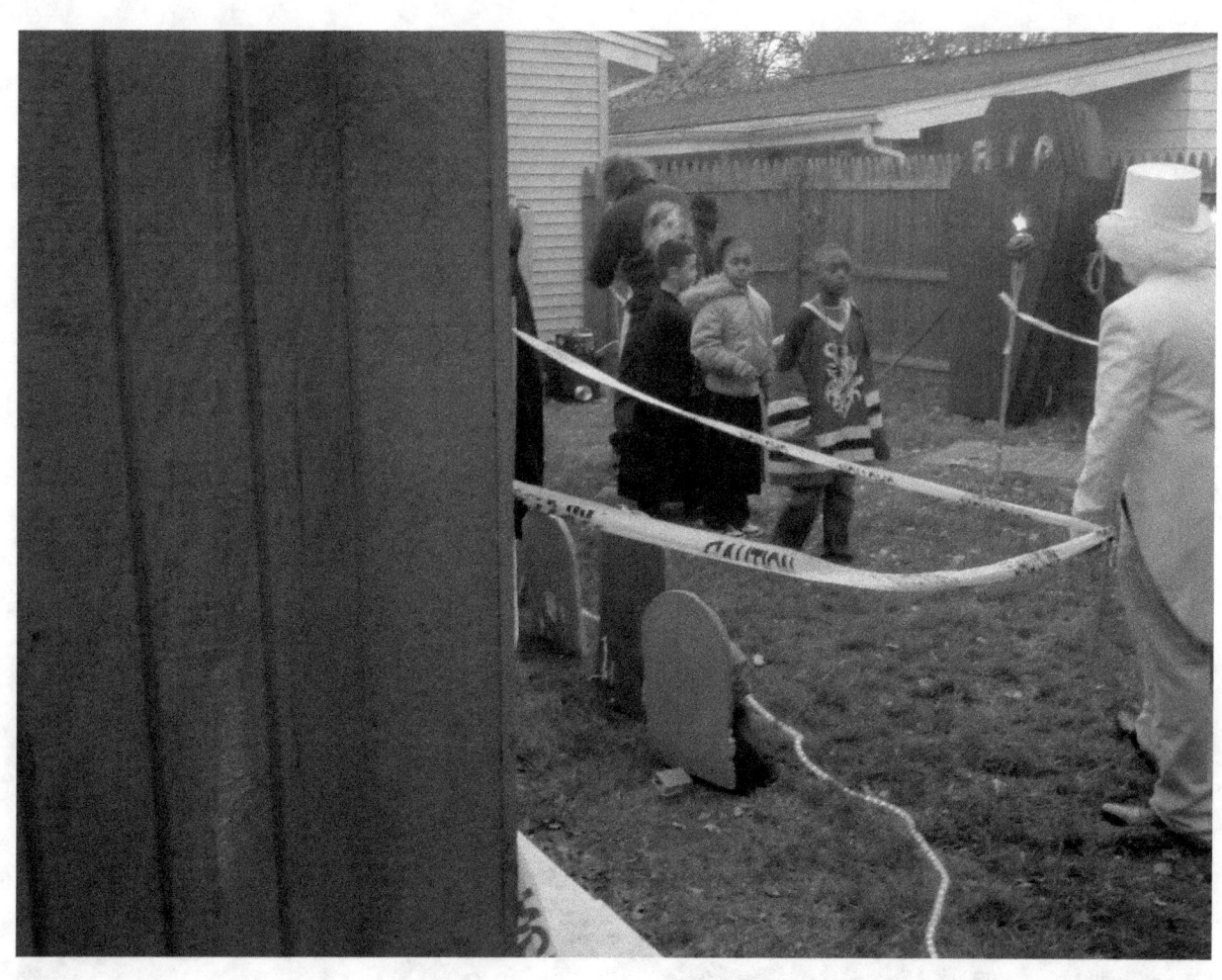

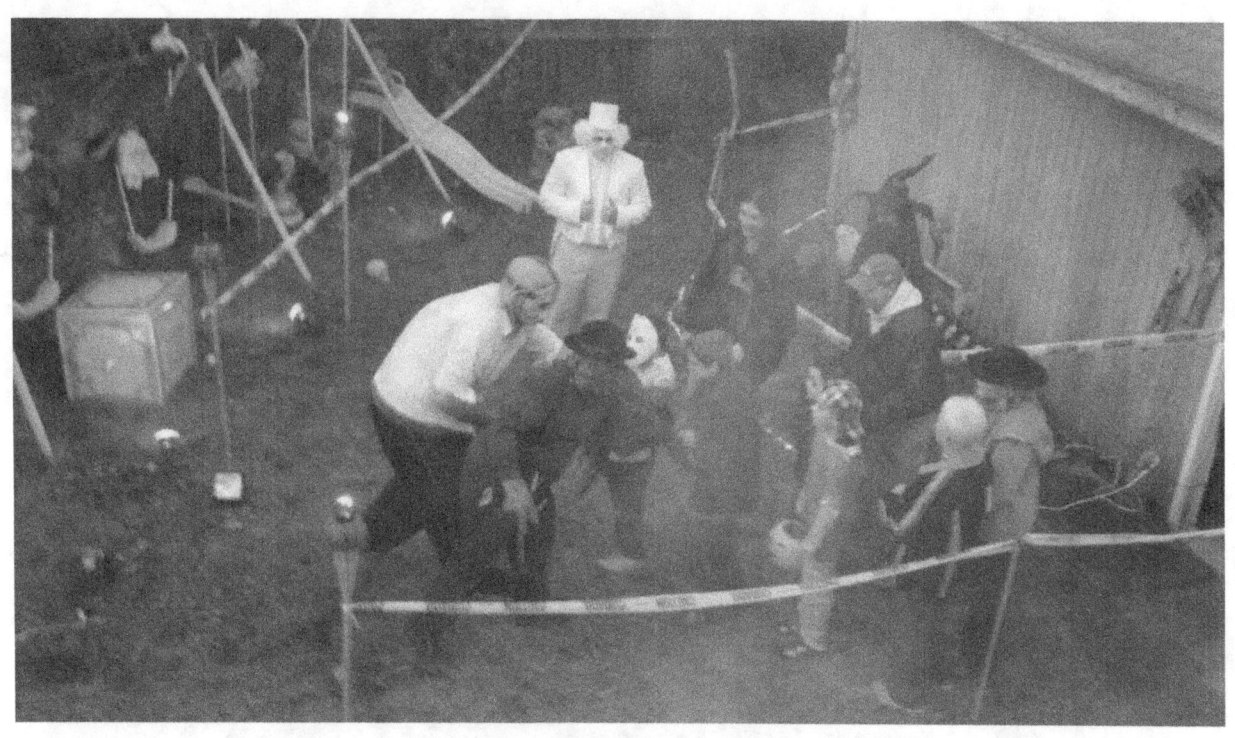

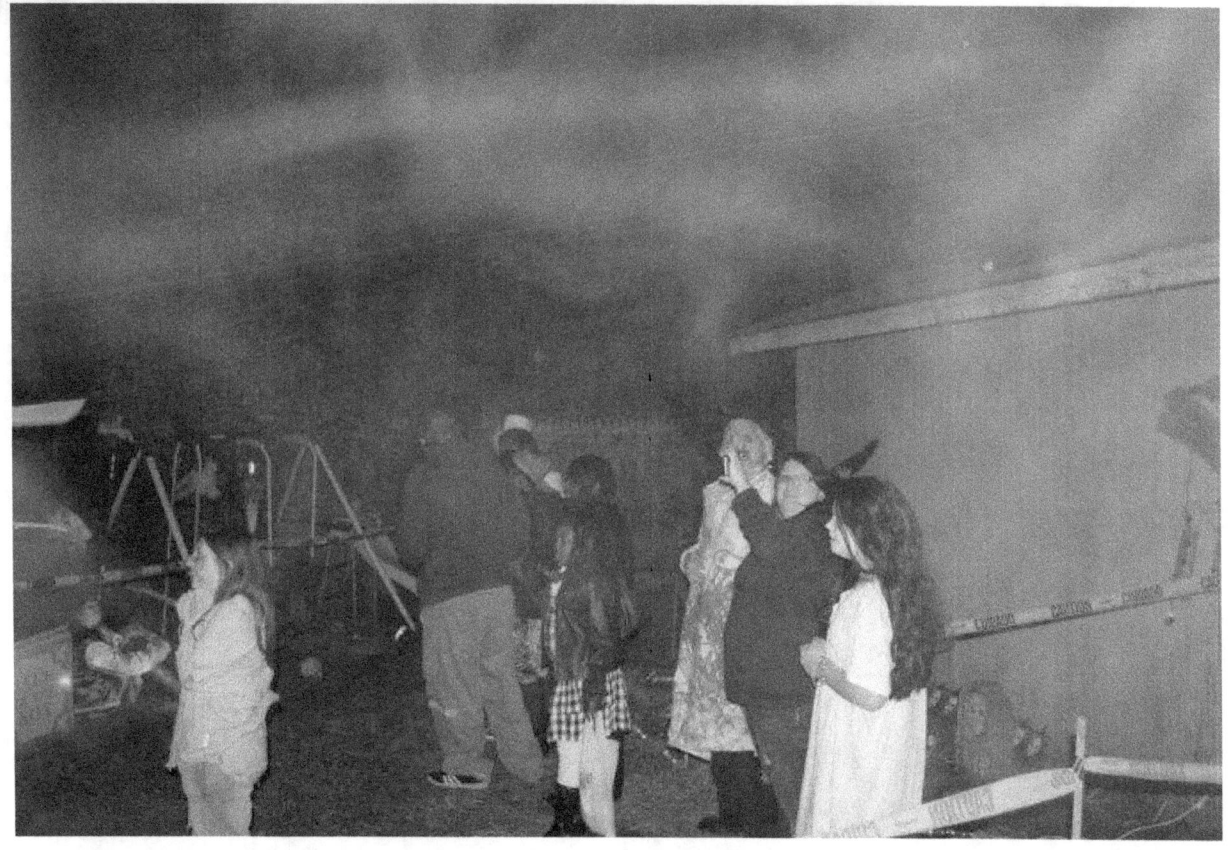

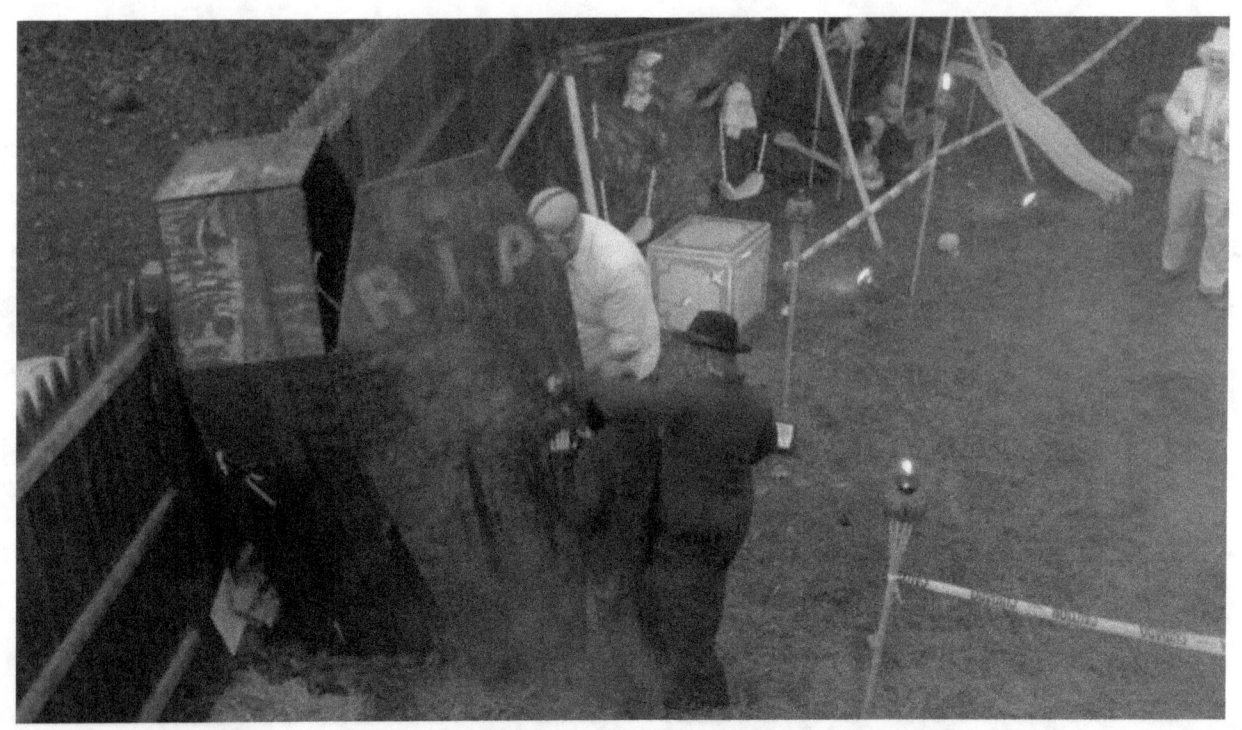

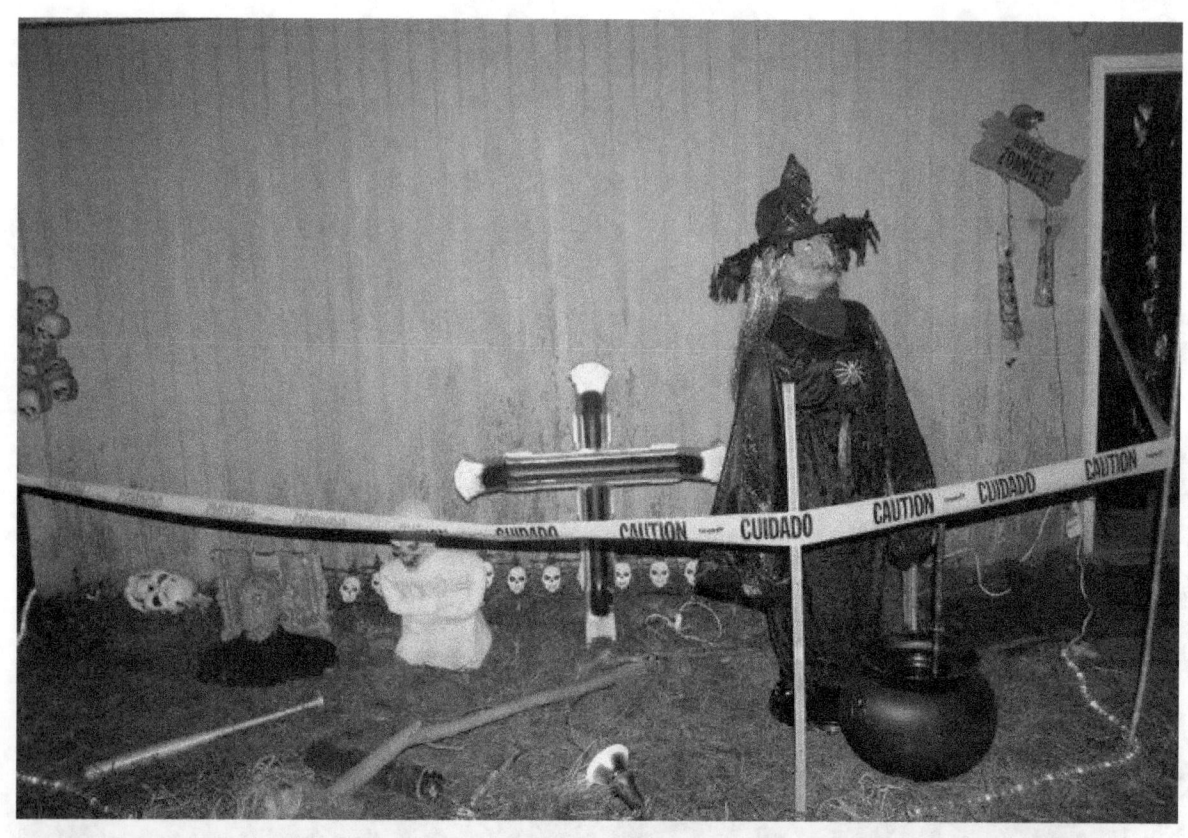
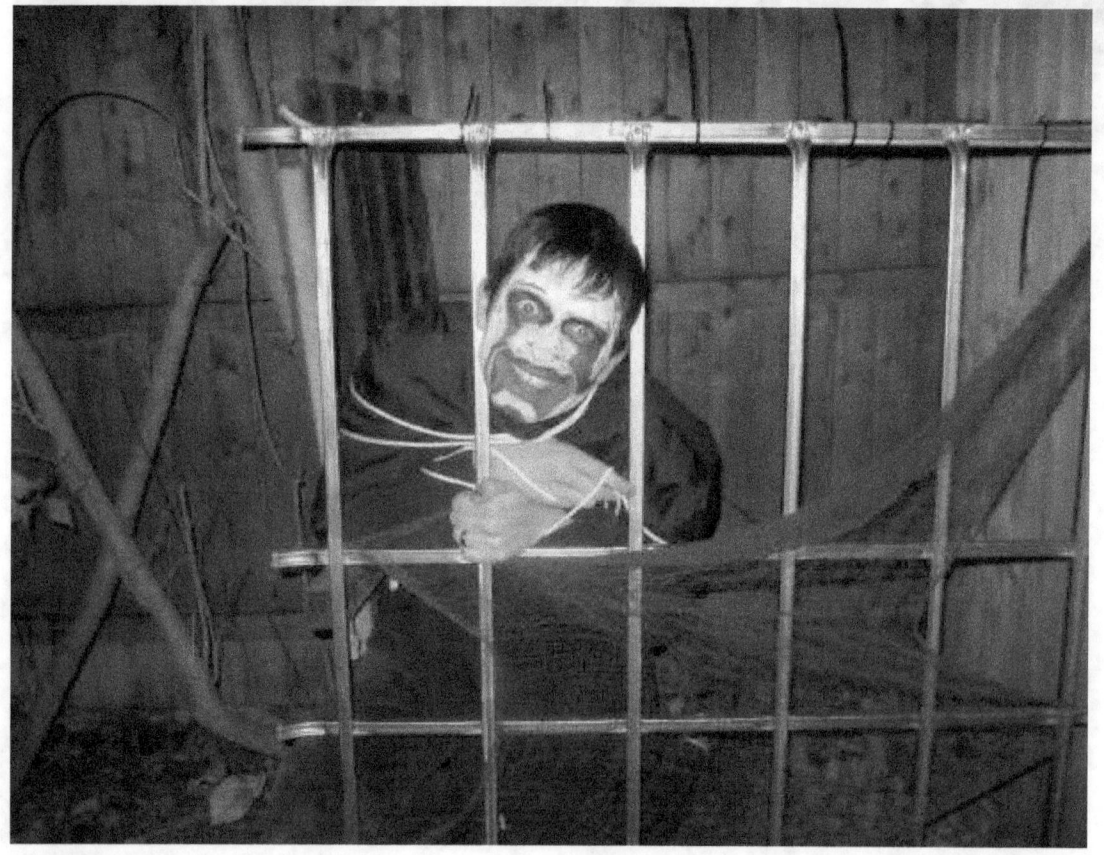

THE SHAPE.

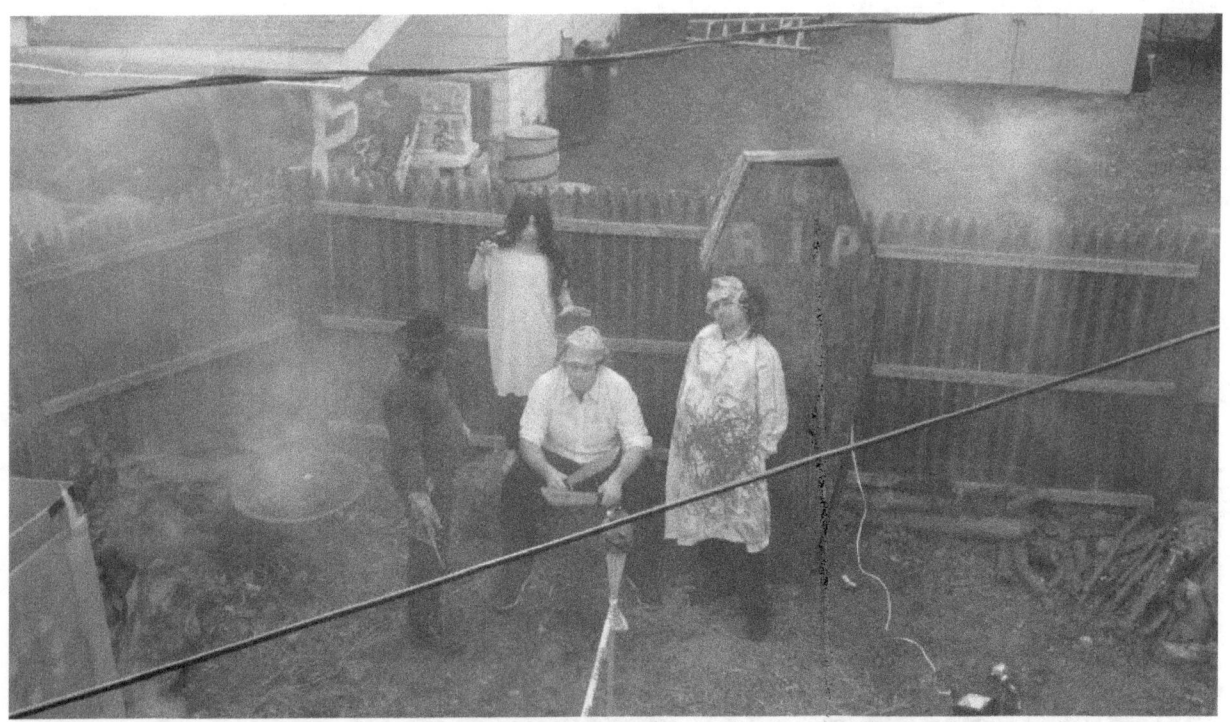

TAKING A BREAK BETWEEN GROUPS.

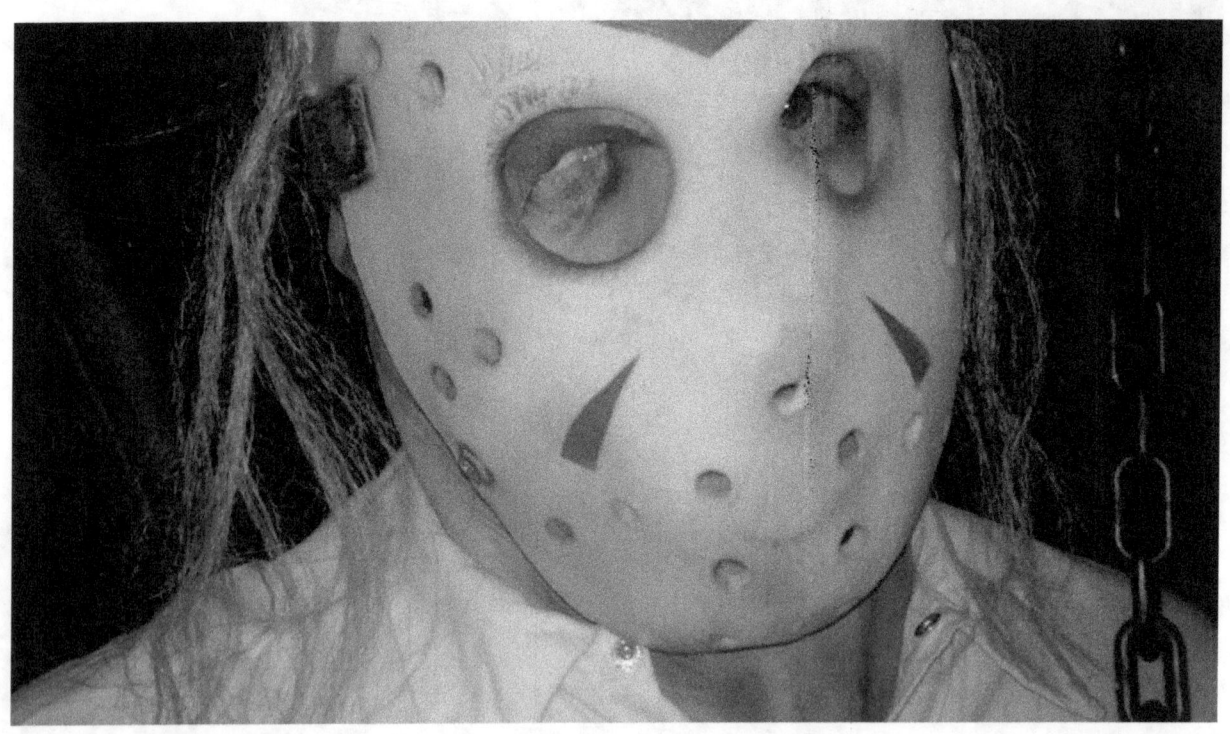

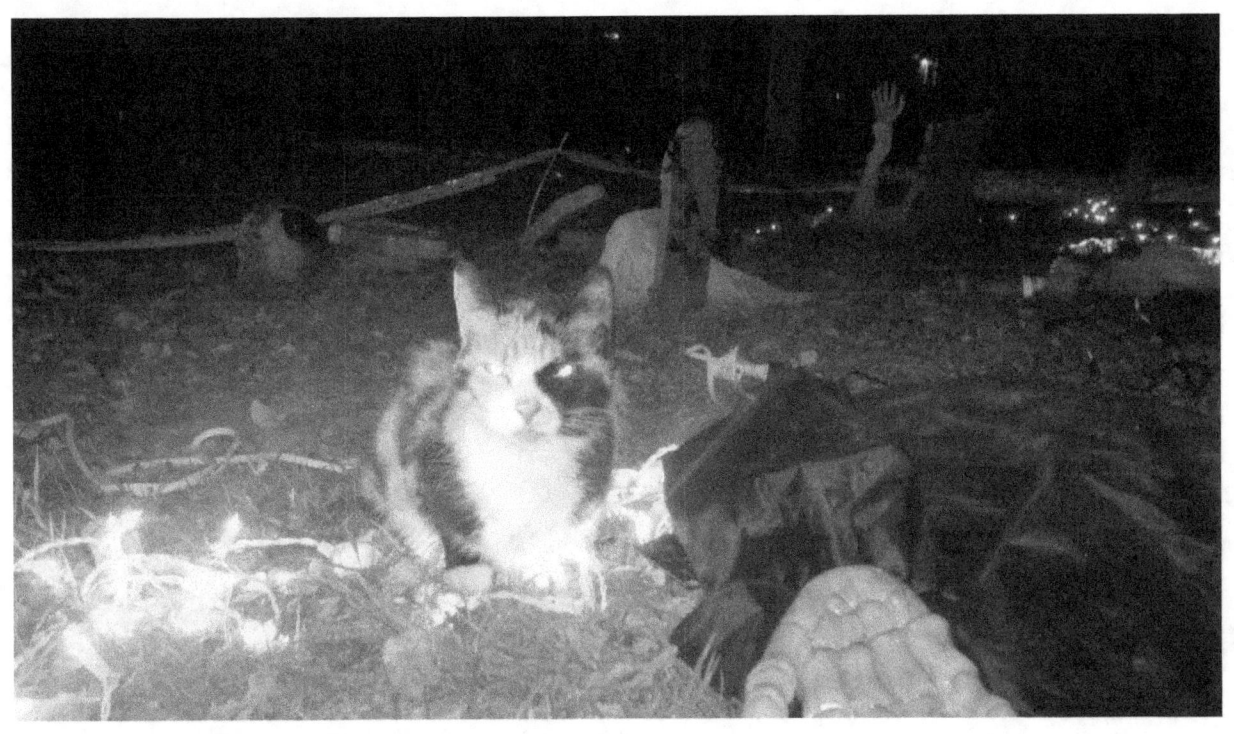

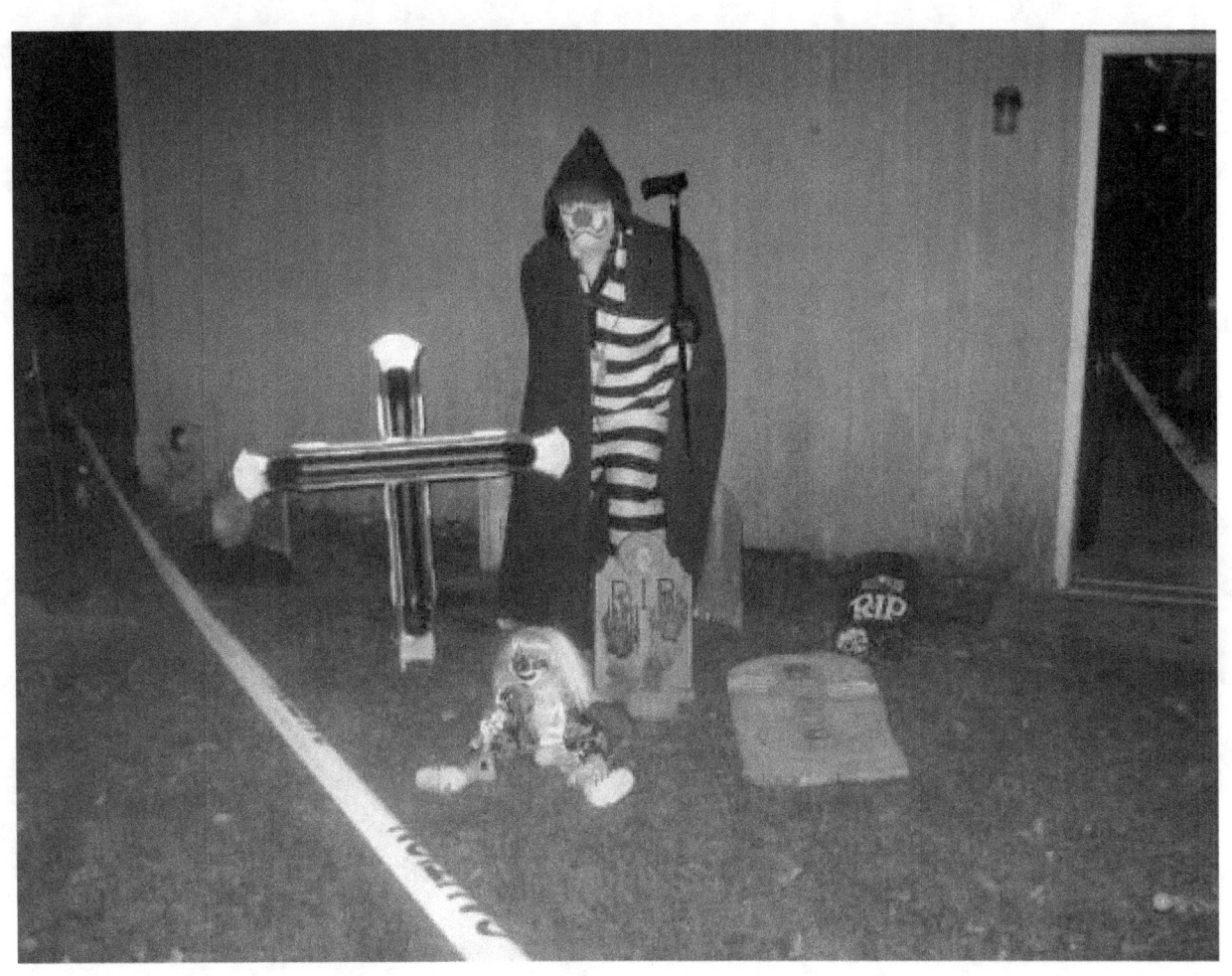

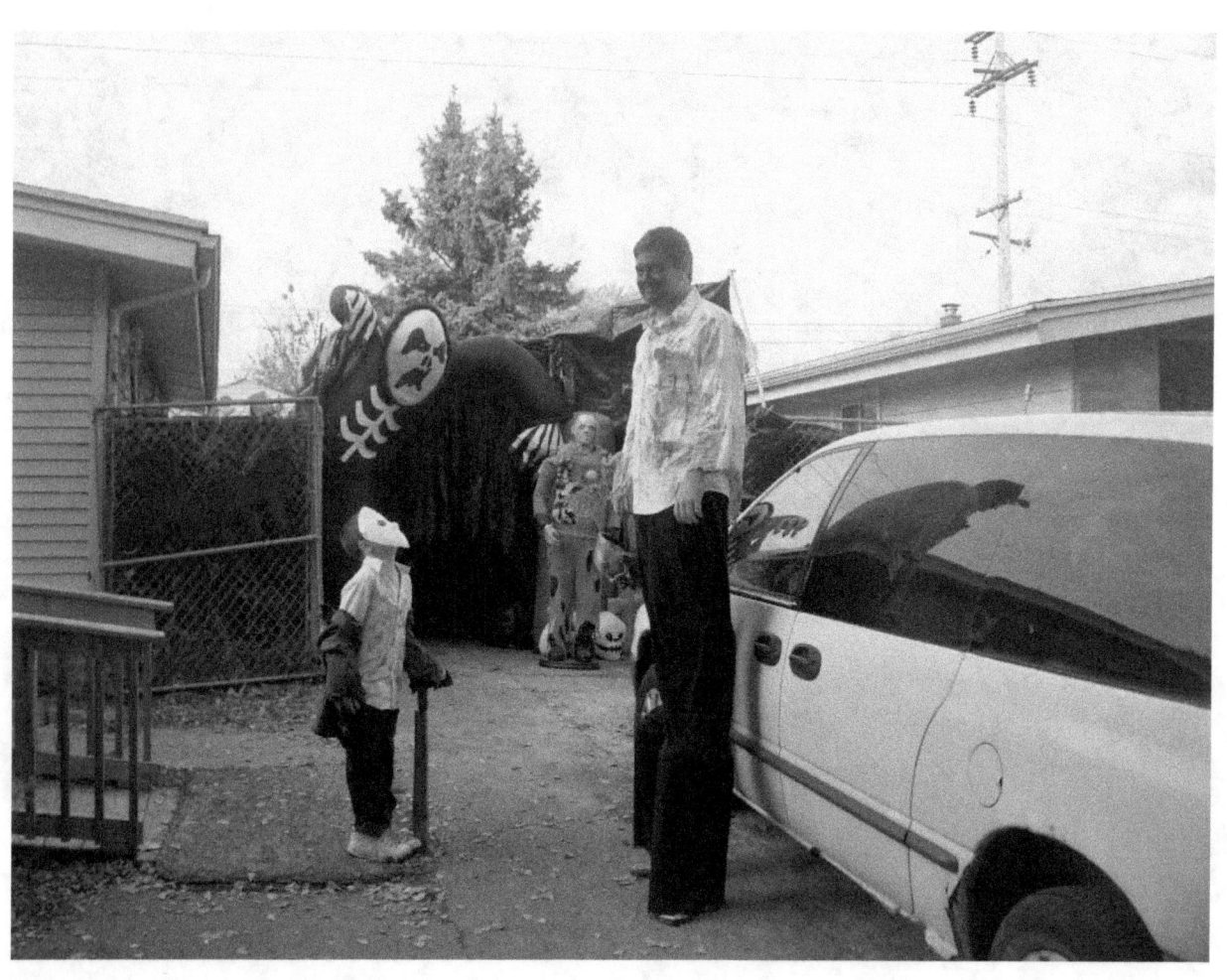

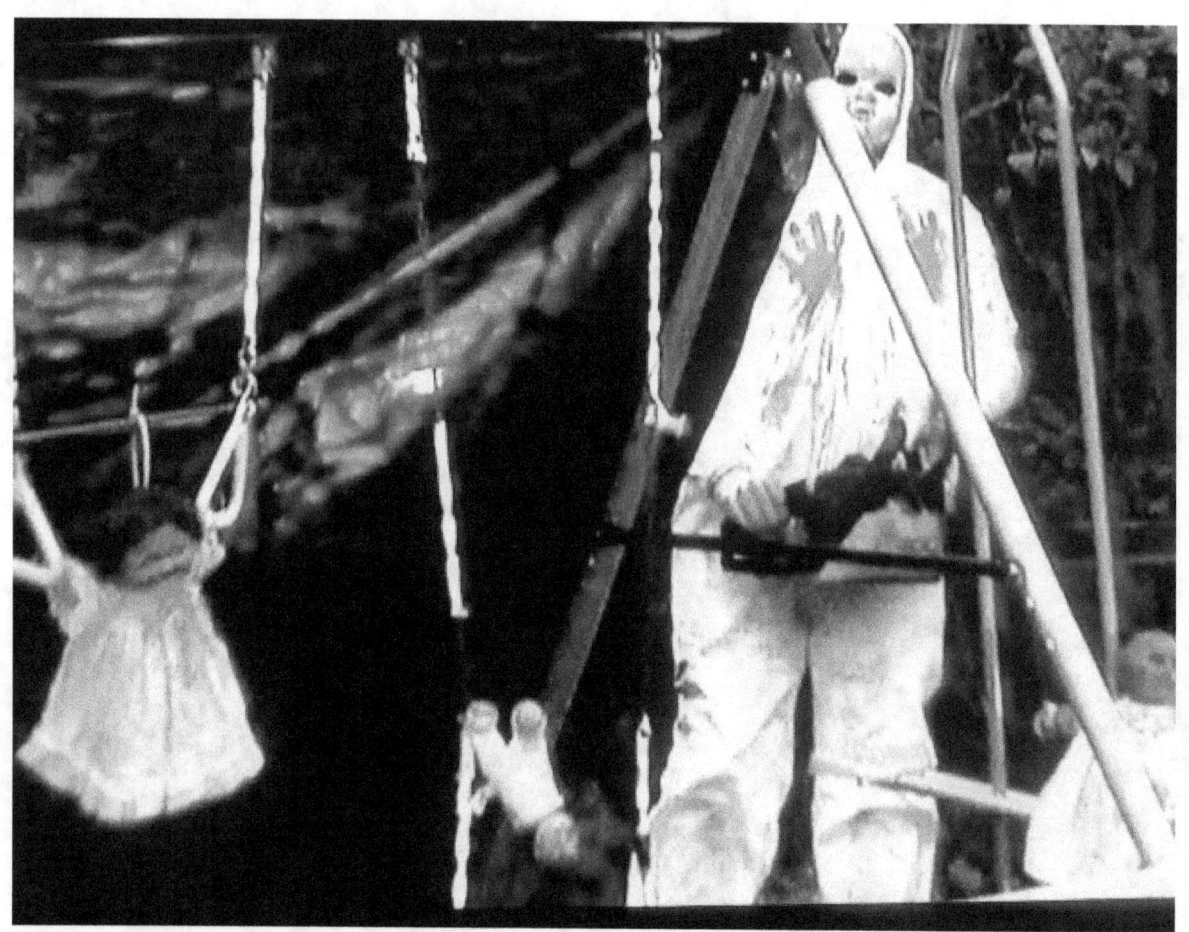

THE CHAINSAW ELEMENT.

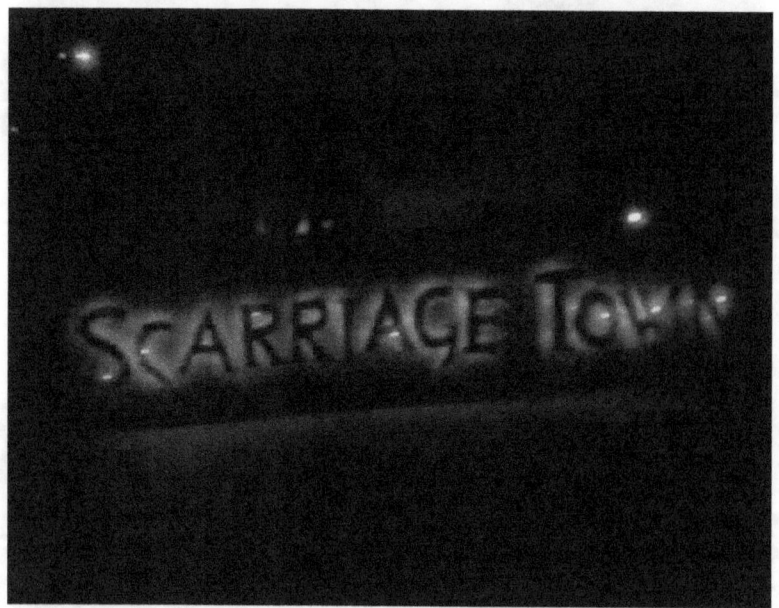

WELCOME, FOOLISH MORTALS.

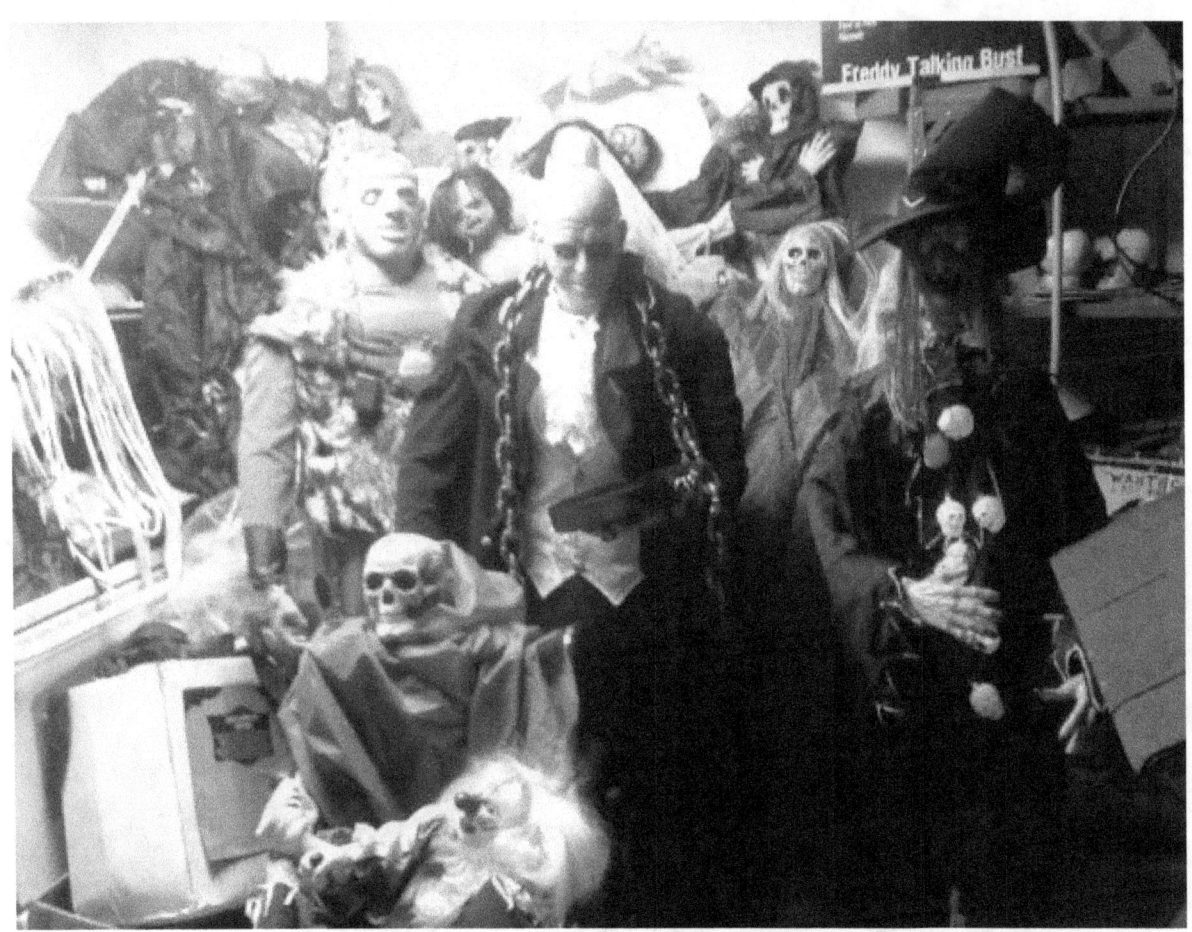

SCARRIAGE STORAGE.

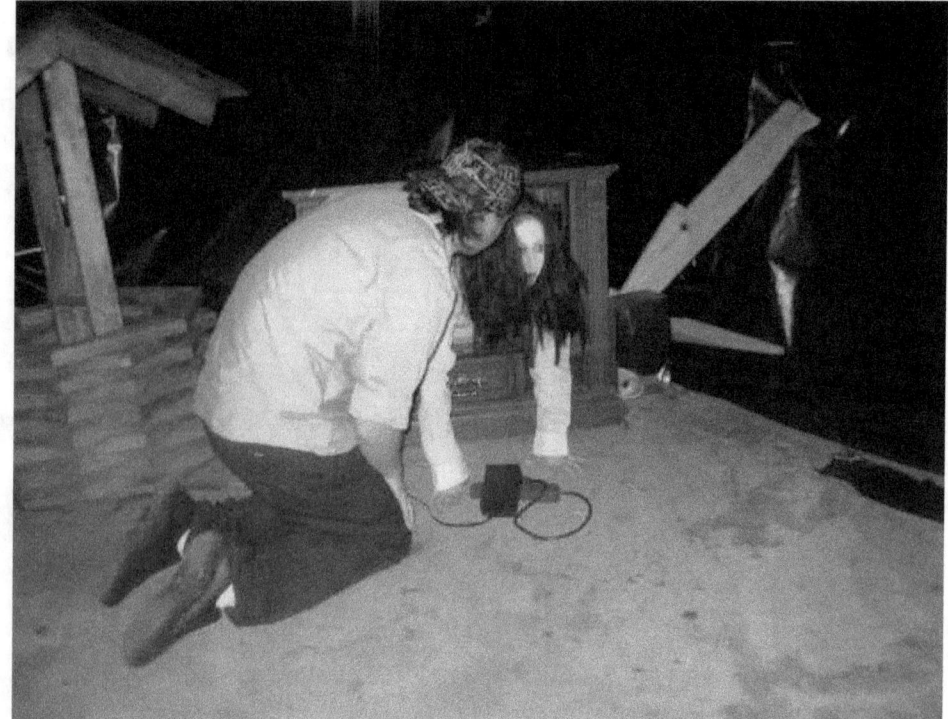

FIXING UP 'THE RING' SCENE.

NIGHT VISION GHOUL. (KATIE RANDOL).

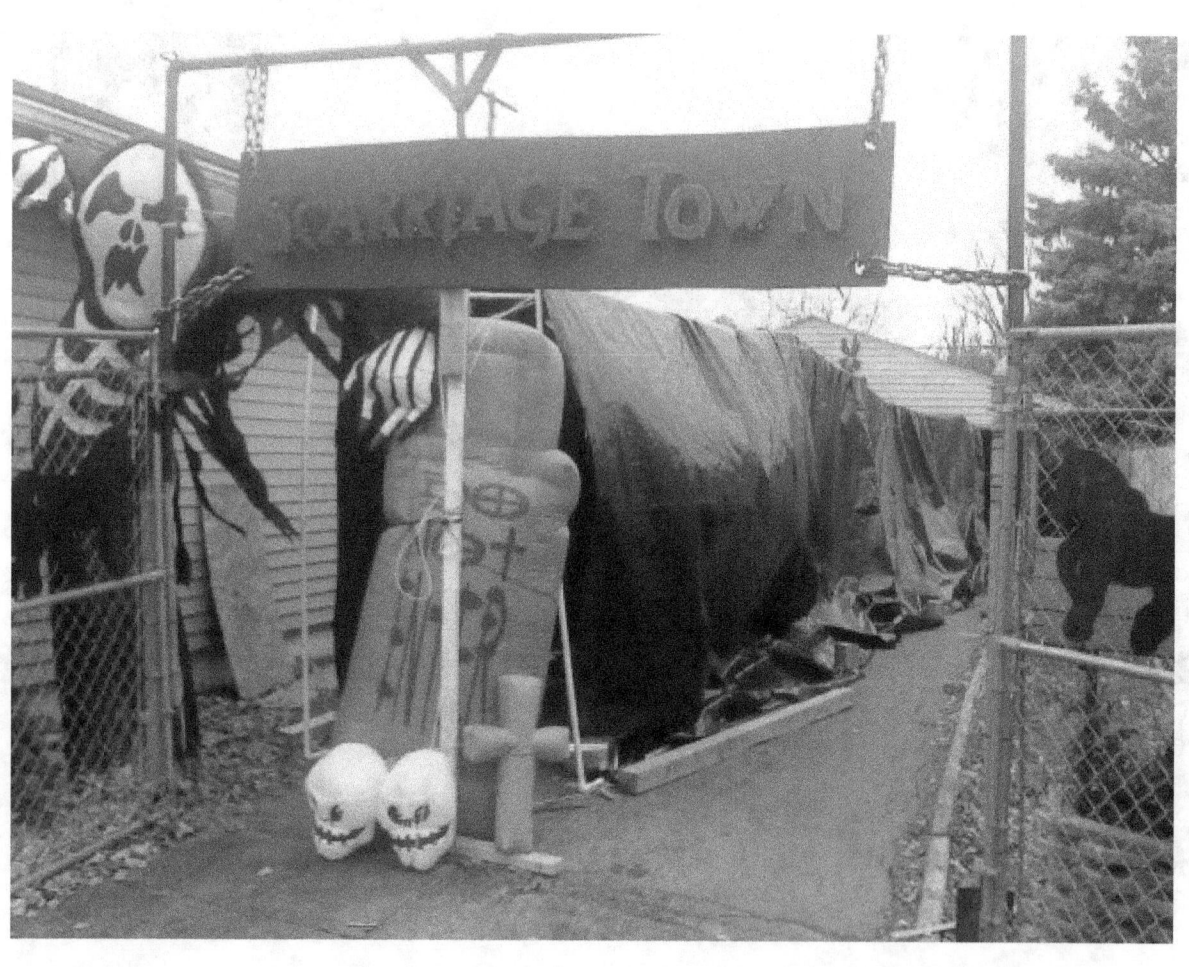

PART THREE: HALLOWEEN COMMERCE

LATE AUGUST SIGN ON NEWLY CHRISTENED HALL'WEEN WALL

AROUND THE MIDDLE OF AUGUST, MANY stores begin to show signs of the season by way of adorning the aisles with decorations and putting out the Halloween and autumn affiliated merchandise. Subsequently, so begins the trek to the local shops, taking in all of the new ideas and different styles that the sellers have to offer.

Though window shopping is the easiest way to enjoy this particular aspect of the holiday, there is a nice thrill in finding that perfect piece, be it a candleholder, sign, mask...whatever it is; that item that speaks to you. Unfortunately, it quite often says, "BUY ME" at an inopportune time. Still, there is much fun to be had amidst the sights and sounds of the various stores.

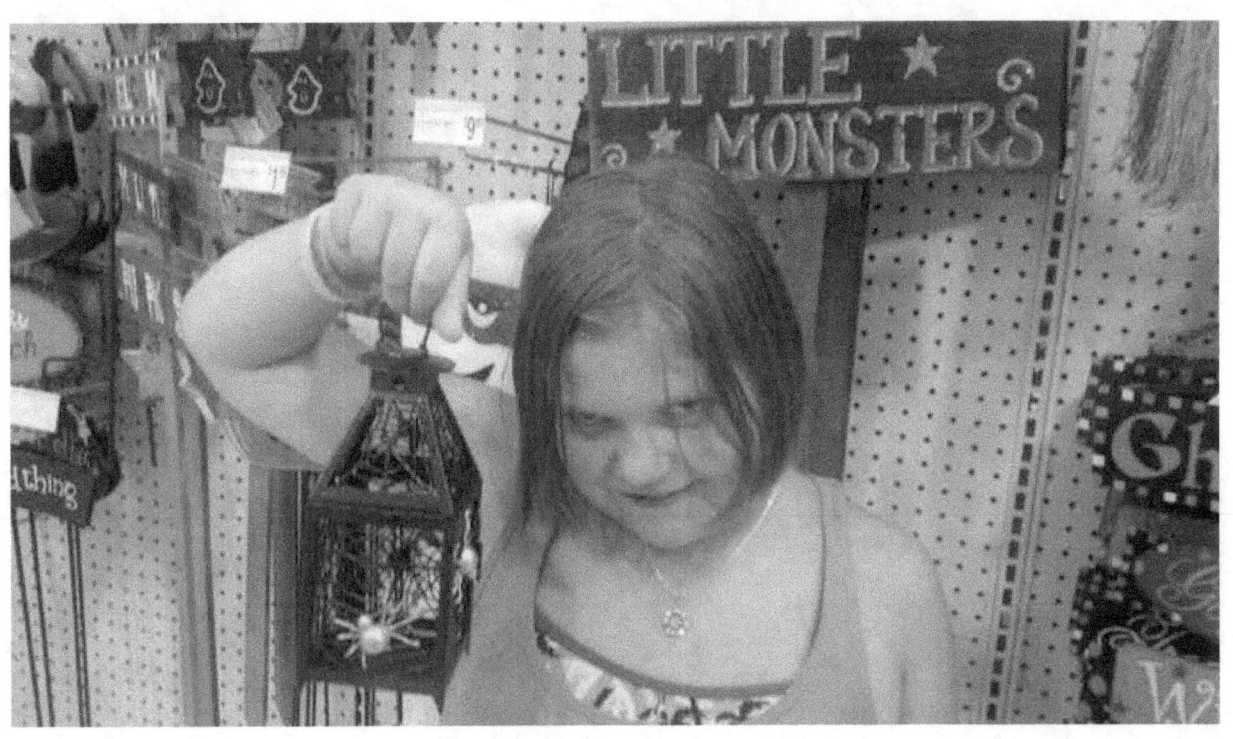

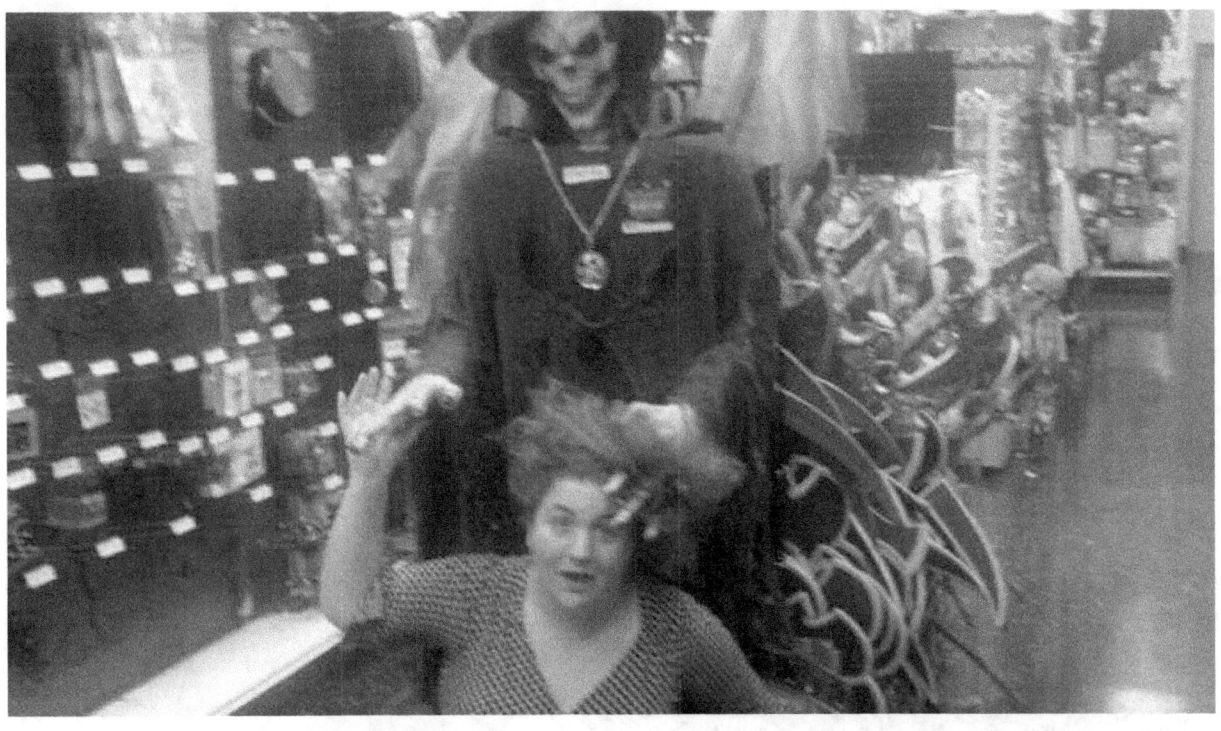

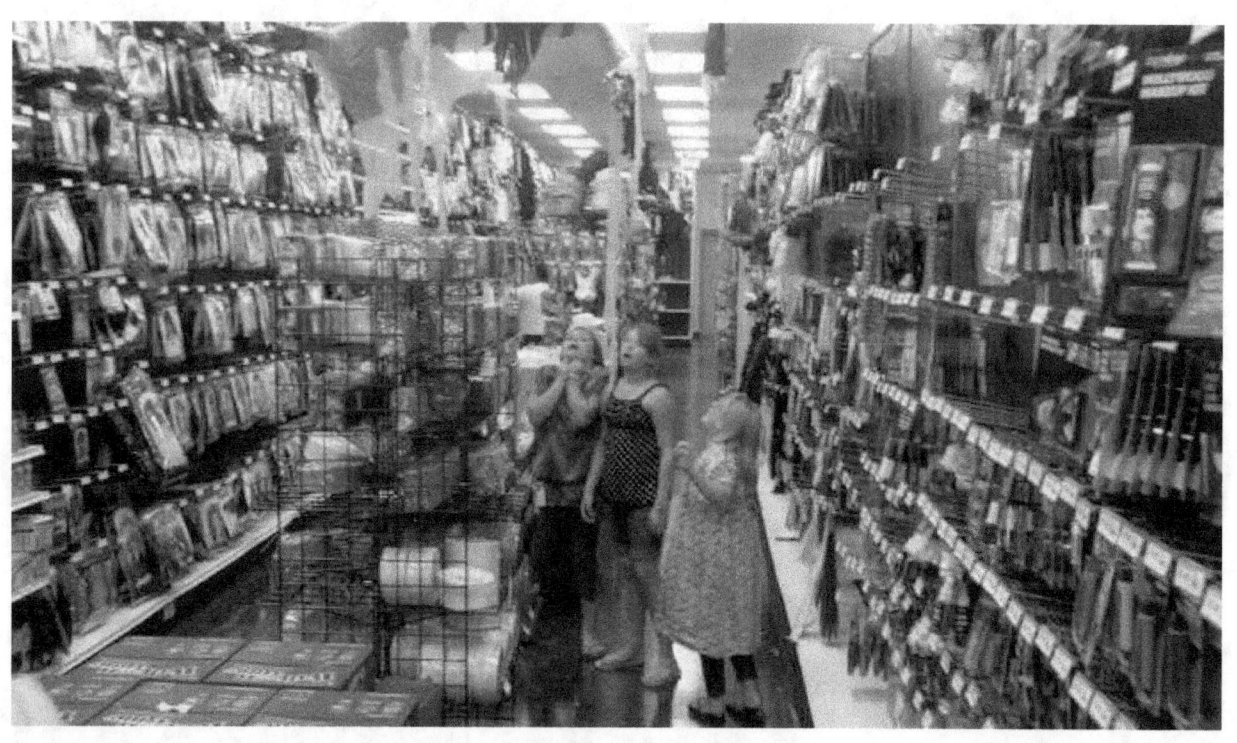

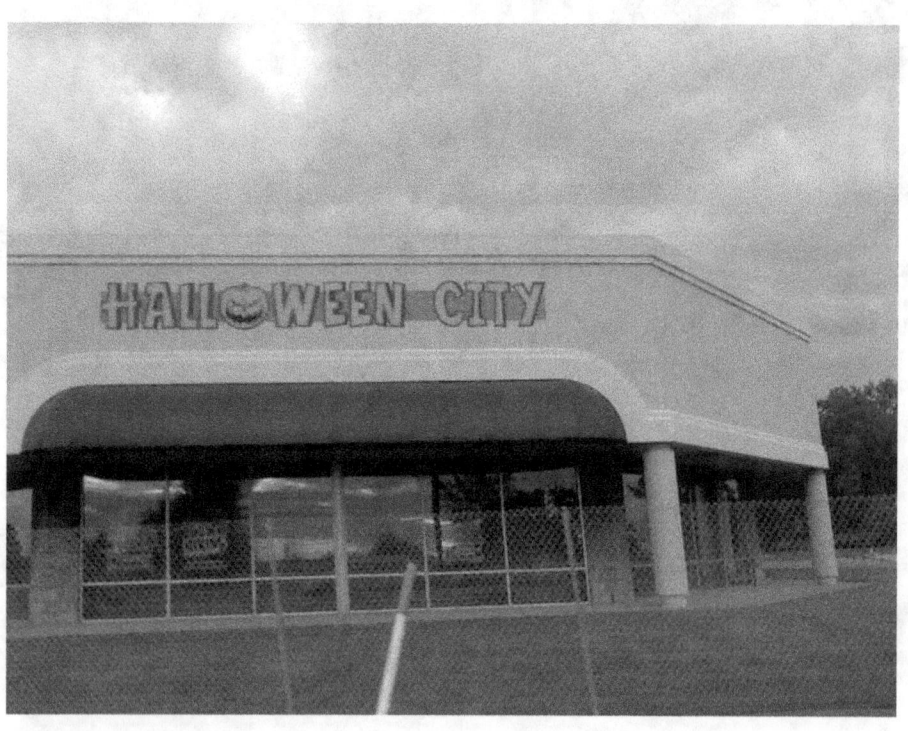

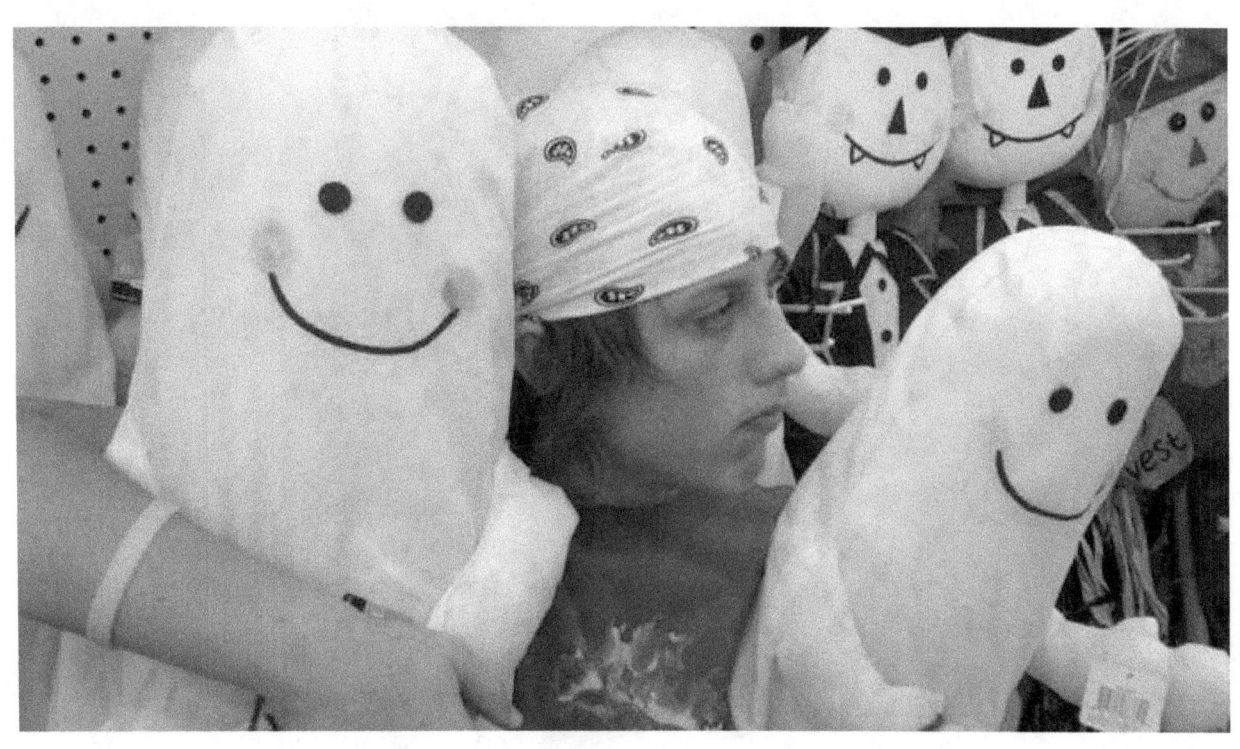

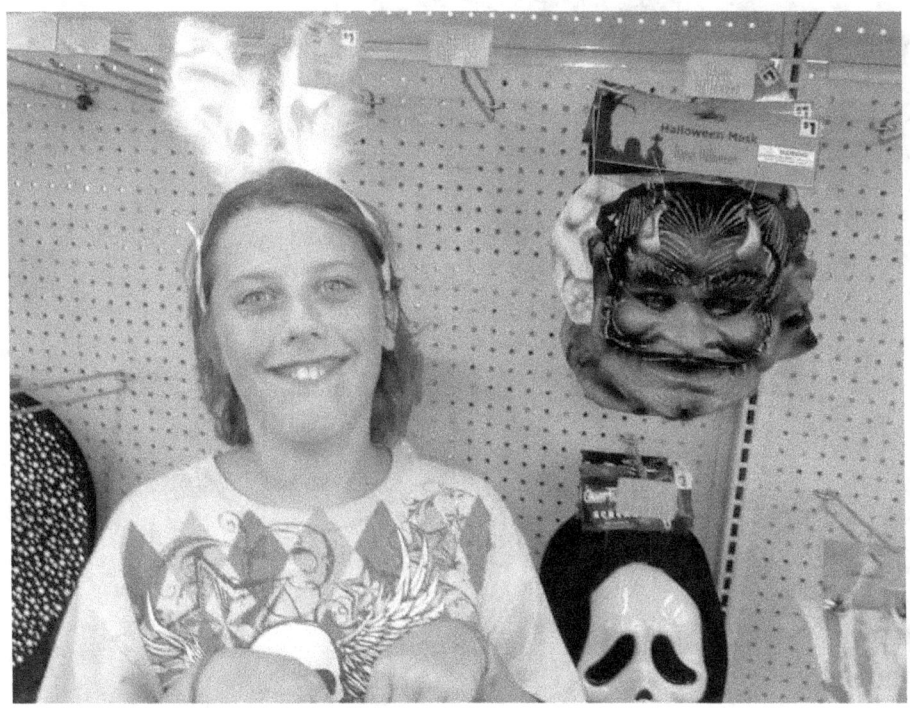

VERY EARLY AUGUST

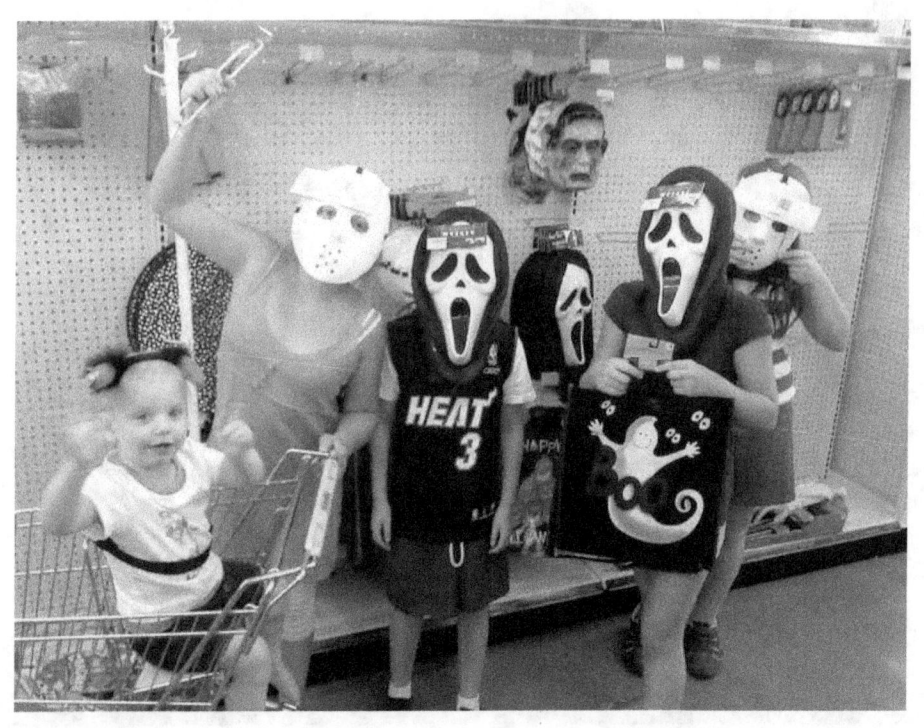

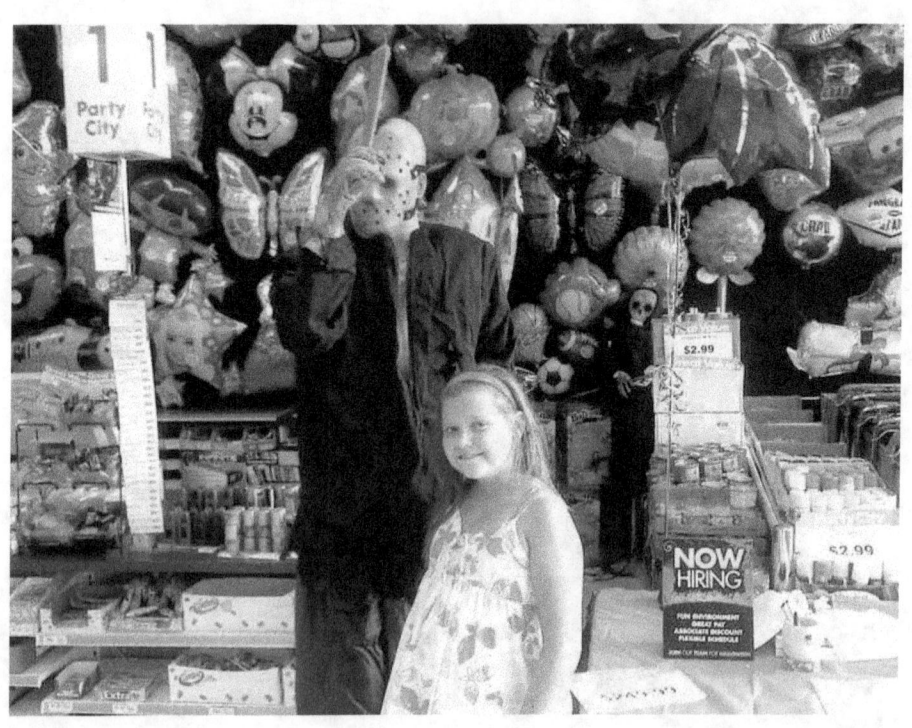

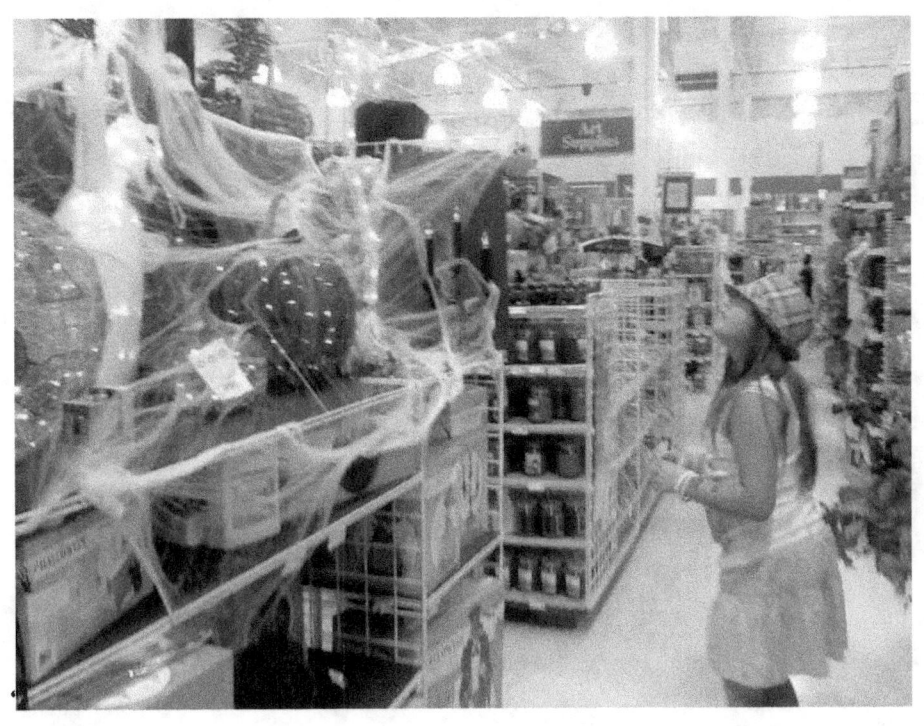

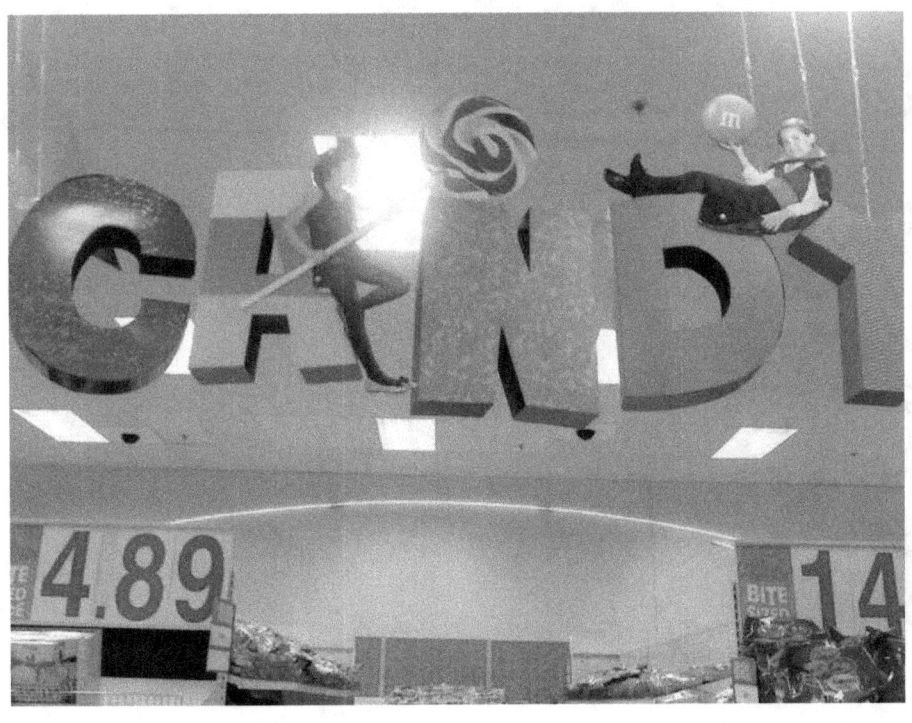

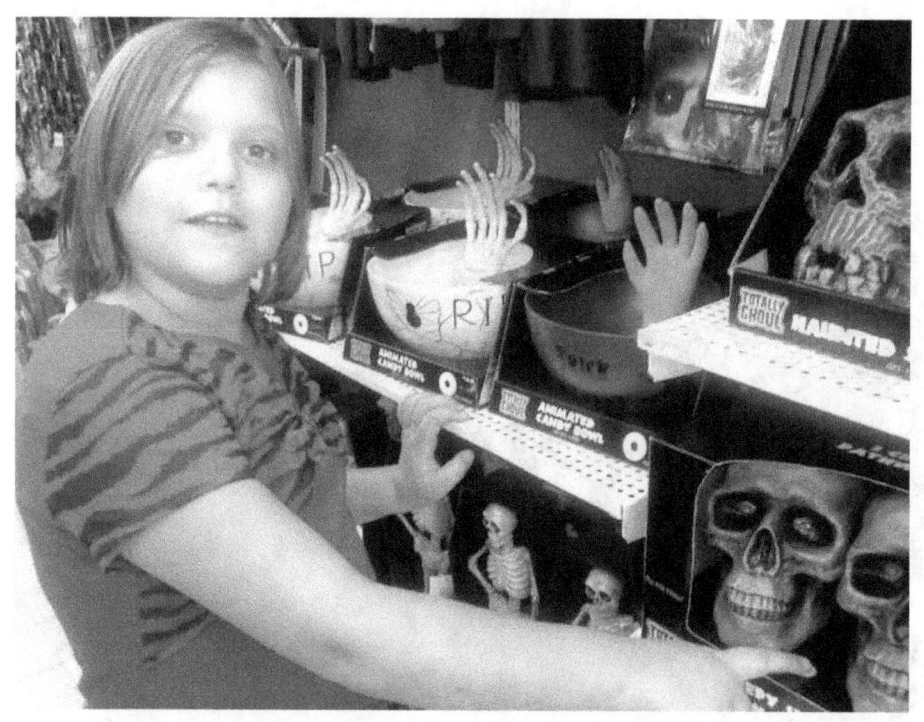

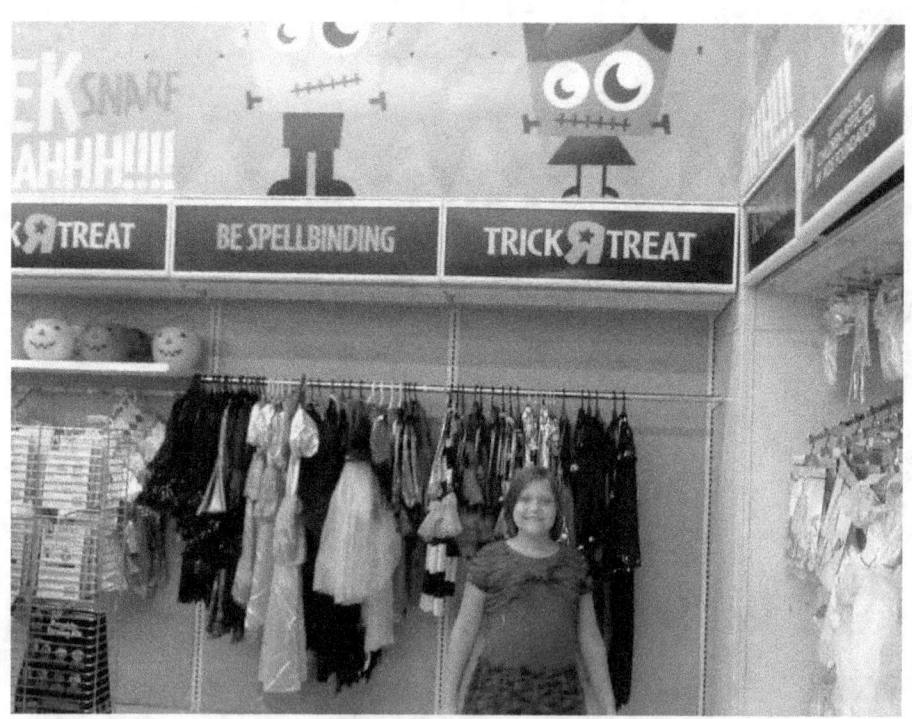

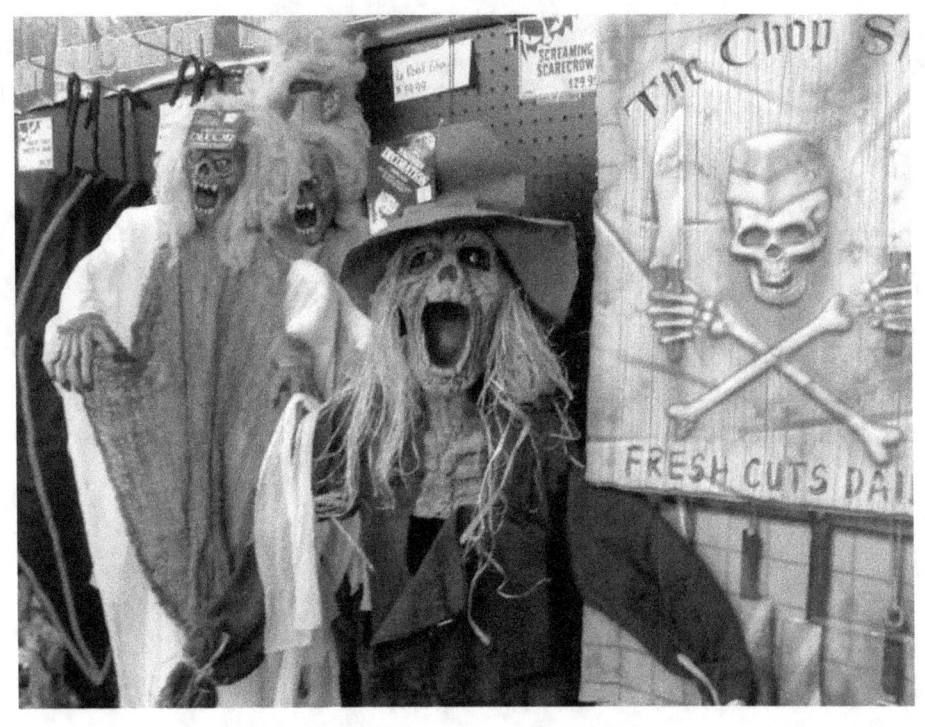

CLOWNING IT UP

88 | VOICES OF OCTOBER

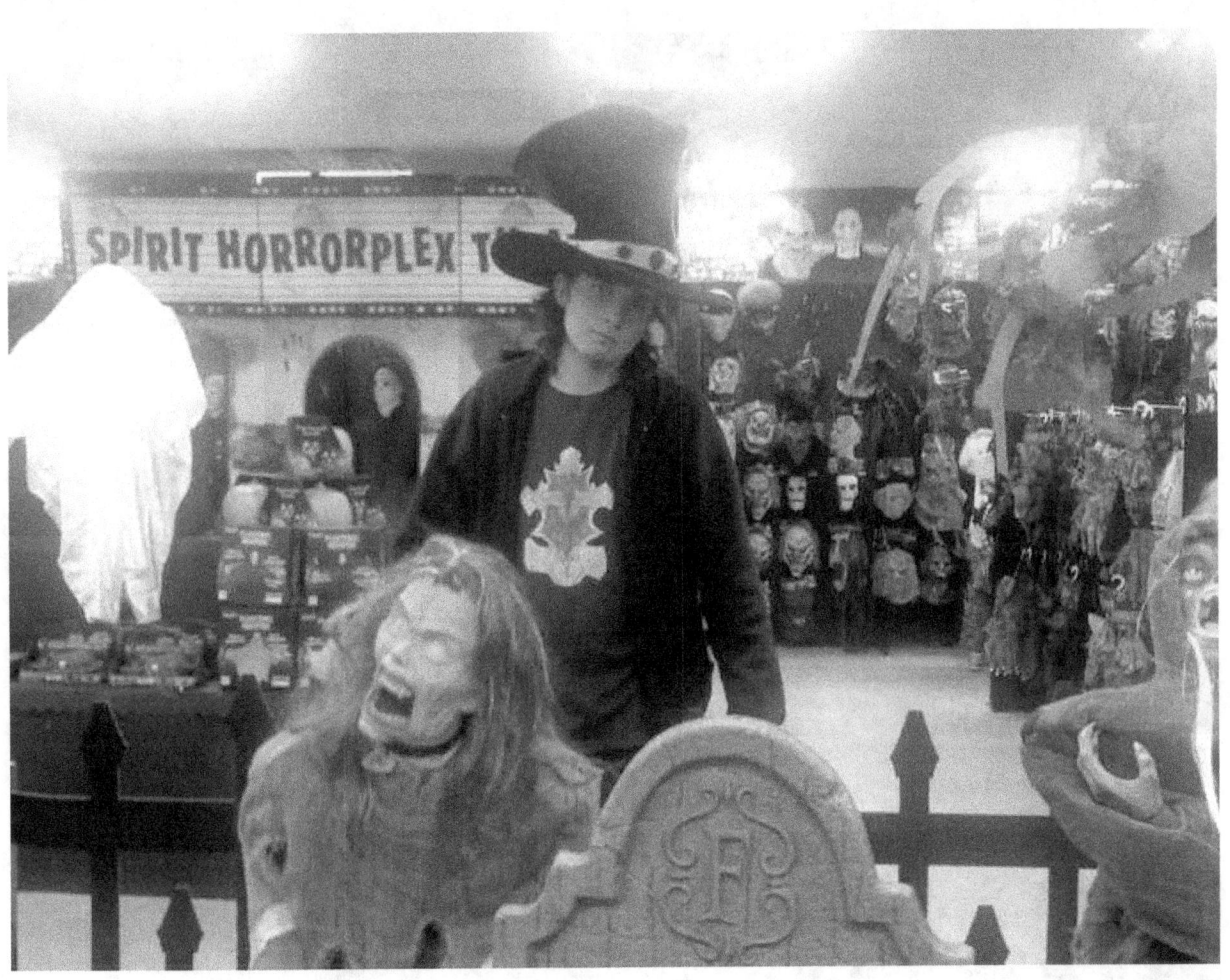

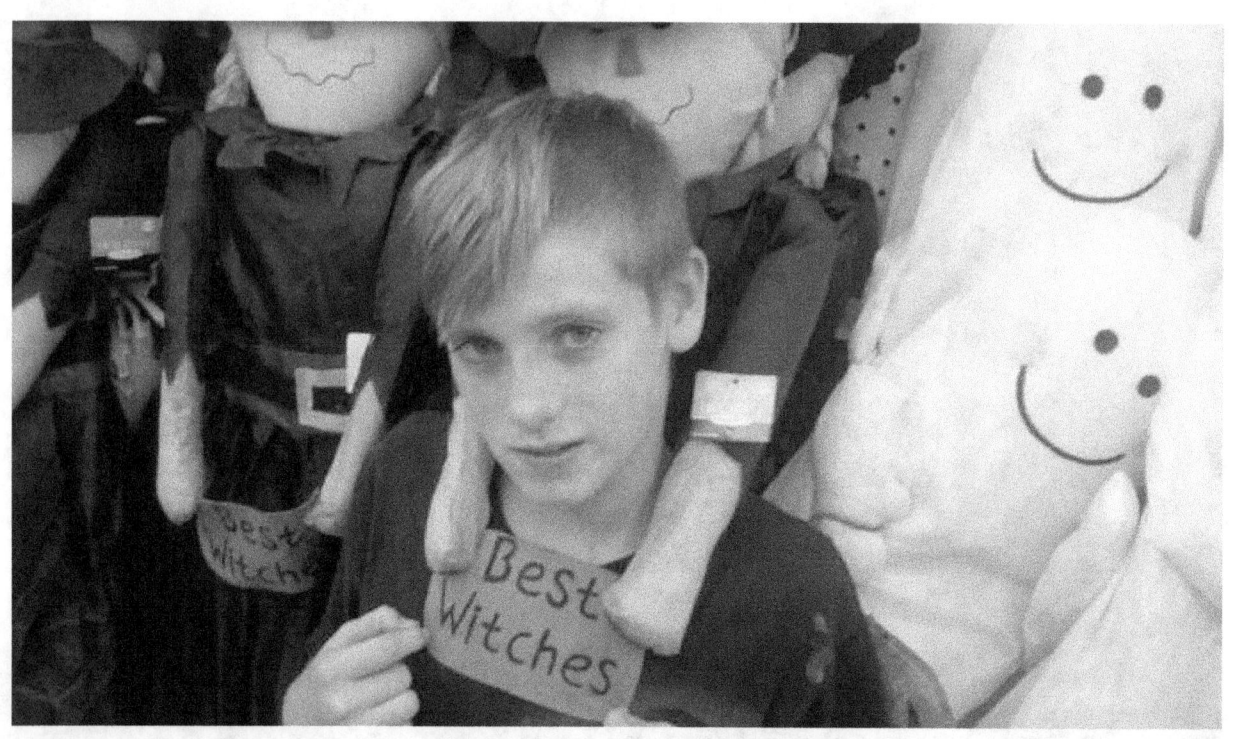

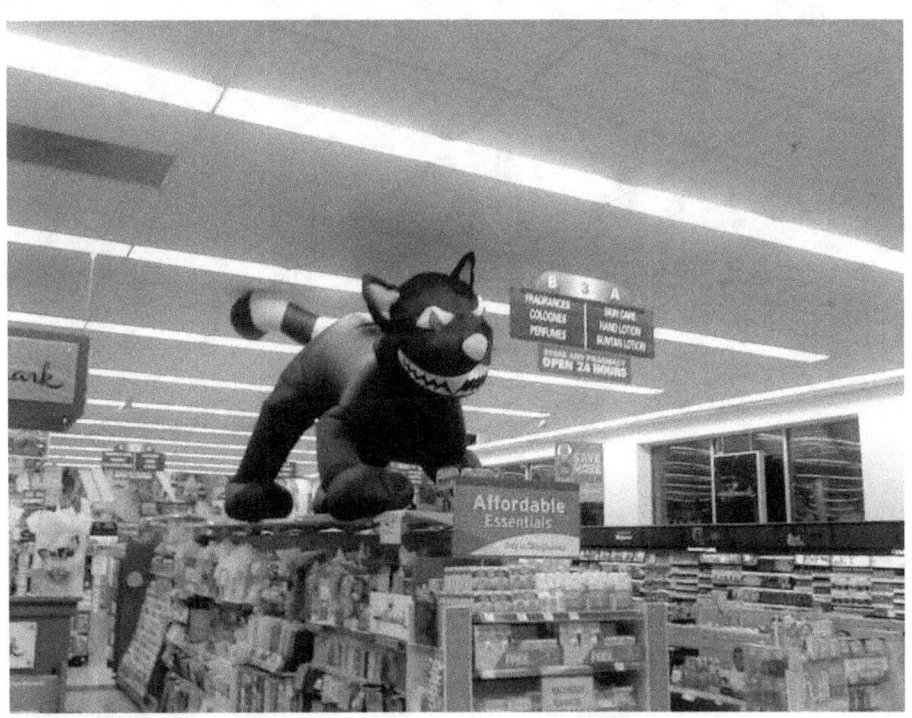

HERE KITTY KITTY

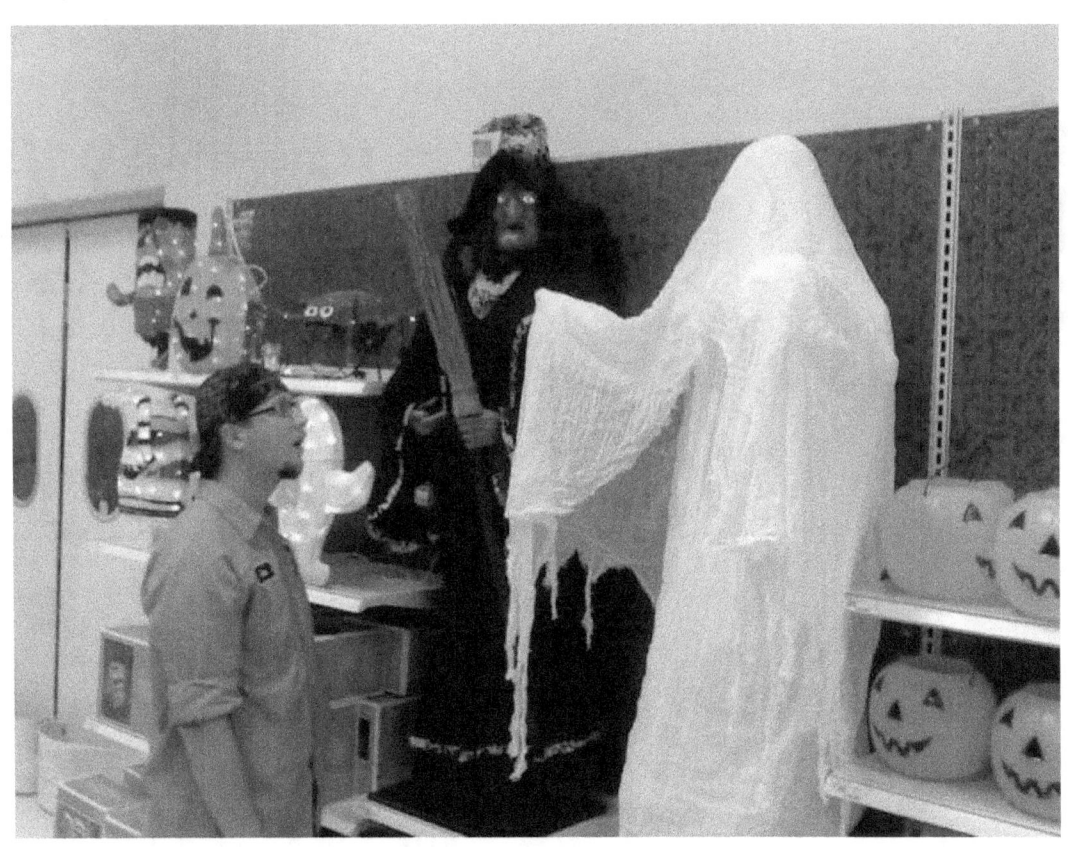

PART FOUR: PICTURES OF AUTUMN

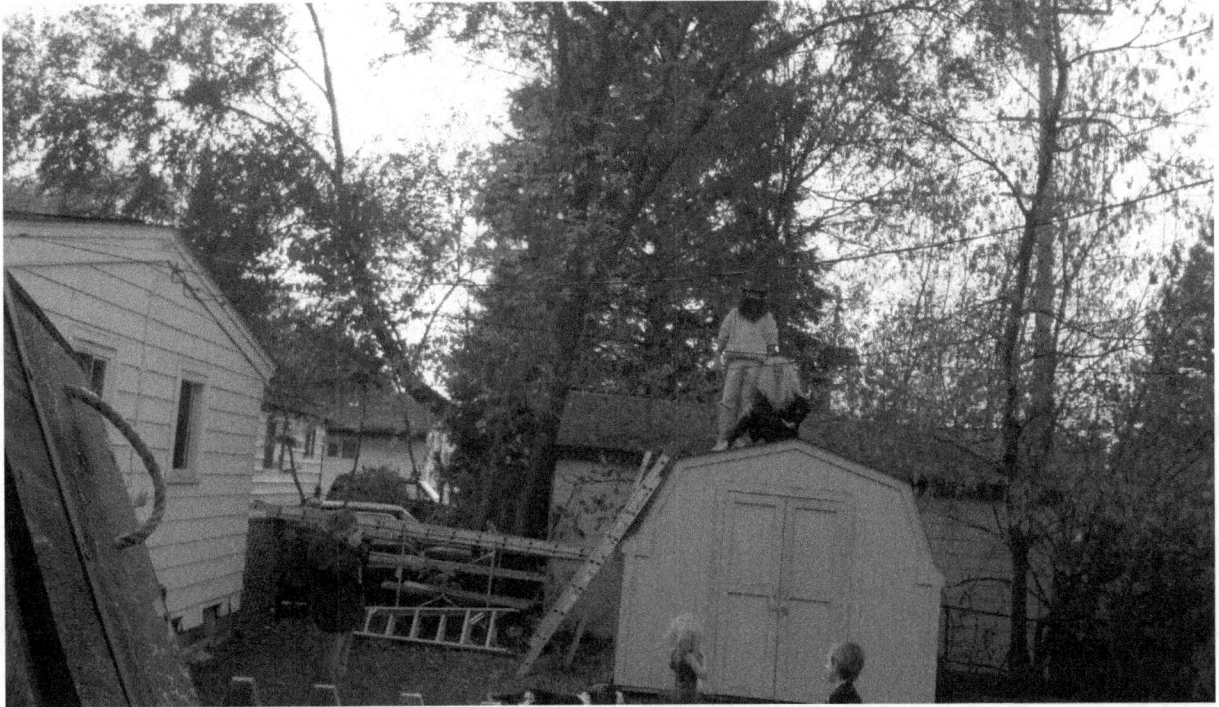

NEIGHBORS GET IN ON THE ACT. FALL FOLIAGE ABOUNDS.

SOMETHING STRANGE HAPPENS every fall season. The nights become longer. The sunsets are streaked with maybe a bit more orange and red. The leaves turn from a lovely green to a festive collection of hues. The moon seems to melt into the skyline of the violet blue sky. In some places, the air turns crisp and cool, and the prospect of staying inside with a warm blanket and hot apple cider becomes an inviting thought. It's a very romantic time of year, as nature dictates.

The coming of Halloween is signaled by many different changes; some small, some more notable. The traditions and activities embraced by various families are therefore quite personal and varied. Some celebrate the entire season of autumn as the holiday approaches. There are parties, scary movies, games, crafts. Some prefer the "harvest" aspect of the season, decorating with gourds and cloth scarecrows, visiting the pumpkin patch, hazelnut scented tealight candles, baking cinnamon cookies.

The truth is, there is no wrong way to celebrate, and each season's signature reveals it's own imprint on every individual.

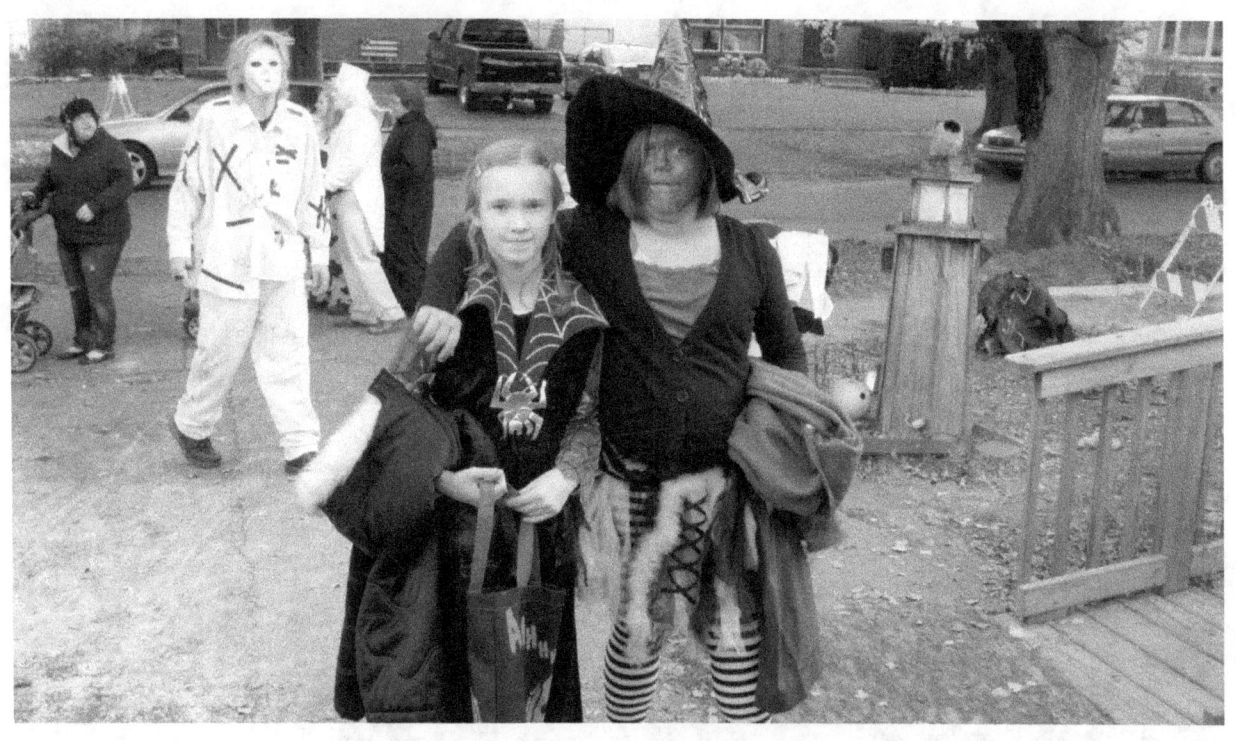

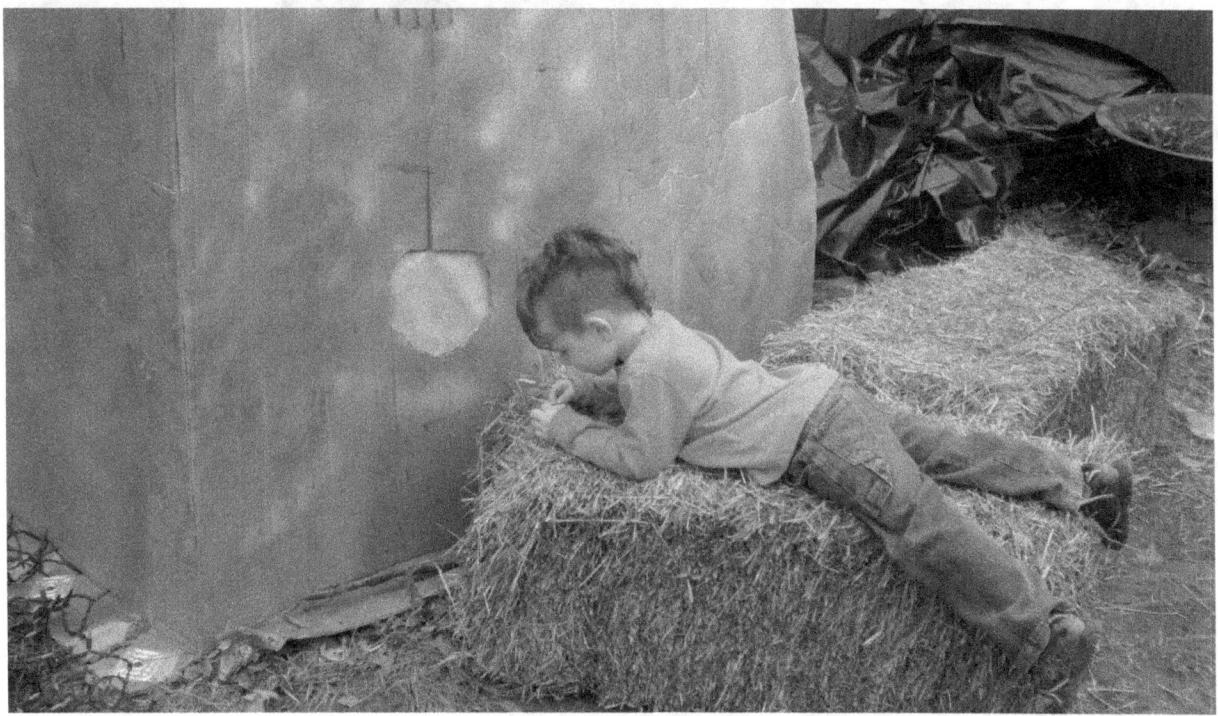

95 | VOICES OF OCTOBER

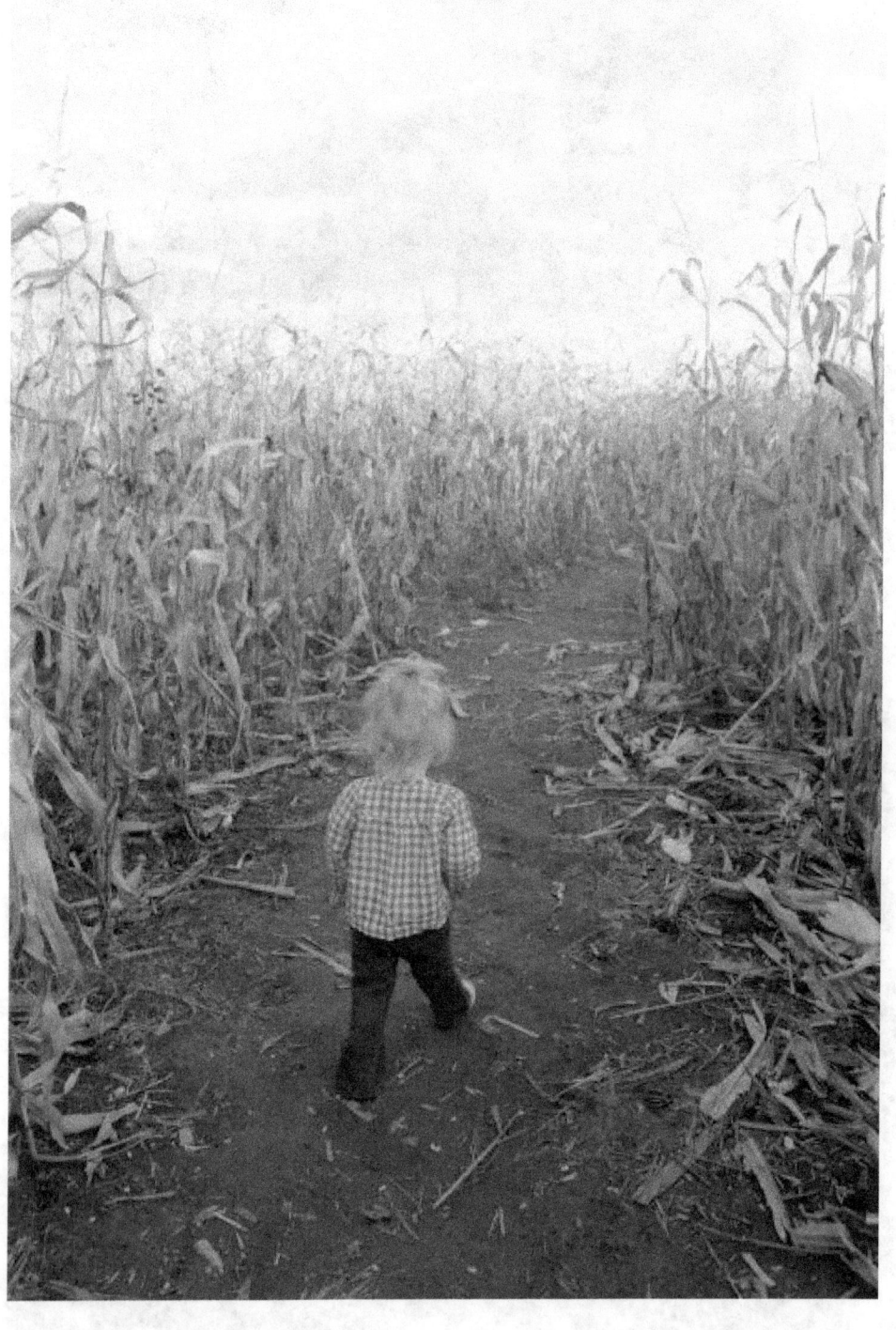

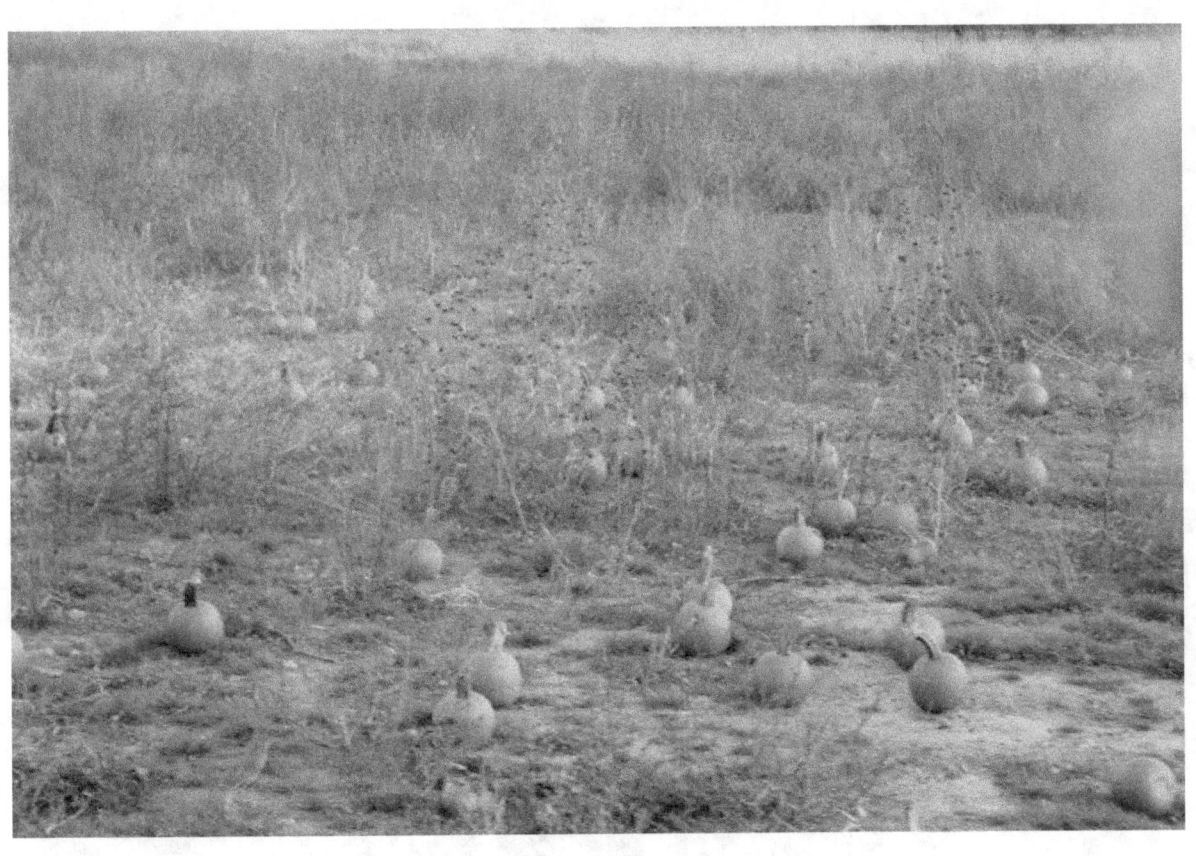

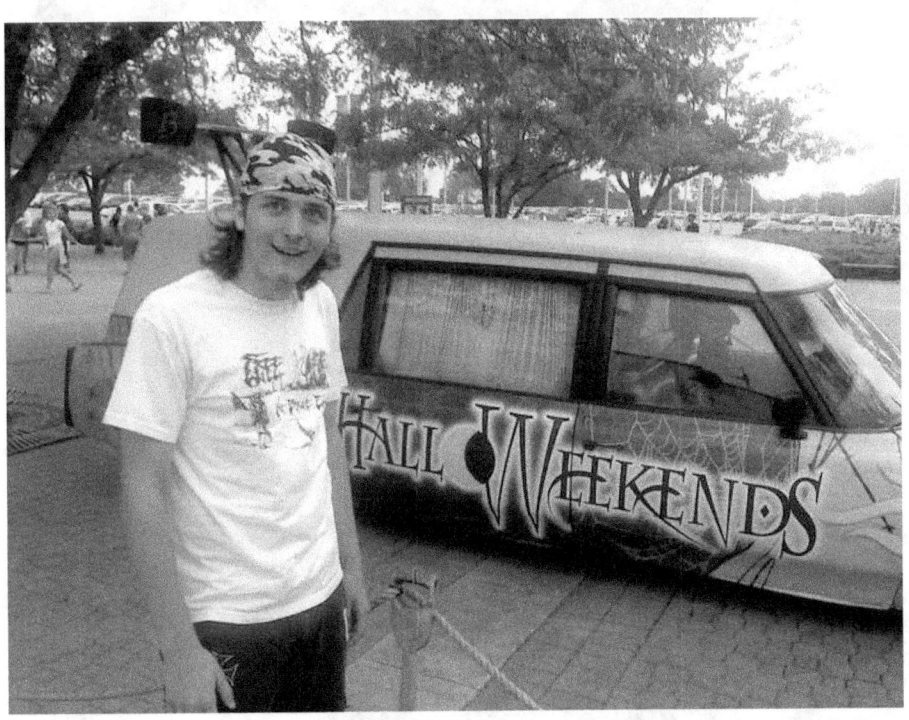

98 | VOICES OF OCTOBER

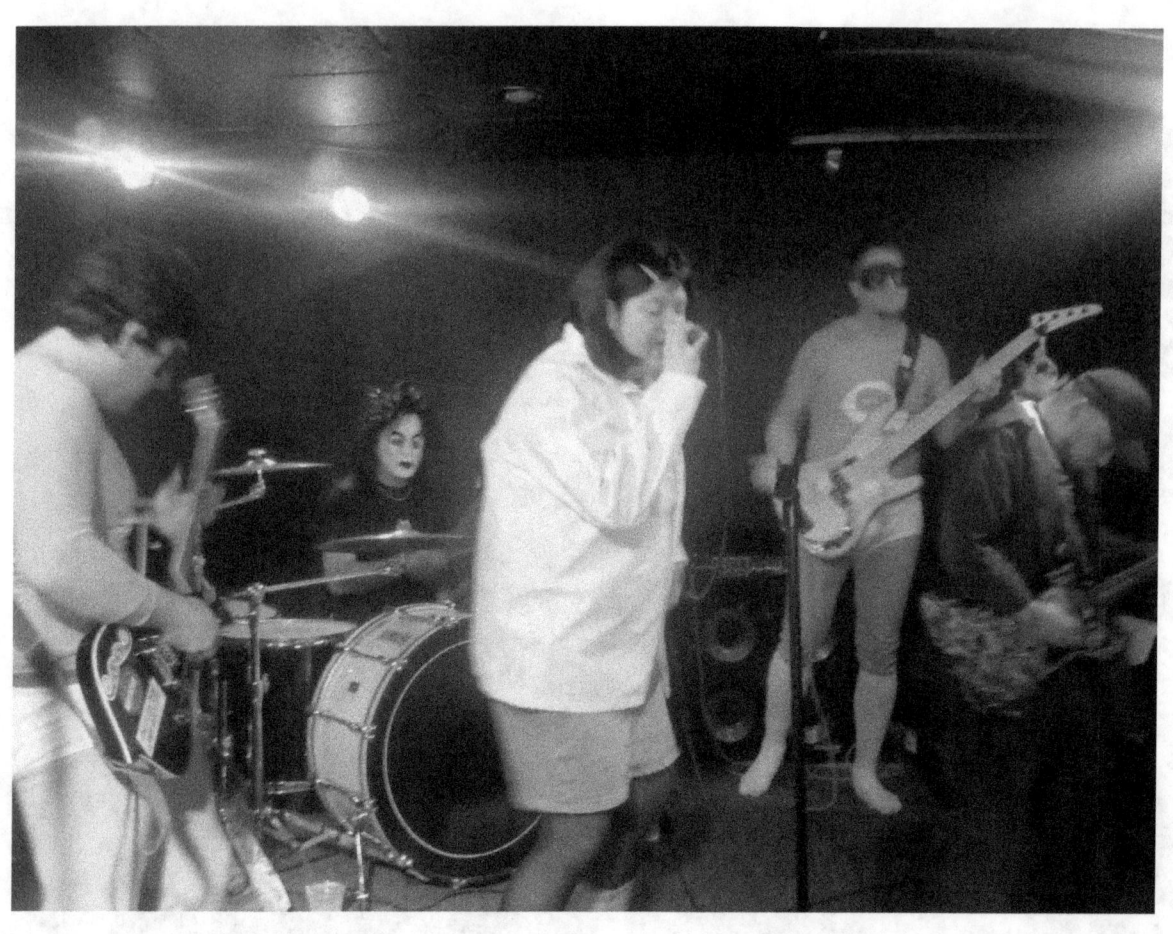

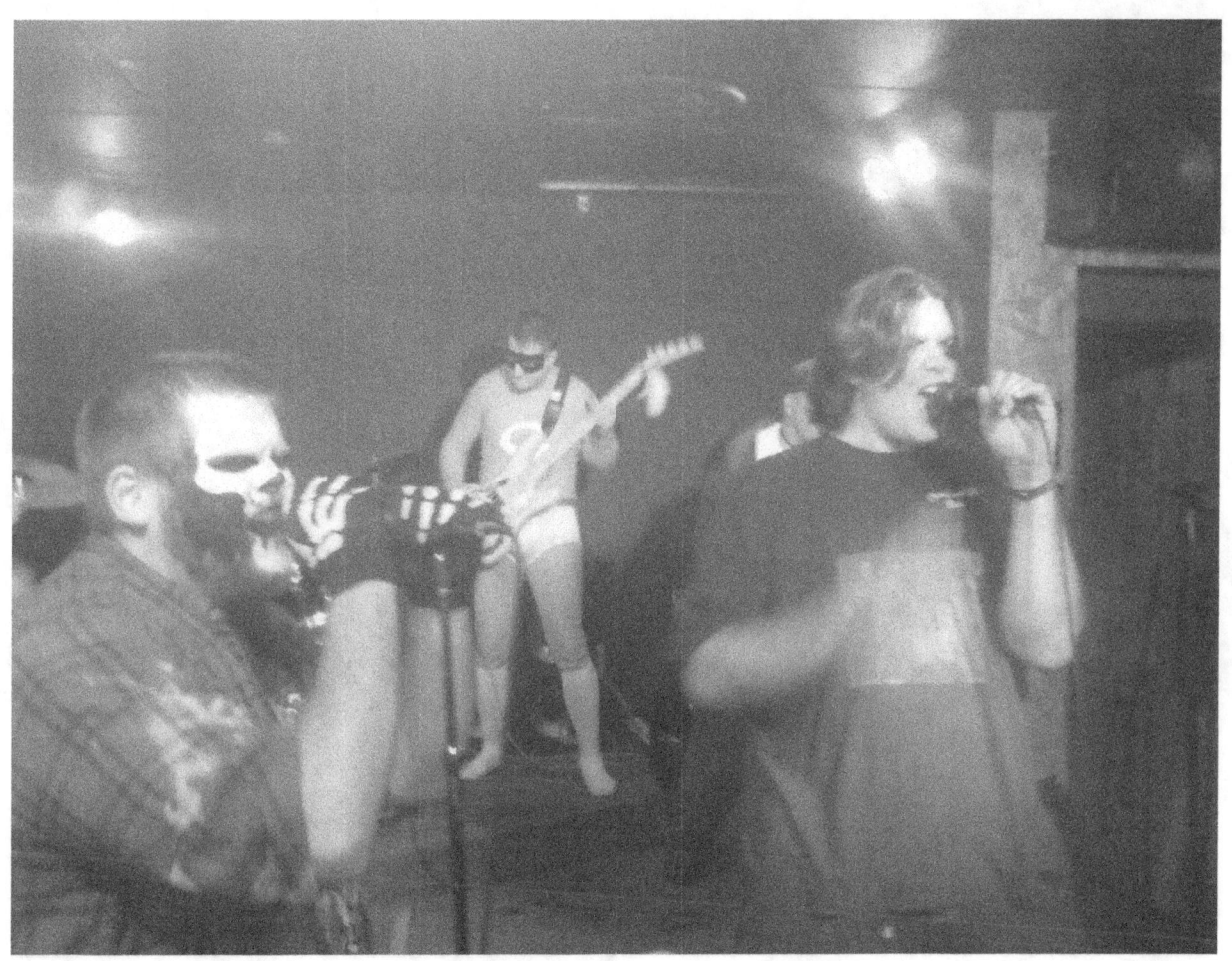
MEMBERS OF LOCAL FLINT BANDS FREE WILL AND MOTHRA, HALLOWEEN SHOW.

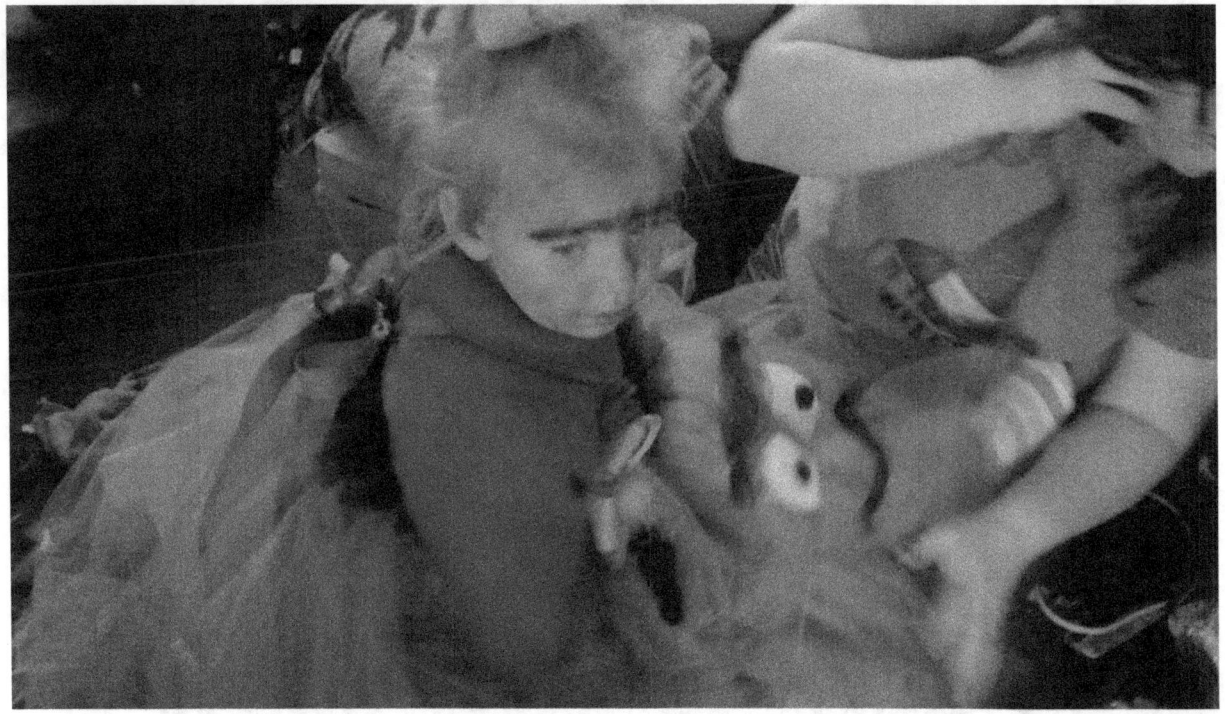

"FRANKENSTEIN'S DAUGHTER" READYING FOR A PARTY.

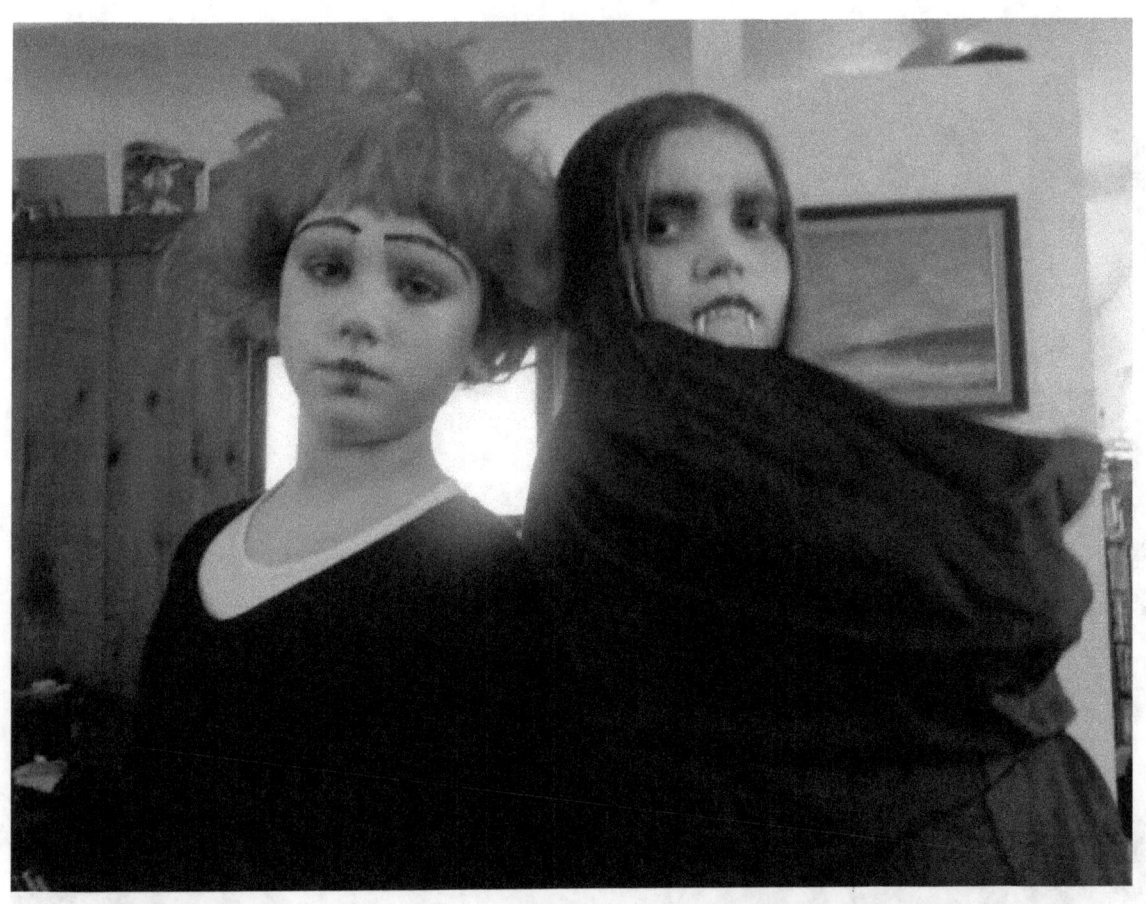
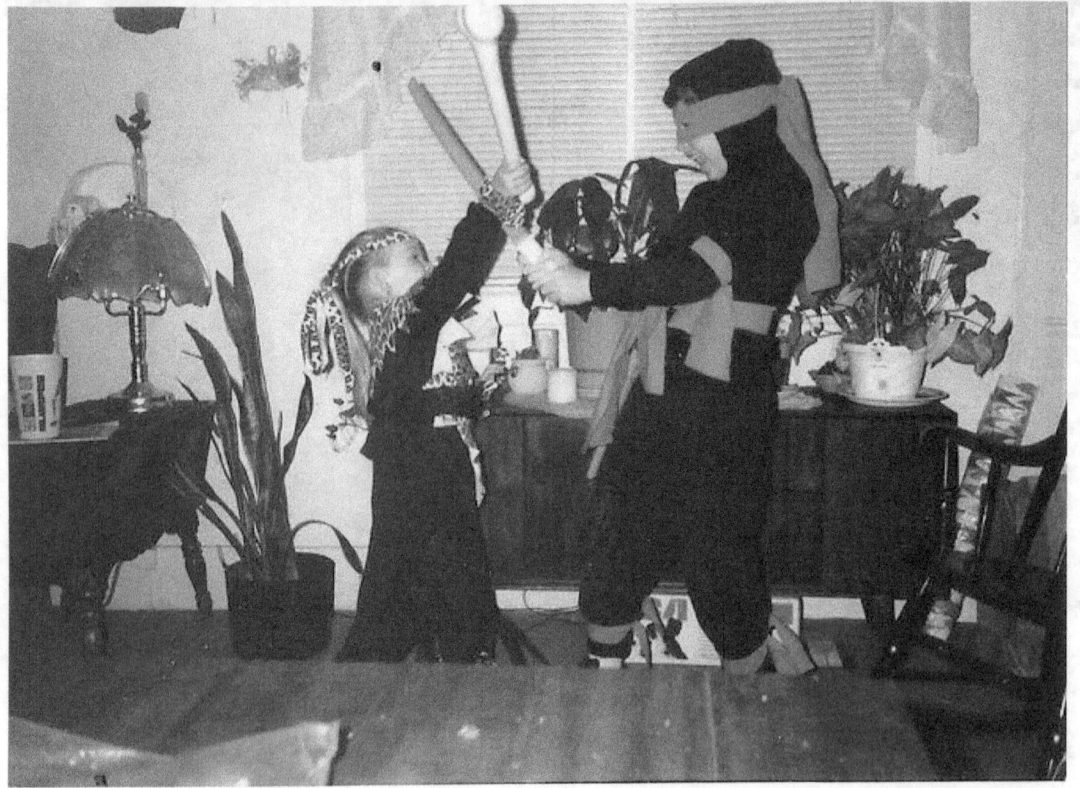

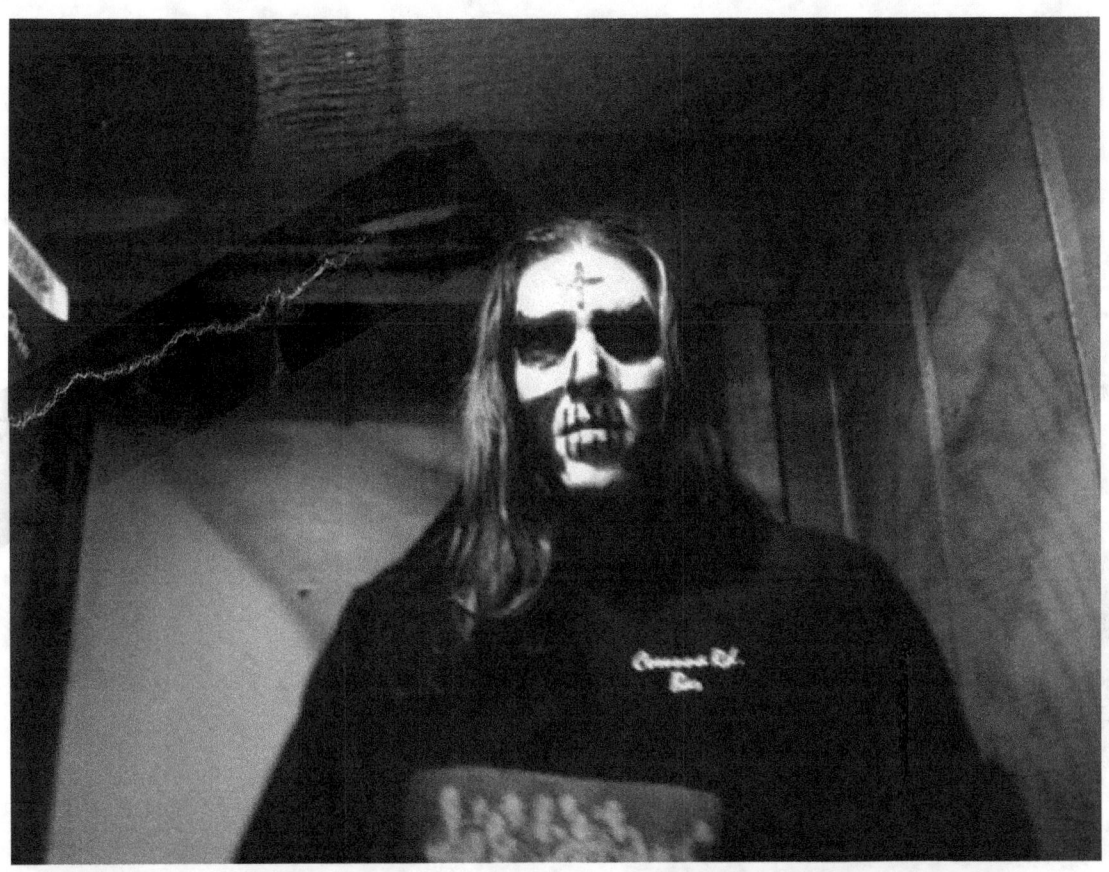

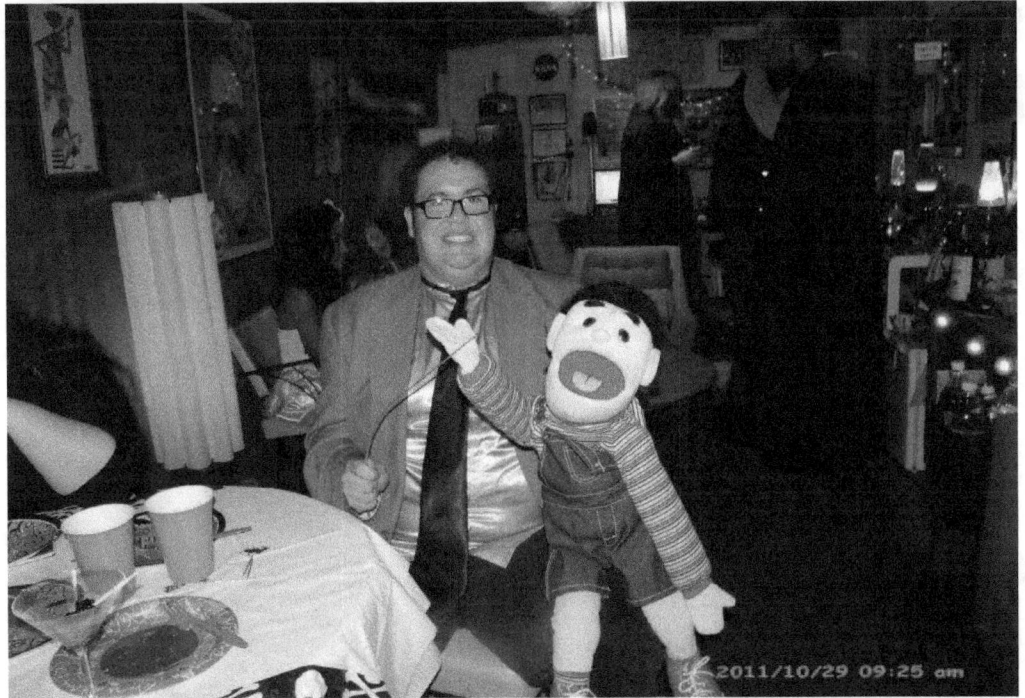

WORLD'S WORST MUPPETEER.

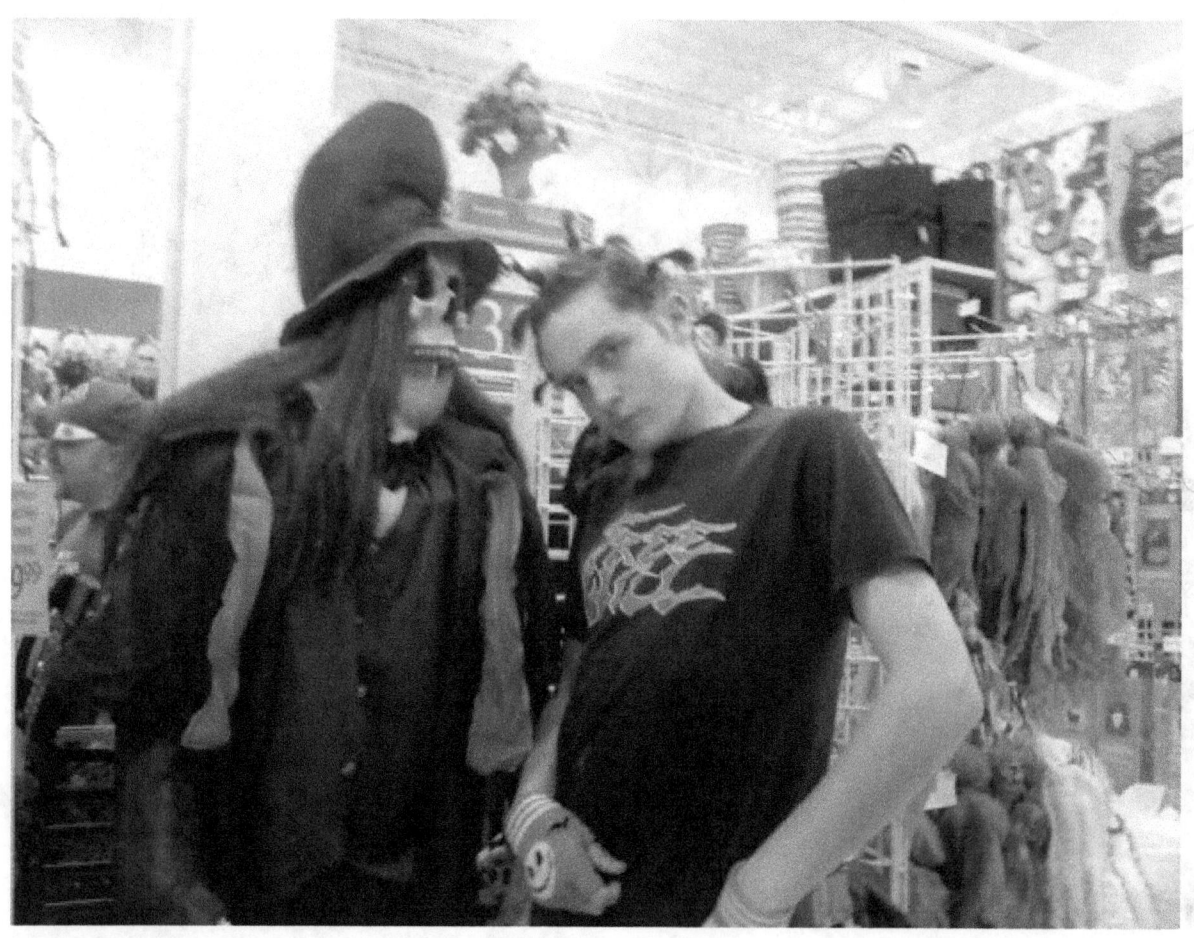

KINDRED SPIRITS.

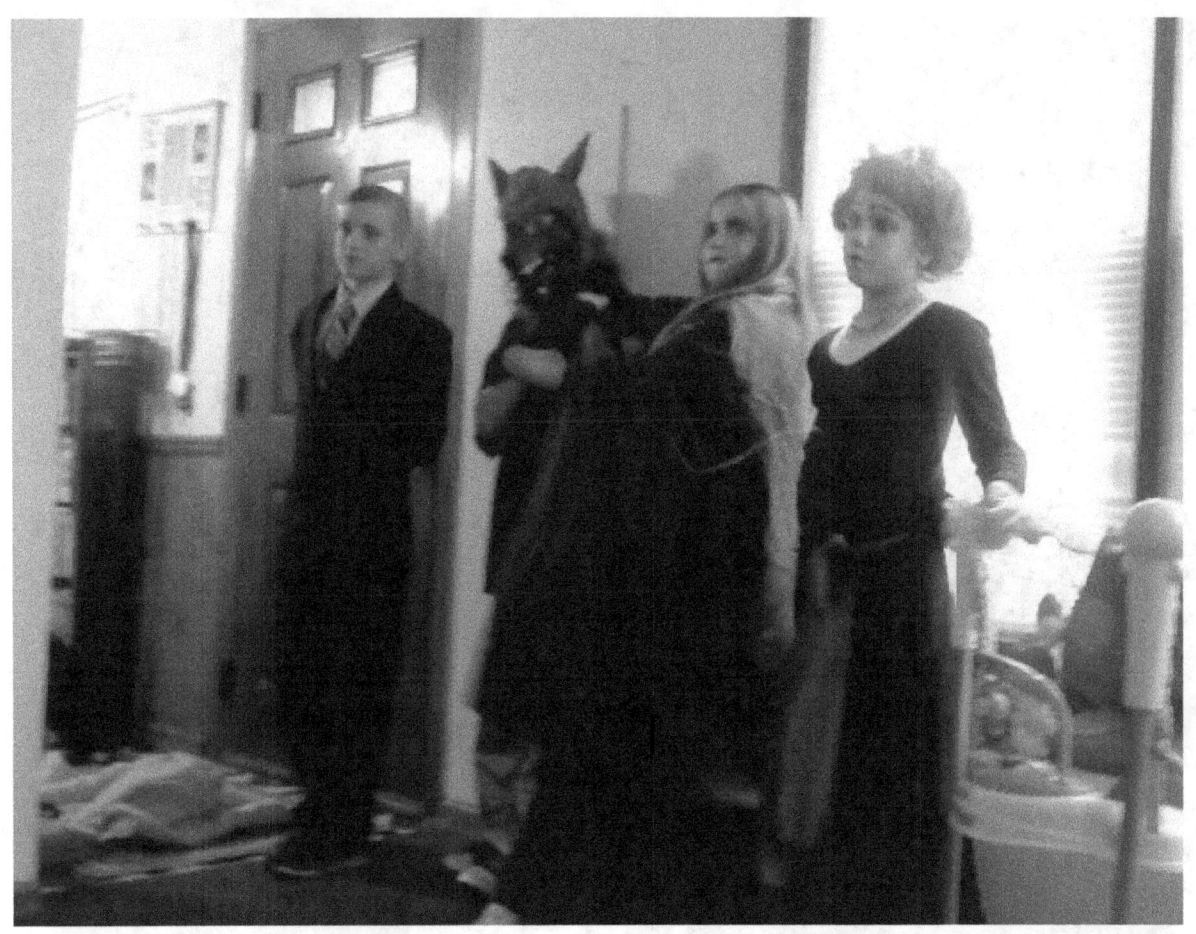

BUSINESS MAN, WEREWOLF, VAMPIRESS, RED QUEEN. HALLOWEEN DIVERSITY.

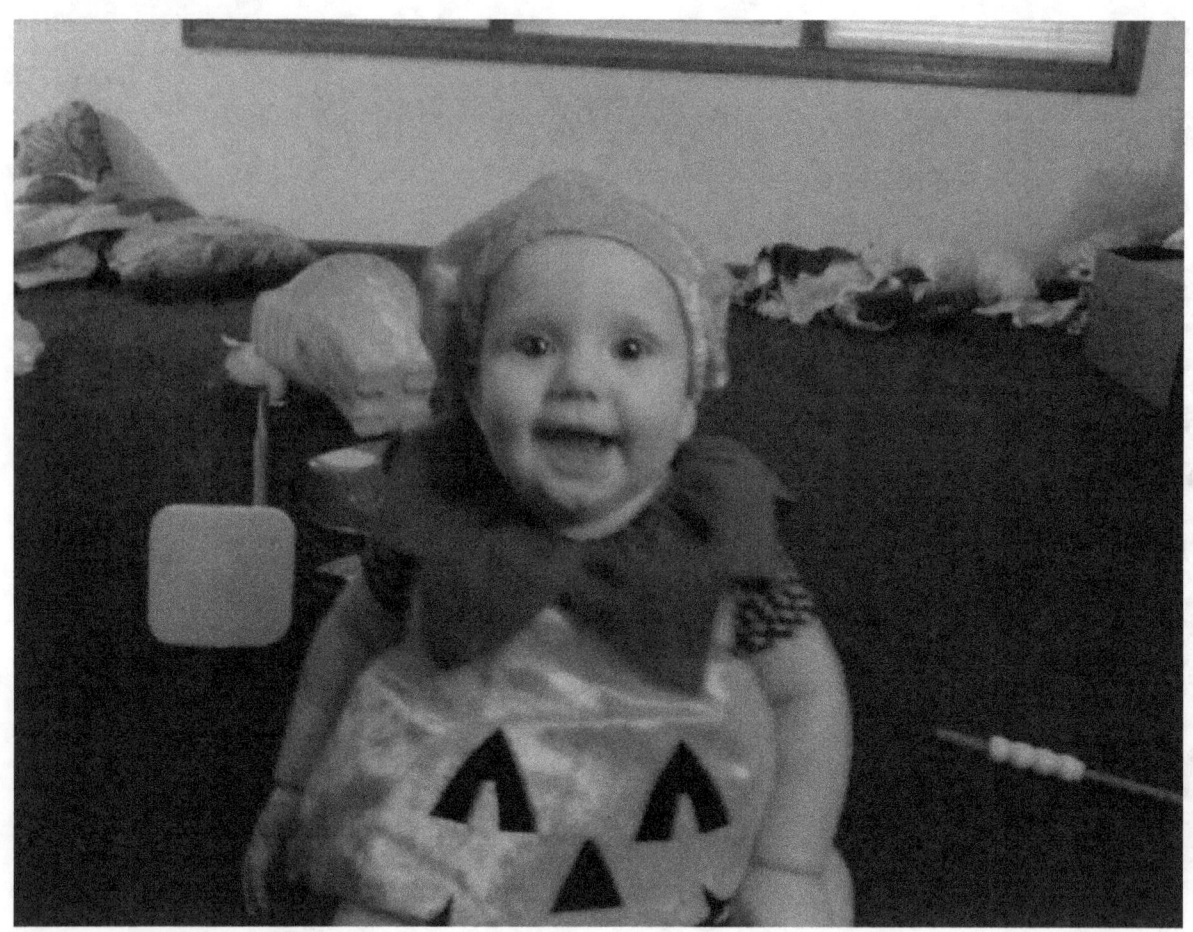

PUMPKIN CUTIE PIE.

KAIDEN RANDOL ENJOYS THE EVENING.

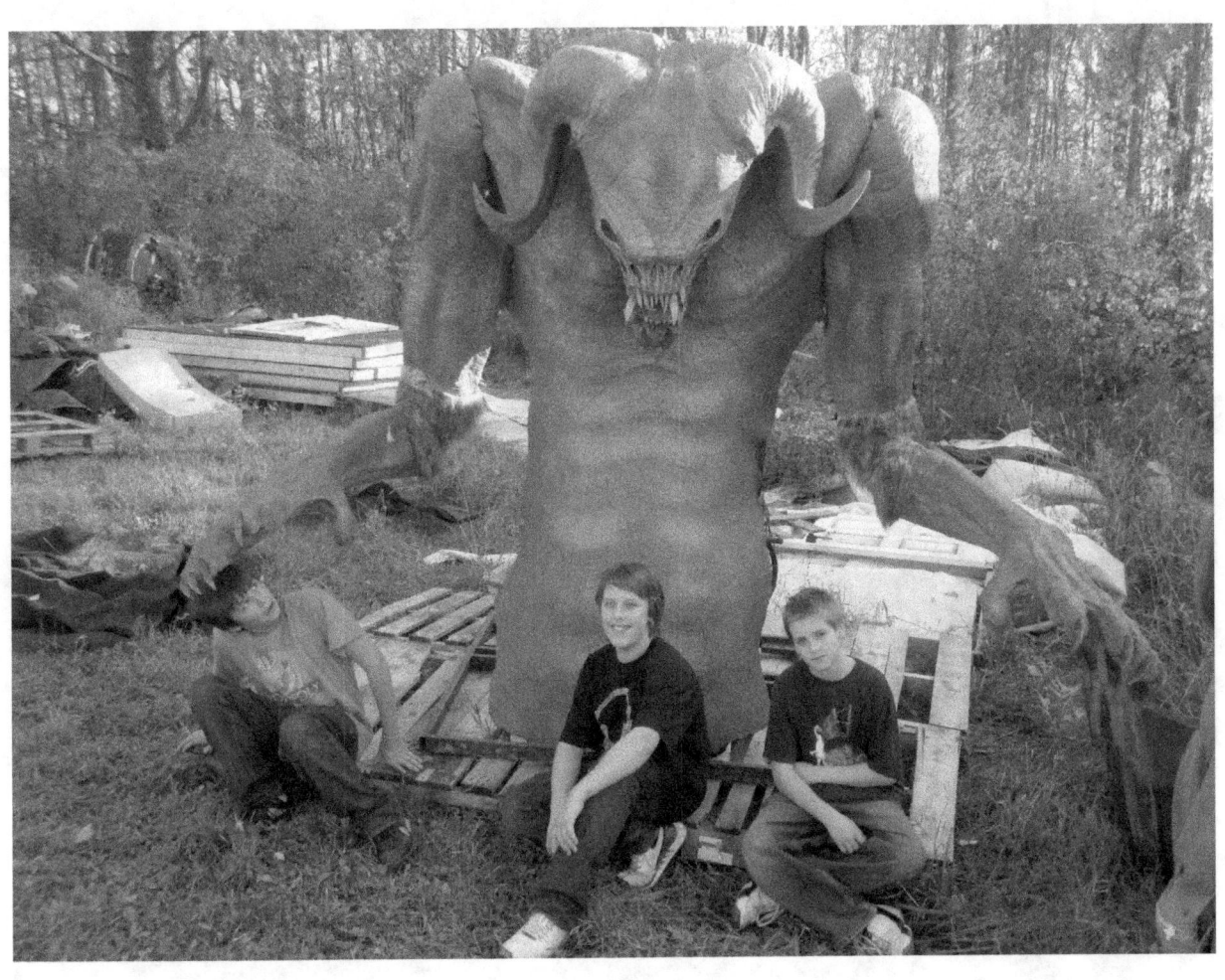

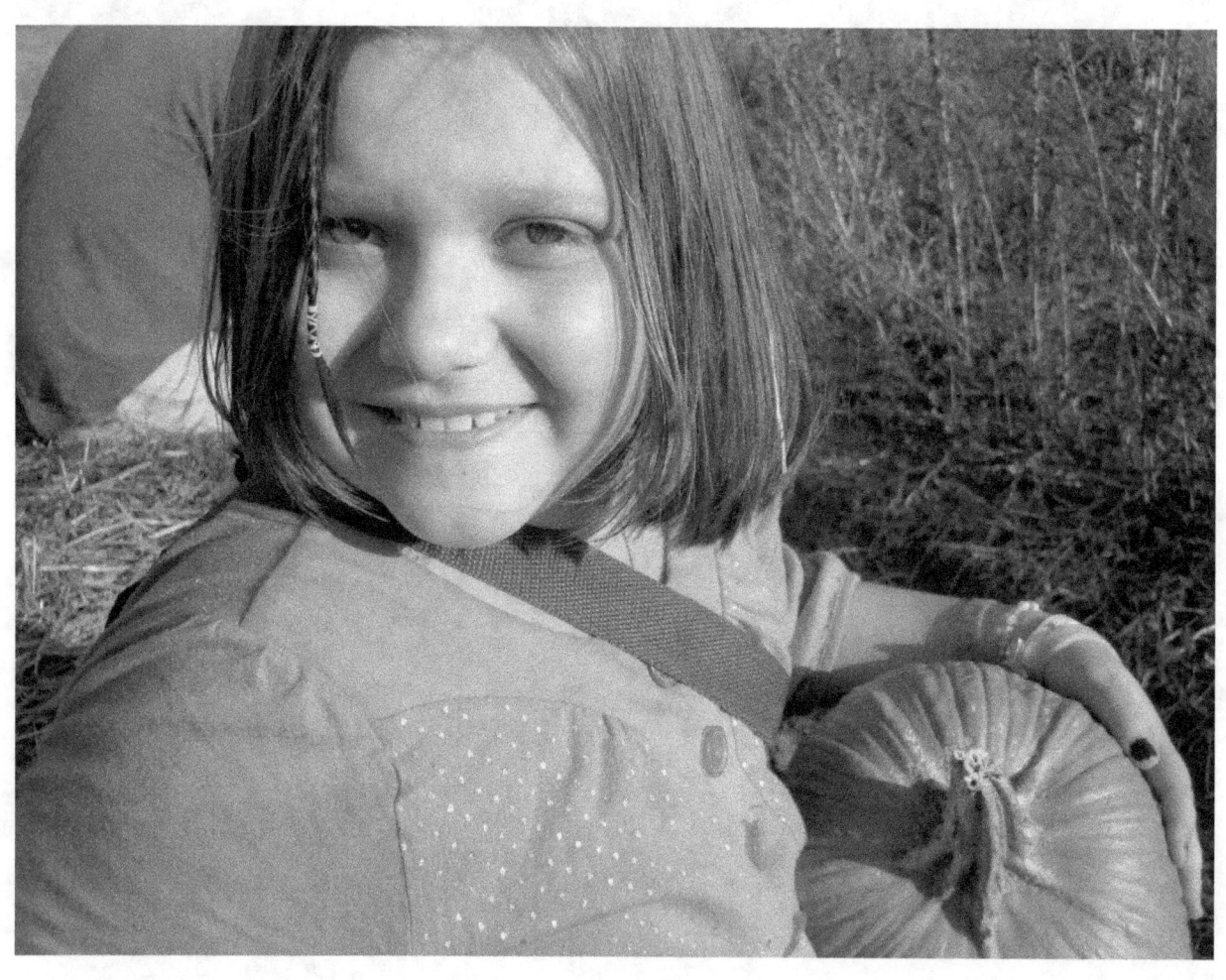

AFTERWORD

Many of us are beyond addicted to Halloween, this night of mystical carnage that wreaks havoc on our already unsettled minds. We all seek out this guilty pleasure of entertainment, whether your choice be practical jokes, jumping out from behind a darkly lit spot and freaking the bajeebies out of your sister Nikki, watching scary movies, telling ghost stories or even riding roller coasters that flip us upside down and make us scream until we have no voice left. We all love a little scare; as the weary anticipation of fright hangs in the balance, our adrenaline pumps, and our hearts beat faster than we thought they could. We all harbor some love for a season tinged with the colors of ember, the sweet scent of fall leaves, chocolate covered treats and tricks that will make the faint hearted weep!

Halloween will be here in no time, once again beckoning our call into the dusky crisp night where goblins lurk and candy calls, treats are had and tricks are worst. Don't let just anyone scare you; if you must be freaked, do it intentionally. See what fun can be had, bring your mom, bring your dad, bring your uncles and your aunts. There's screams to be had, just take a step, open your door, and enter the treat that has waited all year.

Diamond Counelis

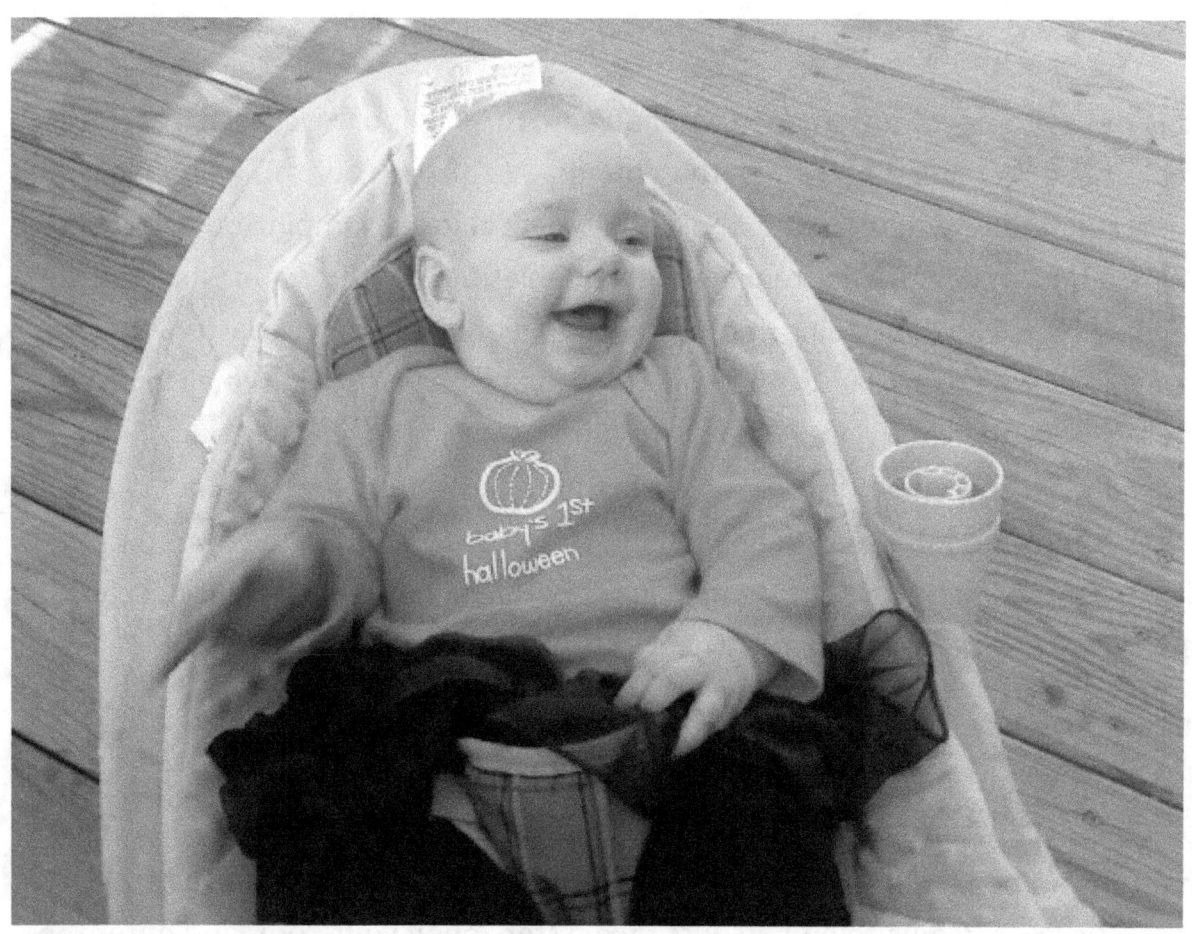

The author thanks:

Magen Randol, Crystal Counelis, Freda Counelis, Stacy Tanguay

Flint Horror Convention

Glen Birdsall

Scarriage Town Crew

Rue Morgue Magazine

Chris Gibson

Tyler Zickafoose

Leslie Lovegrove-Hinojosa

Hallow Harvest
BOOKS

www.ingramcontent.com/pod-product-compliance
Lightning Source LLC
Chambersburg PA
CBHW080930170526
45158CB00008B/2234